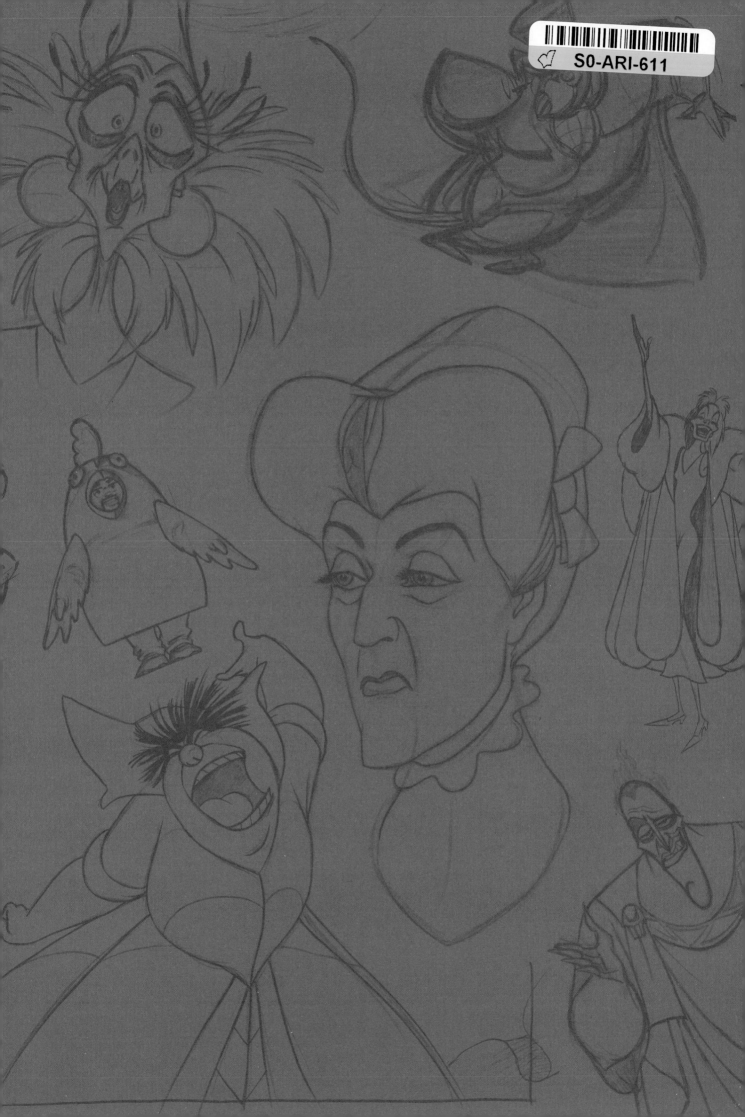

"You poor, simple fools. Thinking you could defeat me. *Me!* The mistress of all evil!"

—Maleficent, *Sleeping Beauty*

# Disney

# VILLAINS

## DELIGHTFULLY EVIL

### THE CREATION • THE INSPIRATION • THE FASCINATION

**JEN DARCY**

To LIV
Enjoy the book!
Jen Darcy

# Disney
EDITIONS

Los Angeles • New York

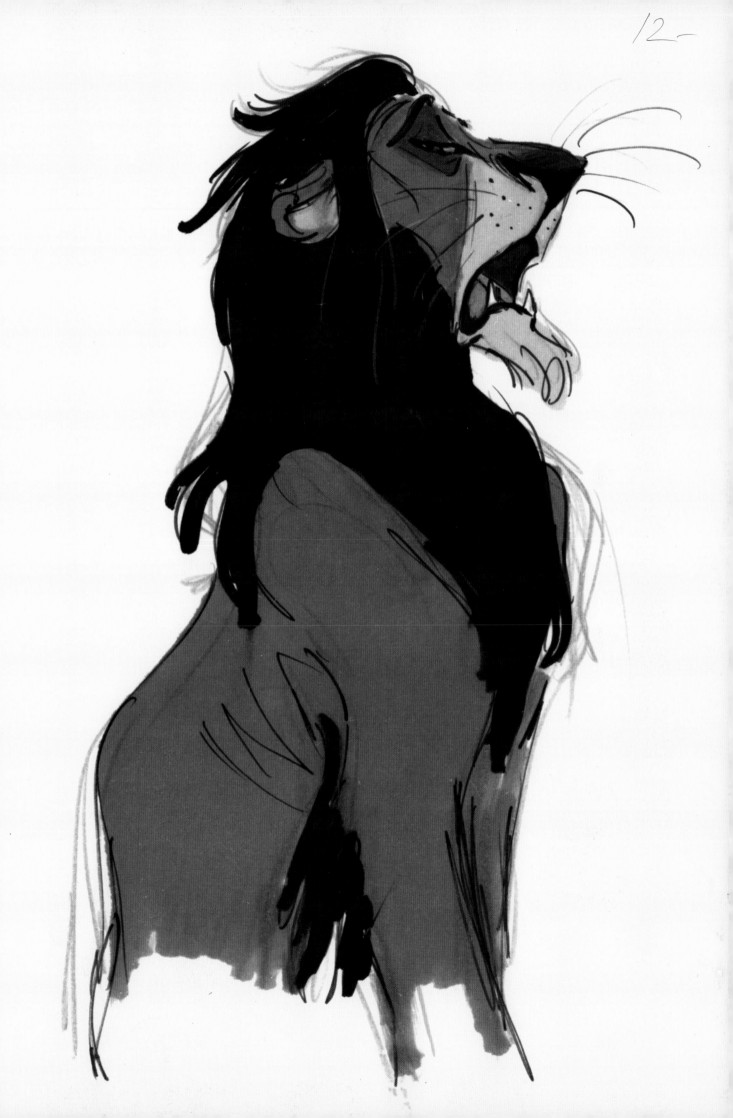

# Acknowledgments

*"You're braver than you believe, stronger than you seem, and smarter than you think."*
—Christopher Robin, *Pooh's Grand Adventure: The Search for Christopher Robin*

Thank you to Jennifer Eastwood at Disney Publishing for knowing I would absolutely love the subject matter and for assigning the book to me. It was amazing to be a team again. I miss working with you every day. You are amazing, and I am glad to be your friend and sometimes freelancer. And a special thanks to Wendy Lefkon for her trust in me and this project.

Thank you to Fox Carney at the Animation Research Library for spending hours going through hundreds of images with me and for all of the time he spent preparing on his own. I cannot thank you enough for all of your insight, knowledge, humor, and patience. It was an absolute pleasure working with you.

Thank you to Rebecca Cline, Michael Buckoff, and Kevin Kern at the Walt Disney Archives for all of your assistance with the photos from your incredibly vast collection and for even going through box-by-box on the fly to find an image from an original press kit.

Thank you to my family: my sister, Rebecca; father, Tom; mother, Lois; and especially my nephews, Keoni and Kainoa; and my niece, Melina, for all of your help watching movies and selecting images for the book. You three are my favorite team, and I am so happy you are in my life. A special thanks to Kyle and Steph for lending me movies that I did not have in my collection.

Thank you to my extended family: Amy, Beki, Gary, Greg, Katie, Ken, Megan, Nate, and Shannon, who have all provided me with endless support, helpful feedback, and patience while I worked on this project and brought the topic of villains into almost every conversation.

Finally, thank you to my constant companion, Bagheera kitty, who has sat patiently by my side through it all.

• • •

Editorial Director: Wendy Lefkon
Editor: Jennifer Eastwood
Design by Sam Dawson

This book's producers would like to thank Jessica Bardwil, Jennifer Black, Steve Borell, Denise Brown, Michael Buckhoff, Fox Carney, Daphne Chang, Becky Cline, Jackie DeLeo, Monique Diman, Dennis Ely, Doug Engalla, Lindsay Frick, Dominique Flynn, Kate Gardner, Delia Greve, Michael Gortz, Vanessa Hunt, Michael Jusko, Dale Kennedy, Kevin Kern, Adrian Liang, Warren Meislin, Betsy Mercer, Scott Piehl, Steve Plotkin, Frank Reifsnyder, Diane Scoglio, Aimee Scribner, Michael Serrian, Betsy Singer, Jeffrey Sotomayor, Muriel Tebid, Marybeth Tregarthen, Stephanie Varela, Mary Walsh, Dushawn Ward, and Jessie Ward.

ISBN 978-1-4847-2678-5

G615-7693-2-16106

Printed in Shenzhen, China

First Edition, July 2016

10 9 8 7 6 5 4 3 2 1

Produced in association with becker&mayer!
11120 NE 33rd Place, Suite 101, Bellevue WA 98004

Visit www.disneybooks.com

The Official Disney Fan Club
D23.com

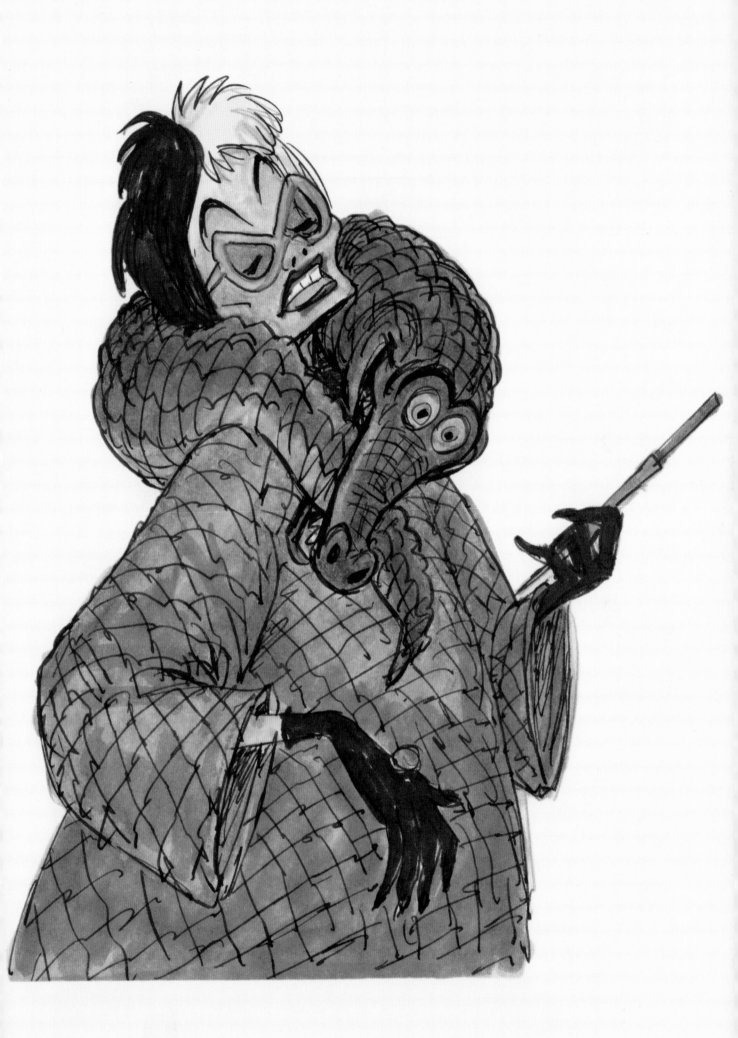

# Contents

# UNFORGETTABLE

Villains can make or break how good a movie is. A *great* villain is remembered and continues scaring us long after the film ends; they become legend. Darth Vader and the Wicked Witch of the West made black capes the symbol of mystery and menace. Norman Bates, with his unfortunate mother issues, made us all wait a beat before hopping into the shower. Dr. Hannibal Lecter made narcissism an art form to be both respected and feared. And Nurse Ratched made a piercing stare and a deadpan expression a symbol for bureaucratic corruption.

The same is true for the villains of the Walt Disney Animation and Pixar Animation Studios. How many movies, books, articles, and social media posts reference a Disney villain? Too many to count; what is known is that Disney is a master of creating those unforgettable villains that have become standards in film history. Our imaginations are captured by those haunting moments:

the evil Queen's cape billowing as the Magic Mirror comes to life, Maleficent's grand entrance within a burst of green flames, and Chernabog's long wings stretching as he awakes.

We're drawn in by their looks: Cruella De Vil's petite, skeletal frame under a bulky fur coat, Ursula's bold blue eye shadow and red lipstick, and Randall's chameleon skin. Our fascination grows as we see their abodes: Captain Hook's *Jolly Roger*, Sid's dark bedroom, and Syndrome's volcanic island hideaway. And we're stirred by their personalities and traits: Lady Tremaine's biting orders, Jafar and Iago's playful banter, and Scar's droll sarcasm.

So sit back and try to rein in your fears; embrace the dark side of Disney as this book showcases the characters that linger in your nightmares long after the film is over and gives you an inside look at the incredible rare art, archival photos, and talented people who made it all possible.

THIS PAGE: Cleanup animation drawing of Ursula from *The Little Mermaid*, 1989. Artist: Ruben Aquino. Medium: graphite, colored pencil. OPPOSITE: Concept art of Captain Hook's *Jolly Roger* from *Peter Pan*, 1953. Artist: Mary Blair. Medium: watercolor, gouache.

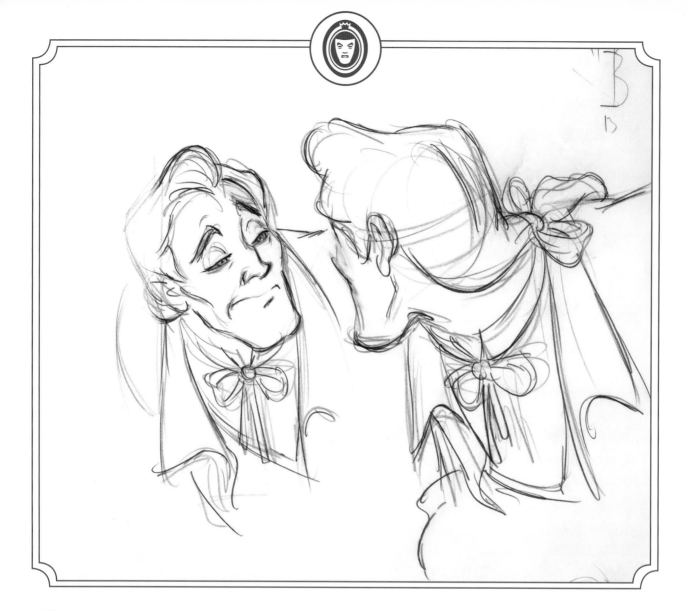

# CHAPTER

# OH SO VAIN

*Magic Mirror on the wall, who is the fairest one of all?* Each one of these villains is looking in the mirror, and they definitely like what they see! For decades, audiences have been fascinated with villains who are involved in a serious love affair with themselves. Is it their confidence that they are going to win the day (even though they won't)? Or is it that they cannot be anything but true to their evil selves, and we all wish we could be so pure of spirit—even if it is a dark spirit? Whatever the reason, we love them almost as much as they love themselves!

THIS PAGE: Rough animation drawing of Gaston from *Beauty and the Beast*, 1991. Artist: Andreas Deja. Medium: graphite, colored pencil. OPPOSITE: Final frame of the Queen from *Snow White and the Seven Dwarfs*, 1937.

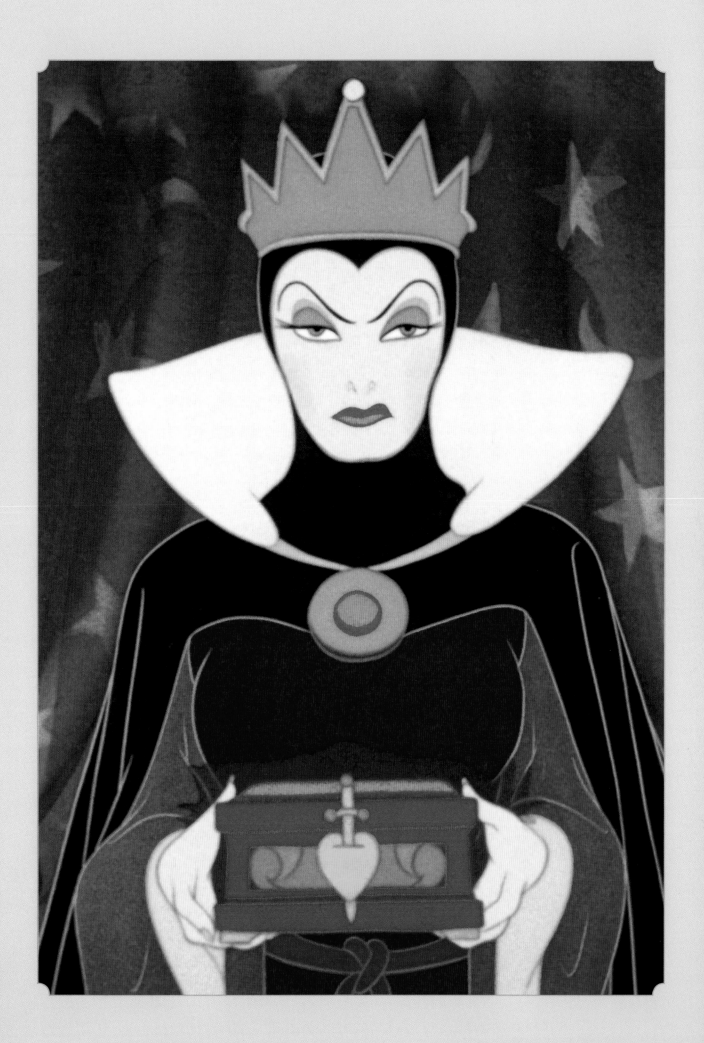

# Queen/the Witch

*SNOW WHITE AND THE SEVEN DWARFS*

**RELEASE DATE:** December 21, 1937

**DIRECTOR:** David Hand (supervising director)

**VOICE TALENT:** Lucille LaVerne

**ANIMATOR:** Norm "Fergy" Ferguson

Who says an apple a day will keep the doctor away? Surely no one familiar with the Witch from *Snow White and the Seven Dwarfs*! For ten cents a ticket, viewers of all ages were introduced to this frail, harmless peddler offering her poison treats to an innocent and trusting Snow White. How did voice actor Lucille LaVerne make the transition from the smooth, polished evil Queen to the haggard old Witch? She reportedly took her teeth out.

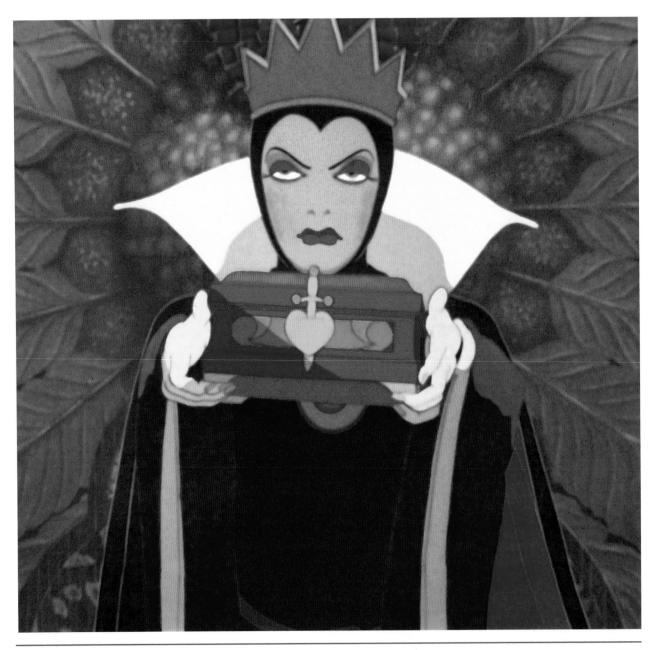

THIS PAGE: Final frame of the Queen from *Snow White and the Seven Dwarfs*, 1937. OPPOSITE: (LEFT COLUMN AND TOP RIGHT) Final frames from the sequence in which the Witch creates the poisoned apple. (BOTTOM RIGHT) Live-action reference image with Don Brodie as the Witch.

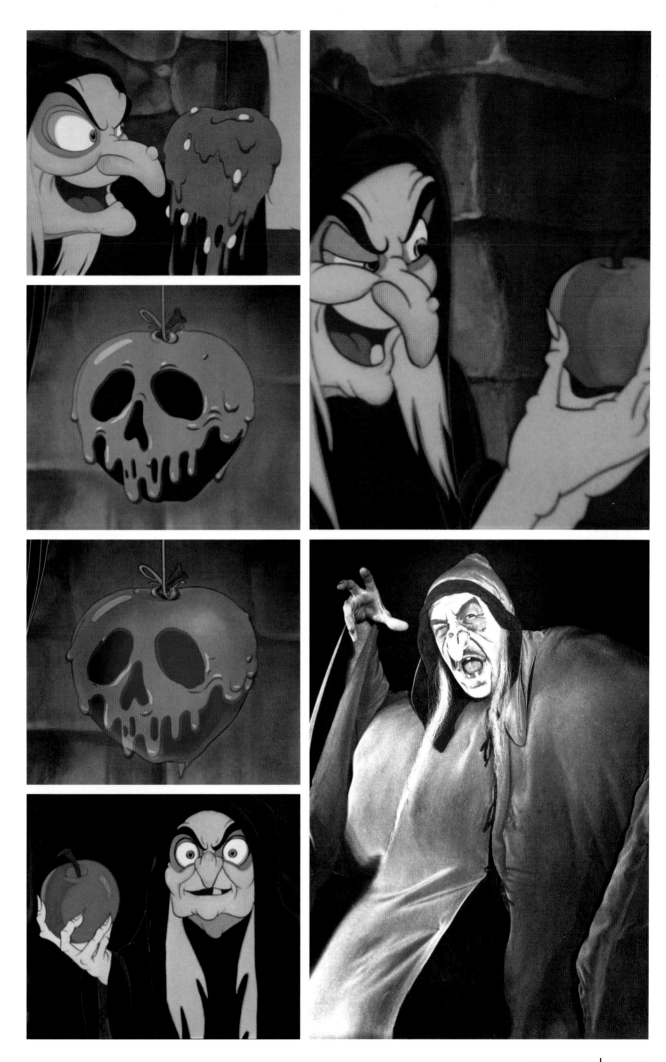

# Captain Hook

*PETER PAN*

**RELEASE DATE:** February 5, 1953

**DIRECTORS:** Wilfred Jackson, Hamilton Luske, Clyde Geronimi

**VOICE TALENT:** Hans Conried

**ANIMATORS:** Les Clark, Marc Davis, Norm "Fergy" Ferguson, Ollie Johnston, Milt Kahl, Ward Kimball, Eric Larson, John Lounsbery, Wolfgang "Woolie" Reitherman, Frank Thomas

It must be difficult to always be bested by a flying boy in tights who never ages and by a hungry old crocodile, but that is the pirate's life for Captain Hook. Captain Hook spends the entire movie trying to find and get rid of Peter Pan with a determined fervor, and with every failure to do so, there is a crocodile . . . waiting . . . hungry for his favorite snack,

Captain Hook! Walt Disney had told his animators, "Maybe with the crocodile and Hook, the crocodile is waiting for him; then have a funny chase; the last you see is Hook going like hell. That's better than having him caught. . . . The audience will get to liking Hook, and they won't want to see him killed."

THIS PAGE: Animator Ward Kimball getting in touch with his inner pirate while animating Captain Hook. OPPOSITE: (TOP) Preliminary study of Captain Hook and Peter Pan. Artist: Mary Blair. Medium: watercolor, gouache. (BOTTOM LEFT) Live-action reference footage from the same scene. (RIGHT SEQUENCE) Final frames of Captain Hook and his nemesis, the Crocodile. (FUN FACT) Cyril Ritchard as Captain Hook in the 1955 *Producer's Showcase* television adaptation of the *Peter Pan* Broadway musical.

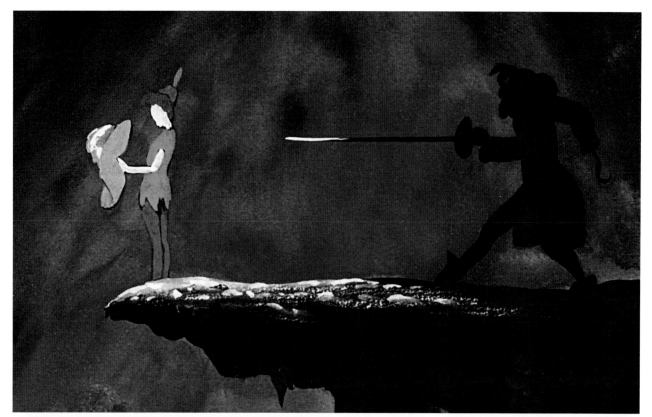

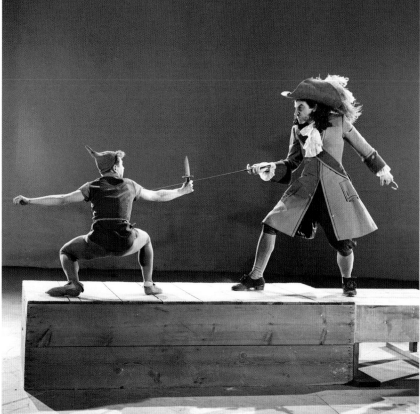

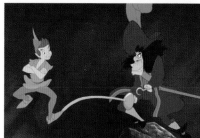

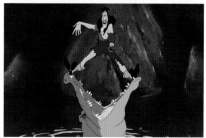

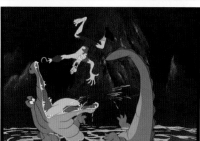

## FUN FACT

Hans Conried played the voices of both Captain Hook and Mr. Darling (Wendy, Michael, and John's father). Cyril Ritchard and Jason Isaacs followed his lead and played both characters as well.

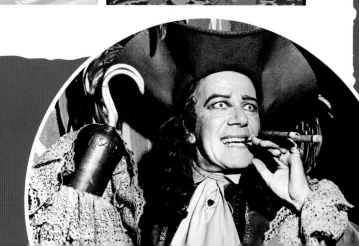

# Give That Captain a Hand . . . Or a Hook

In the original play by J. M. Barrie, Captain Hook lost his right hand. But the story writers and animators at the Walt Disney Studio thought it might limit the captain, so they made the decision to have Captain Hook lose his left hand instead. Here are other Captain Hooks from television, movies, the park, and even Broadway. How many followed the 1953 film's lead?

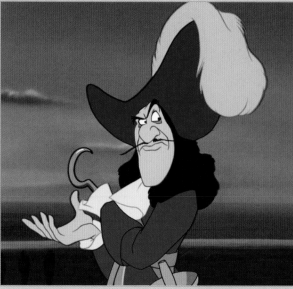

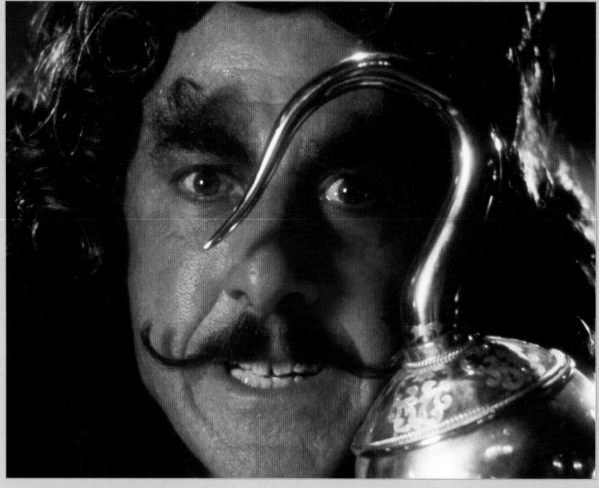

(CLOCKWISE FROM TOP LEFT) Captain Hook at Disneyland in 1955 (left hand). Final frame of Captain Hook from *Peter Pan*, 1953 (left hand). Dustin Hoffman as Captain Hook from Sony Pictures' *Hook*, 1991 (left hand).

| Disney Villains: Delightfully Evil

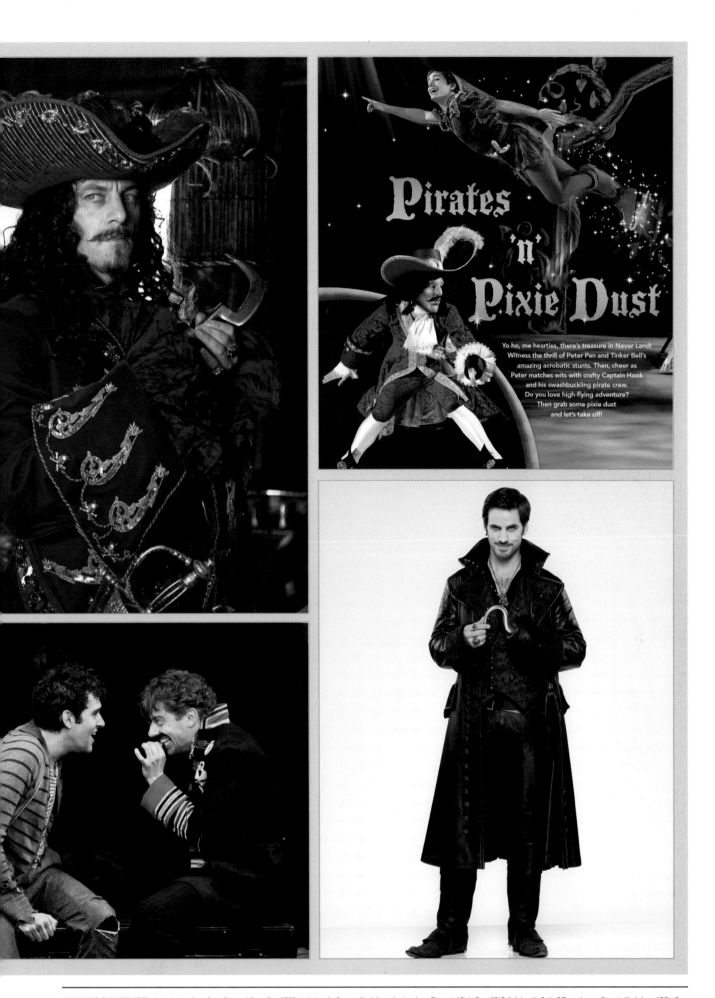

## Pirates 'n' Pixie Dust

Yo ho, me hearties, there's treasure in Never Land! Witness the thrill of Peter Pan and Tinker Bell's amazing acrobatic stunts. Then, cheer as Peter matches wits with crafty Captain Hook and his swashbuckling pirate crew. Do you love high-flying adventure? Then grab some pixie dust and let's take off!

(CLOCKWISE FROM TOP LEFT) Jason Isaacs from Sony Pictures' *Peter Pan*, 2003 (right hand). Captain Hook from the ice show *Pirates 'n' Pixie Dust*, 2015 (left hand). Colin O'Donoghue as Captain Hook from ABC's *Once Upon a Time* (left hand). Christian Borle as Black Stache from the play *Peter and the Starcatcher* (no hook: missing right hand).

# Cruella De Vil

*ONE HUNDRED AND ONE DALMATIANS*

**RELEASE DATE:** January 25, 1961

**DIRECTORS:** Wolfgang "Woolie" Reitherman, Hamilton Luske, Clyde Geronimi

**VOICE TALENT:** Betty Lou Gerson

**ANIMATORS:** Marc Davis, Ollie Johnston, Milt Kahl, Eric Larson, John Lounsbery, Frank Thomas

"Cruella De Vil, Cruella De Vil, if she doesn't scare you, no evil thing will." How many other villains inspire someone to write lyrics to a song about how horrible they are? Not many. Cruella is a woman who is used to getting what she wants. So what does she do when she is told no? She comes up with a plan for her two bumbling henchmen, Horace and Jasper Badun, to steal what she wants. Cruella is an eccentric millionaire whose widely known love of furs is said to be partially based upon the famous original Hollywood bad girl: the chain-smoking, fur-wearing actress of the 1940s, Tallulah Bankhead. Cruella would be the last villain that Marc Davis would animate before he left the Walt Disney Studio and moved over to Walt Disney Imagineering, known then as WED [Walter Elias Disney] Enterprises, to work on park attractions like "it's a small world," Pirates of the Caribbean, and the Haunted Mansion.

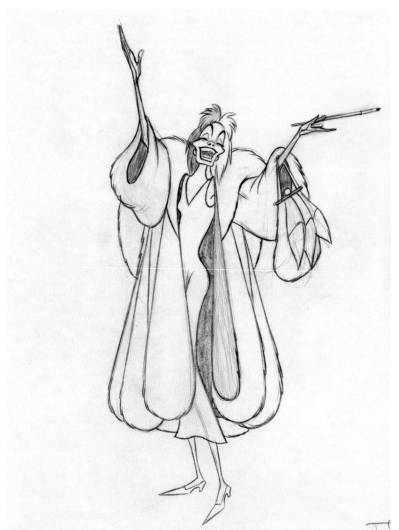

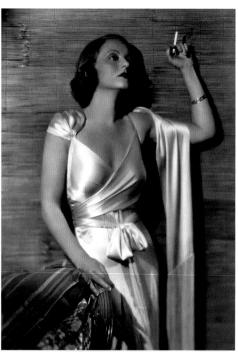

THIS PAGE: (LEFT) Cleanup animation drawing of Cruella De Vil. Artist: Marc Davis. Medium: graphite, colored pencil. (TOP RIGHT) Tallulah Bankhead, who served as an inspiration for the artists. (BOTTOM RIGHT) Story sketch of Cruella De Vil. Artist: Disney Studio Artist. Medium: graphite. OPPOSITE: (TOP) Final frames of Cruella from *101 Dalmatians*, 1961.

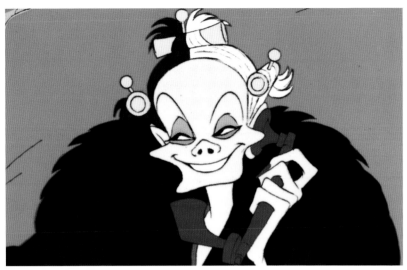

## All About Me

In the spirit of Cruella De Vil and the song that Pongo's owner Roger created for her, here are several other villain-inspired songs focused on a villain's favorite subject: themselves! Unlike Cruella De Vil, these songs are sung by the villain; so the songs are about how these characters see themselves. No surprise here—they really seem to like what they see.

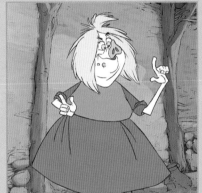

"Mad Madam Mim"—*The Sword in the Stone*
Music and lyrics by Robert B. Sherman and Richard M. Sherman (the first time the Sherman brothers worked on a movie)
Performed by Martha Wentworth

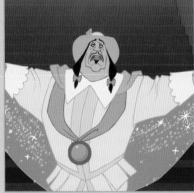

"Mine, Mine, Mine"—*Pocahontas*
Music by Alan Menken; lyrics by Stephen Schwartz
Performed by David Ogden Stiers and Mel Gibson

"Gaston"—*Beauty and the Beast*
Music by Alan Menken; lyrics by Howard Ashman
Performed by Jesse Corti and Richard White

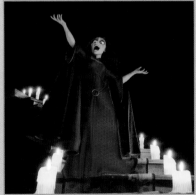

"Mother Knows Best"—*Tangled*
Music by Alan Menken
Lyrics by Glenn Slater
Performed by Donna Murphy

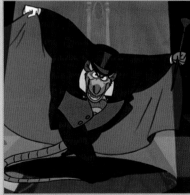

"The World's Greatest Criminal Mind"—*The Great Mouse Detective*
Music and lyrics by Henry Mancini, Ellen Fitzhugh, and Larry Grossman
Performed by Vincent Price

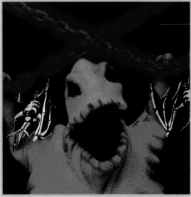

"Oogie Boogie's Song"—*Tim Burton's The Nightmare Before Christmas*
Music and lyrics by Danny Elfman
Performed by Ken Page with Ed Ivory

# Madam Mim

*THE SWORD IN THE STONE*

**RELEASE DATE:** December 25, 1963

**DIRECTOR:** Wolfgang "Woolie" Reitherman

**VOICE TALENT:** Martha Wentworth

**ANIMATORS:** Milt Kahl, Frank Thomas

If she can dream it, she can be it! Madam Mim can transform herself into anything she can think of, except a creature or person without wild purple hair. She is Merlin and Arthur's nemesis throughout the movie; she never plays fair, even cheating at solitaire, and is completely and utterly in love with herself and her powers. Madam Mim was voiced by Martha Wentworth, who also was the voice of the nanny, the cow Queenie, and the goose Lucy in 1961's *One Hundred and One Dalmatians*, in what would be her last movie before her death eleven years later in 1974. This would also be the last animated movie Walt Disney would see from beginning to end before he passed away on December 15, 1966, during production of *The Jungle Book*.

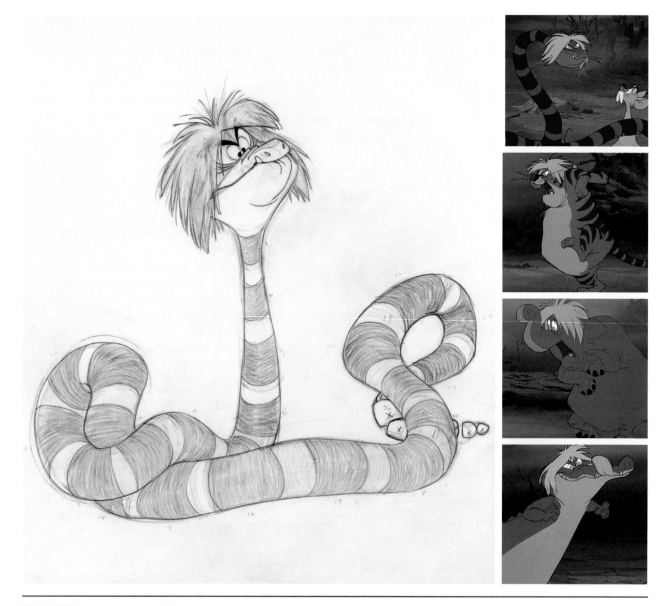

THIS PAGE: (LEFT) Cleanup animation drawing of Madam Mim as a snake. Artists: John Sibley, Wolfgang "Woolie" Reitherman. Medium: graphite, colored pencil. (RIGHT SEQUENCE) Final frames of Madam Mim from *The Sword in the Stone*, 1963. OPPOSITE: (TOP LEFT) Cleanup animation drawing of Madam Mim as a rhinoceros. Artist: Hal Ambro. Medium: graphite, colored pencil. (TOP RIGHT) Final frames of Madam Mim in the Wizards' Duel sequence. (SIDEBAR, LEFT) Richard M. Sherman and Robert B. Sherman at the piano. (SIDEBAR, CENTER) "it's a small world" poster from the 1964–1965 New York World's Fair. (SIDEBAR, RIGHT) "Chim Chim Cher-ee" sheet music cover.

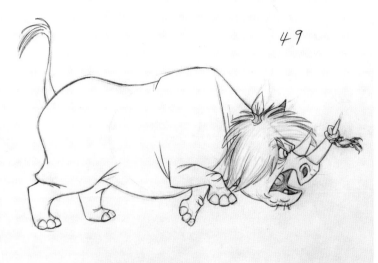

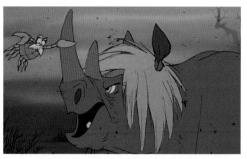

# Sherman Brothers: Brothers in Songs

*The Sword in the Stone* marked a few key milestones for its director and composers: this would be the first time that Wolfgang "Woolie" Reitherman would be the only director instead of working with a team of directors, and this would be the first movie those fabulous Sherman brothers would write the songs, including "Mad Madam Mim." Richard M. Sherman and Robert B. Sherman were born three years apart in the late 1920s in New York. The brothers had their first hit song with "Tall Paul," which was sung by everyone's favorite Mouseketeer, Annette Funicello, and it led to them eventually joining the Walt Disney Studios as staff songwriters. While they were there, they would write songs for movies like *The Jungle Book*, *The Parent Trap*, *Bedknobs and Broomsticks*, *The Aristocats*, and, most famously, *Mary Poppins*, for which they won two Academy Awards. The Sherman brothers are also the geniuses behind one of the catchiest songs in Walt Disney park history, "it's a small world" for the park attraction with the same name. (It's happening now. You can't fight it or get the song out of your head.)

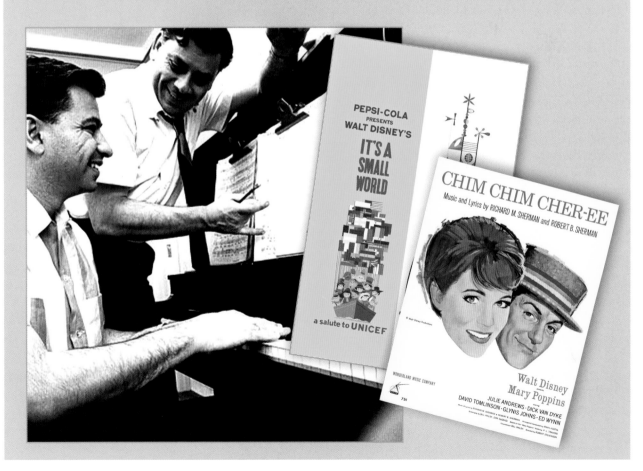

# Gaston

*BEAUTY AND THE BEAST*

**RELEASE DATE:** November 22, 1991

**DIRECTORS:** Gary Trousdale, Kirk Wise

**VOICE TALENT:** Richard White

**ANIMATOR:** Andreas Deja

No one loves Gaston more than Gaston! He knows he is good-looking and that many women adore him, so he just cannot comprehend how Belle could not want him. It just goes to show we always want what we cannot have. Animator Andreas Deja struggled with the character, wanting to make him a bit more a caricature of a completely self-adoring Romeo, but Jeffrey Katzen-

berg (who then presided over Walt Disney Feature Animation) explained to him that he had to go in a different direction: "I know it's more fun to animate the villain in broad, evil strokes, but what we're trying to convey is the important message of 'don't judge a book by its cover.' You've got the girl in the middle and she has to make a difficult choice between the 'two heroes.'"

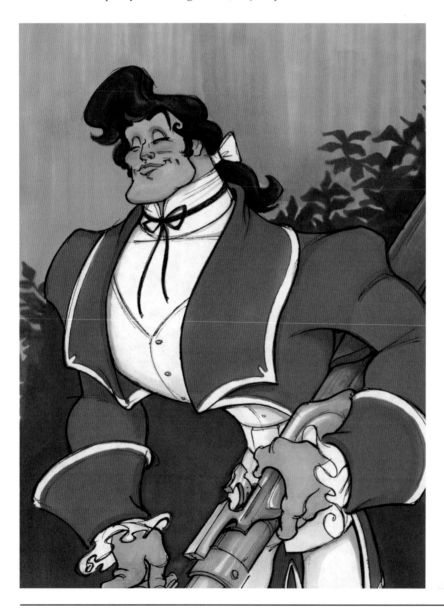

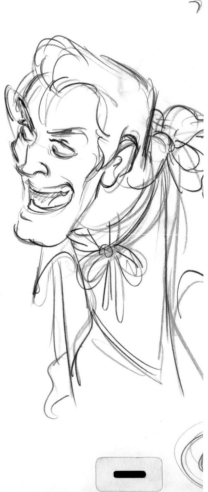

THIS PAGE: (LEFT) Concept art of Gaston as a Romeo. Artist: Sue Nichols. Medium: ink and marker. (RIGHT) Rough animation drawing of Gaston. Artist: Andreas Deja. Medium: graphite, colored pencil. OPPOSITE: (TOP AND BOTTOM SEQUENCES) Final frames of Gaston from *Beauty and the Beast*, 1991. (CENTER) Rough animation drawing of Gaston. Artist: Andreas Deja. Medium: graphite, colored pencil.

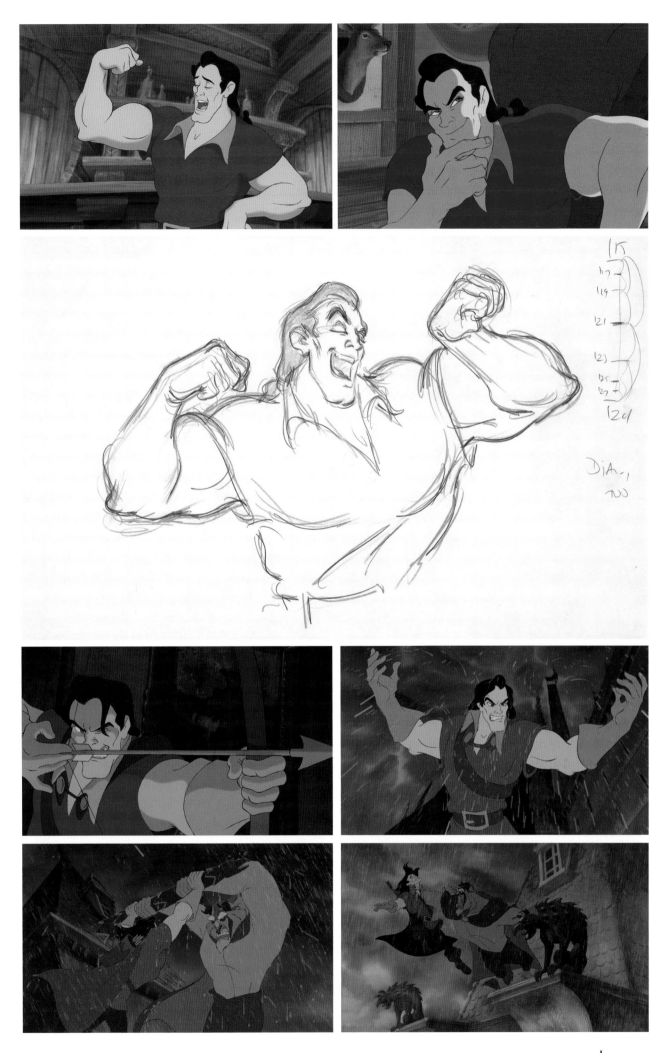

# Randall Boggs

*MONSTERS, INC.*

**RELEASE DATE:** November 2, 2001

**DIRECTORS:** Pete Docter; David Silverman, Lee Unkrich (co-directors)

**VOICE TALENT:** Steve Buscemi

**ANIMATORS:** Scott Clark, Doug Sweetland (directing animators); Glenn McQueen, Rich Quade (supervising animators)

Filled with a cast of creepy, scary monsters, *Monsters, Inc.* might seem like a film where it's a little hard to pin down just one or two villains. But Randall Boggs, the colorful chameleon-like creature that slithers all around children's bedrooms at night with an almost smokelike fluidness, is a clear candidate. As Sulley's main competition on the Scare Floor, Randall is obsessed with beating his longtime rival (we find out just how *long* the two

have been rivals in *Monsters University*). When the pressure is on, Boggs can't see anything but the win, yelling at his Scare assistant, Fungus: "If I don't see a door in my station in five seconds, I will personally put you through the shredder." This is funny because Steve Buscemi, the voice of Randall Boggs, once played a character in the movie *Fargo* (1996) who was murdered and eventually shredded through a wood chipper.

THIS PAGE: Concept sketches of Randall Boggs. Artist: Nicolas Marlet. Medium: colored pencil, ink. OPPOSITE: (TOP LEFT) Final character pose of Randall. (RIGHT SEQUENCE) Final frames of Randall and Boo from *Monsters, Inc.*, 2001. (BOTTOM LEFT) Steve Buscemi, the voice of Randall.

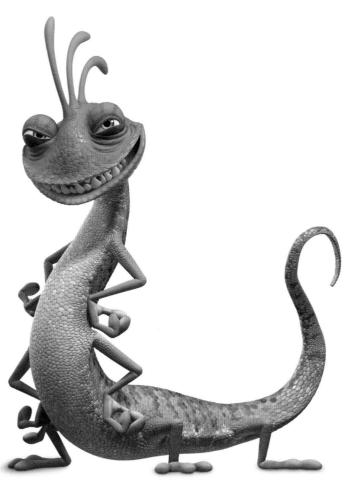

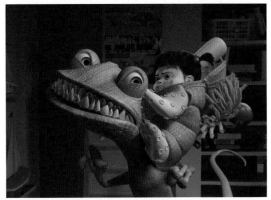

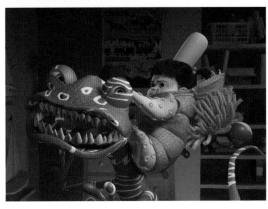

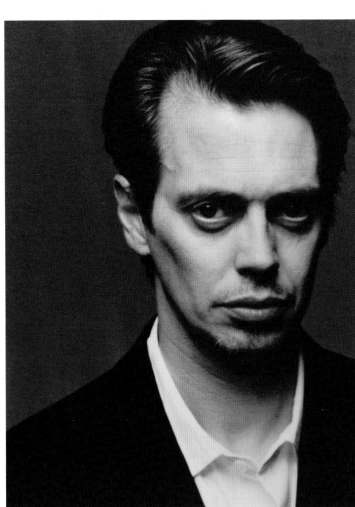

# Chick Hicks

*CARS*

**RELEASE DATE:** June 9, 2006

**DIRECTORS:** John Lasseter, Joe Ranft

**VOICE TALENT:** Michael Keaton

**ANIMATORS:** Scott Clark, Doug Sweetland (supervising animators); Bobby Podesta (directing animator)

Sponsored by Hostile Takeover Bank, Chick Hicks (also known as "Thunder"), along with Lightning McQueen and "The King," end the last race of the Piston Cup in a three-way tie. Chick Hicks has spent his career coming in runner-up to "The King" and wants to win that race at any cost—and to get the Dinoco sponsorship. Even though Chick Hicks never really spent any time in Radiator Springs (outside of being in Lightning McQueen's nightmare, which centers on staying in the town), the voice actor who played the role of Chick Hicks, Michael Keaton, had this to say: "I personally want to live in Radiator Springs. I would be quite happy settling down in Radiator Springs. I just love it there. It is just so great. That's the heart of the picture really."

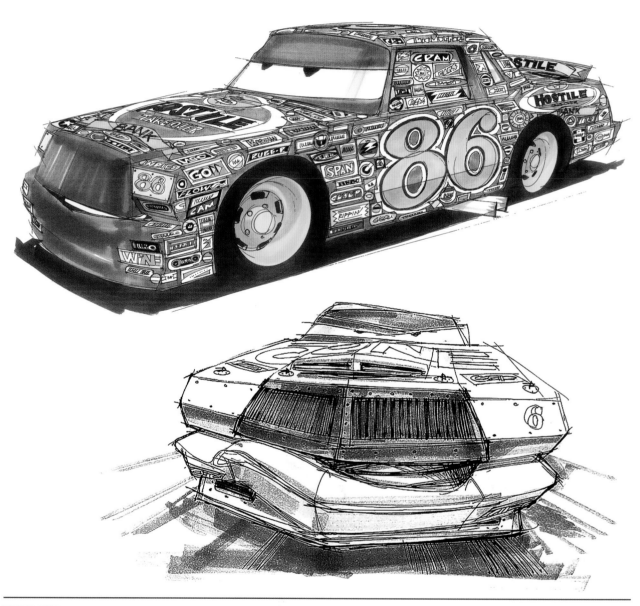

THIS PAGE: (CENTER AND BOTTOM) Preliminary studies of Chick Hicks. Artist: Jay Shuster. Medium: pen, marker. OPPOSITE: (TOP SEQUENCE) Racing storyboard. Artist for Chick Hicks and Lightning McQueen: Garett Sheldrew. Artist for Doc Crew Chief and Tex Dinoco with "The King": Steve Purcello. Artist for Mia and Tia: Rob Gibbs. Artist for final image of "The King": Brian Fee. Mediums: marker, pencil. Track reference photographs by John Lasseter. (CENTER AND BOTTOM) Final frames of Chick Hicks from *Cars*, 2006.

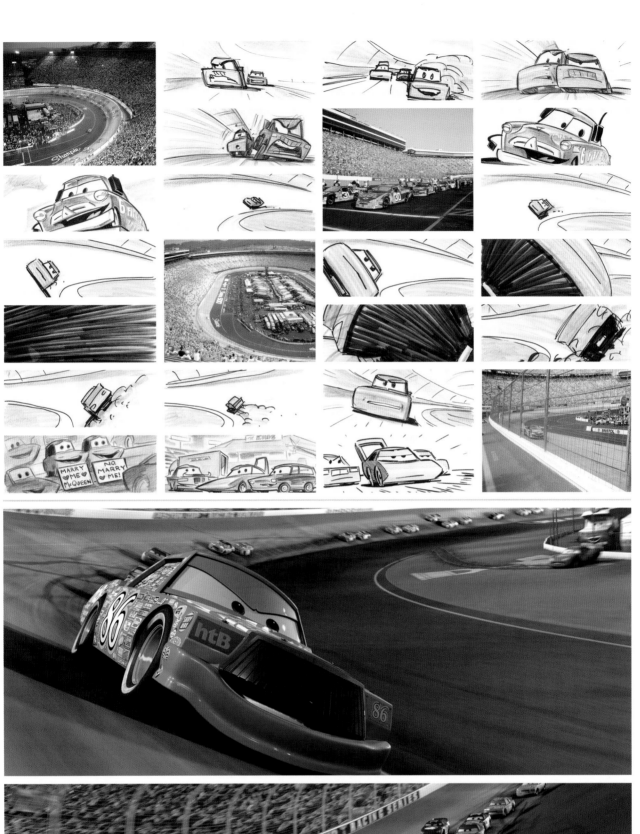

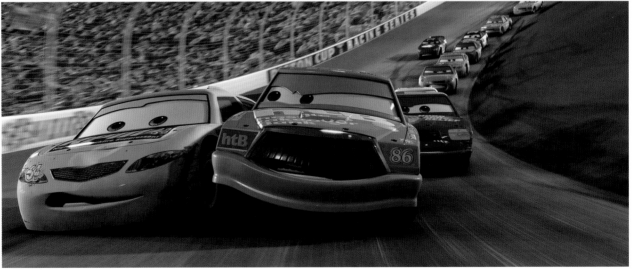

# Johnny Worthington

*MONSTERS UNIVERSITY*

**RELEASE DATE:** June 21, 2013

**DIRECTOR:** Dan Scanlon

**VOICE TALENT:** Nathan Fillion

**ANIMATORS:** Scott Clark (supervising animator); Andrew Gordon, Robert H. Russ, Michael Stocker (directing animators)

Johnny Worthington is the top Scare student at Monsters University, as well as the president of the most prestigious fraternity on campus, Roar Omega Roar (RΩR). As the big monster on campus, he is confident, and as voice actor Nathan Fillion put it in several interviews, he is "smarmy." Johnny sizes everyone up by their appearance and is unforgiving if someone does not fit into his limited view of what a Scarer should be. He constantly torments and antagonizes the crew of Mike and Sulley's fraternity, Oozma Kappa.

Again, Fillion is able to assess his character with precision: "One of the themes in this movie is seeing a person's hidden value—a skill Johnny certainly lacks. He takes people at face value, and he'll never know them." When Fillion was asked if he was anything like his character, and he was asked this *a lot*, his answer was always some version of no.

"I looked like a normal guy on the outside," Fillion once said, "but I was nerdy and geeky."

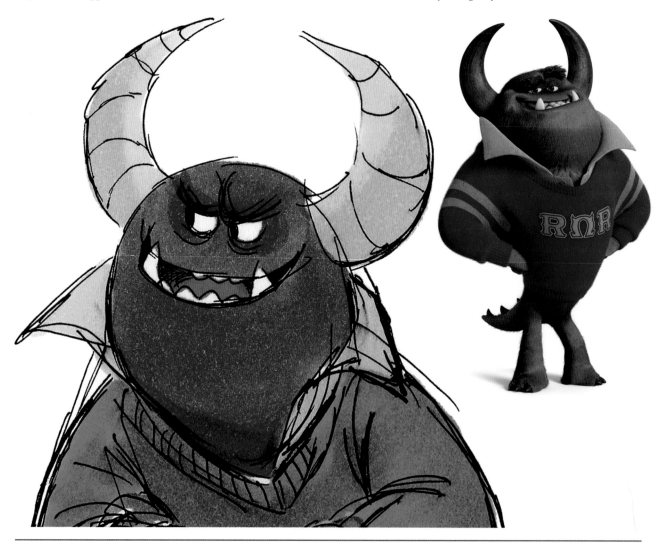

THIS PAGE: (LEFT AND RIGHT) Preliminary study, and then a final character pose of Johnny. OPPOSITE: (TOP AND BOTTOM) Preliminary studies of Johnny with his fraternity brothers. (CENTER LEFT) Nathan Fillion, the voice of Johnny. (CENTER RIGHT) Final frame of Johnny with his fraternity brothers from *Monsters University*, 2013.

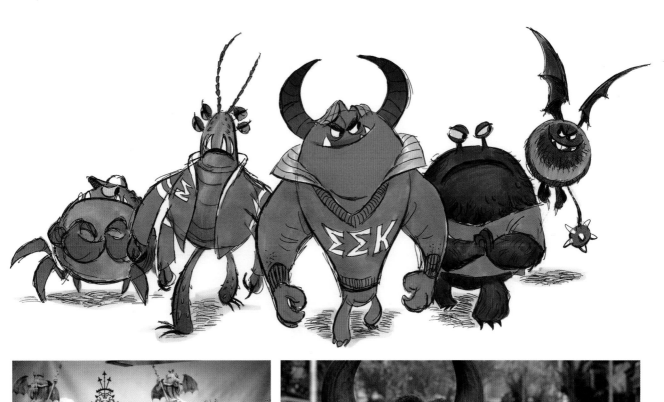

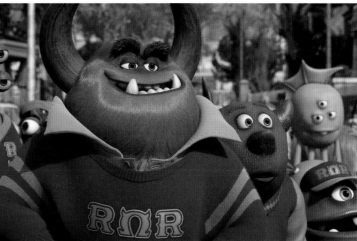

CHAPTER

# "TAILS" OF THE DARK SIDE

All creatures great and *foul*? Audiences love a story with animals, and what Walt Disney figured out with a special little mouse named Mickey is that audiences really love a story where the animal is the star. Well, not all of the creatures in the animal kingdom can be as good and kind as Mickey or Minnie Mouse. Walt Disney and his team had to represent and reimagine the bad guys, too. Thankfully, there are plenty of villains out there in the animal kingdom—whether it is just their nature or there is another motivation driving them to do the dastardly things they do.

THIS PAGE: Concept art of Shere Khan from *The Jungle Book*, 1967. Artist: Ken Anderson. Medium: ink, colored pencil, watercolor. (OPPOSITE): Final frame of Mor'du from *Brave*, 2012.

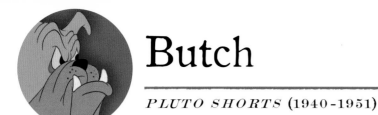

# Butch

**RELEASE DATE (FIRST APPEARANCE):** *Bone Trouble*, June 28, 1940

**DIRECTOR:** Jack Kinney

**VOICE TALENT:** No voice

**ANIMATORS:** Preston Blair, John Lounsbery, Reuben Timmins

Butch, an English bulldog who is Pluto's nemesis, got his start in the 1940 short *Bone Trouble* in which Pluto steals Butch's bone. Butch, in return, seeks retaliation on Pluto with fierce determination on par with, well, a dog with a bone. Butch is a large dog complete with a red spiked collar. He is all brawn, but he also has brains—which makes him almost unstoppable—and is incredibly aggressive and frightening. Veteran Disney animators Ollie Johnston and Frank Thomas wrote, "Story men quickly saw him [Butch] as another villain to replace Peg Leg Pete, especially if one of the cats was involved in trespassing or trying to get some of the bulldog's food."

THIS PAGE: Final frames of Butch and Pluto from *Bone Trouble*, 1940.

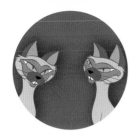

# Aunt Sarah, Si, Am, Rat

*LADY AND THE TRAMP*

**RELEASE DATE:** June 22, 1955

**DIRECTORS:** Wilfred Jackson, Hamilton Luske, Clyde Geronimi

**VOICE TALENT:** Verna Felton (Aunt Sarah), Peggy Lee (Si and Am), no voice (Rat)

**ANIMATORS:** Les Clark, Ollie Johnston, Milt Kahl, Eric Larson, John Lounsbery, Wolfgang "Woolie" Reitherman, Frank Thomas

While there are no clear-cut villains in *Lady and the Tramp*, there are a few villainous characters, like Aunt Sarah (with her dislike of dogs) and her troublemaking cats, Si and Am, and the rat that threatens the baby. Aunt Sarah was the ultimate original cat lady. To her, Si and Am could do no wrong and were the perfect pets, but Lady got a firsthand, or *first-paw*, look at how horrible those conniving cats could be. Ollie Johnston and Frank Thomas had the inside scoop on the movie's development and recalled how Wolfgang "Woolie"

Reitherman, who would soon animate the threatening rat, wanted to convey the real animal's movements within the film. "He had the carpenter shop build a large cage that could fit into his room next to his desk, and he filled it with over a dozen rats," Johnston and Thomas wrote. The story goes that Reitherman kept an eye on the rats while he finished up other work until he was finally ready to draw the infamous sequence. "The animation he eventually created was just what the picture needed," deemed Johnston and Thomas.

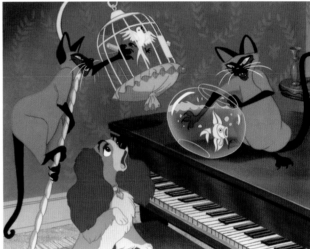

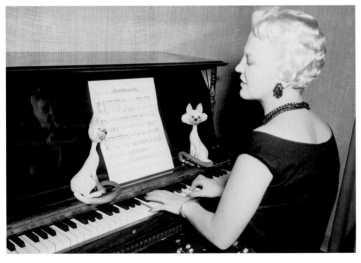

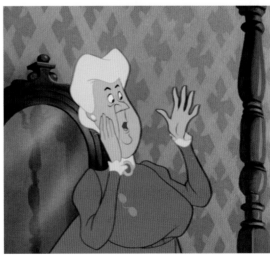

THIS PAGE: (TOP LEFT AND RIGHT, AND BOTTOM RIGHT) Final frames of Si and Am and Aunt Sarah from *Lady and the Tramp*, 1955. (BOTTOM LEFT) Peggy Lee, the voice of Si and Am, finding inspiration from her feline friends.

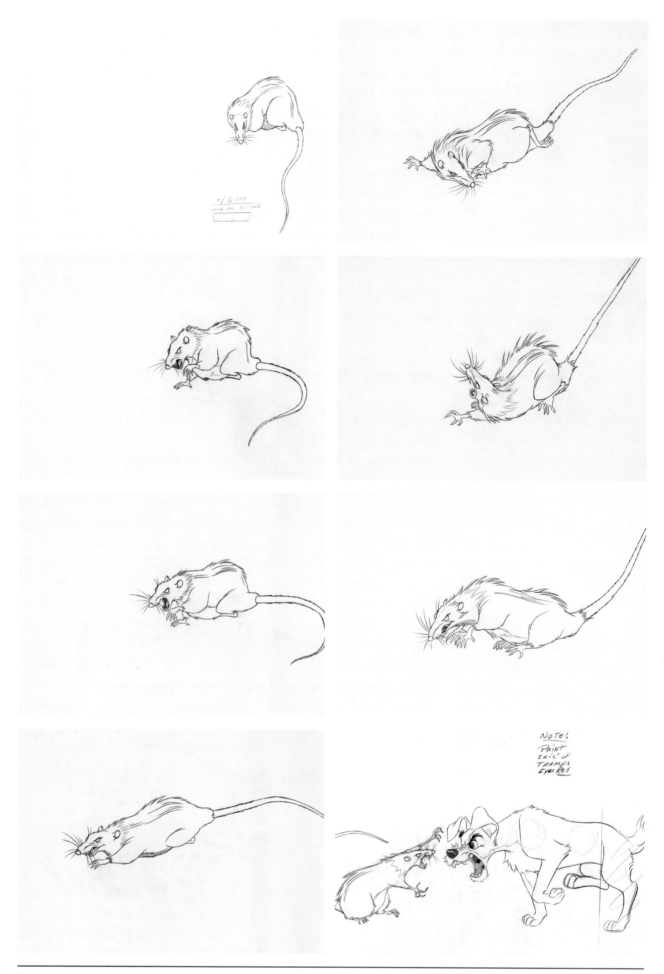

NOTES
PAINT
IRIS' OF
TRAMPS
EYES RED

THIS PAGE: Cleanup animation drawings of the rat from *Lady and the Tramp*, 1955. Artist: Wolfgang "Woolie" Reitherman. Medium: graphite, colored pencil.

# Shere Khan, Kaa, King Louie

*THE JUNGLE BOOK*

**RELEASE DATE:** October 18, 1967

**DIRECTOR:** Wolfgang "Woolie" Reitherman

**VOICE TALENT:** George Sanders (Shere Khan), Sterling Price Holloway, Jr. (Kaa), Louis Prima (King Louie)

**ANIMATORS:** Milt Kahl (Shere Khan); Milt Kahl, Frank Thomas (Kaa); Milt Kahl, Frank Thomas, John Lounsbery (King Louie)

Shere Khan is the arrogant, self-proclaimed king of the jungle who loves flashing his claws and his disdain for everything. He seems to bask in the fear all the other jungle creatures feel whenever they see him or hear his name. But there is one thing this giant Bengal tiger fears: man's red flower, aka fire. Shere Khan is loosely based on the character from Rudyard Kipling's book *The Jungle Book*, but Walt Disney felt the book was too dark and encouraged those working on the film not to read it. Instead, Shere Khan's character drew inspiration from the frightful, unsettling voice given to him by actor George Sanders. According to Frank Thomas and Ollie Johnston, "Sanders was asked if he would like a drawing of Shere Khan as a souvenir from the movie, to which he responded, 'I suppose so.'" Seemingly still in character, when asked further if he would like Walt to autograph it, he replied, "How utterly absurd. Why would I want his signature? He might want mine; I created the character."

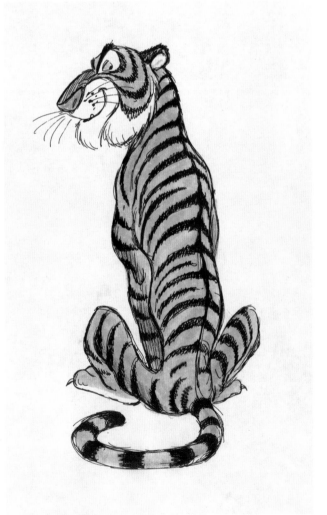

THIS PAGE: (LEFT COLUMN) Story sketches of Shere Khan and Kaa. Artist: Disney Studio Artist. Medium: graphite, conte crayon. (RIGHT) Concept art of Shere Kahn. Artist: Ken Anderson. Medium: ink, colored pencil, and watercolor.

With his power to hypnotize, Kaa is possibly the only creature in the jungle that could be of any danger to Shere Khan. Again, Walt Disney went in a completely different direction with this character. In Kipling's original story, Kaa is actually a friend and adviser to young Mowgli. He is not trying to entrance him to sleep so he can become the next item on Kaa's lunch menu. Kaa's hypnotizing song, "Trust in Me," was originally written by the Sherman brothers as "The Land of Sand" for *Mary Poppins*. Thank goodness it was not in that movie! Otherwise, how would that slick serpent ever get a meal?!

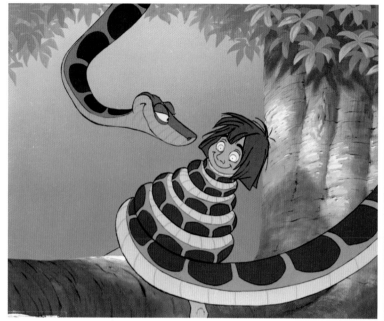 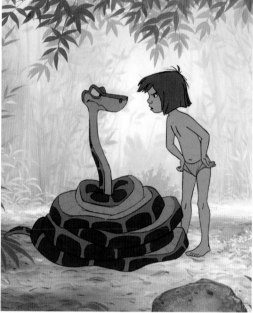

King Louie is the kind of character who is so fun and likable that it is easy to forget that he is a villain. On his quest "to be a man" and "stroll right into town," King Louie will try to get Mowgli to give up the "secret of man's red flower." Too bad Mowgli has no idea how to make fire. (After all, he did grow up in the jungle away from other men.) Louis Prima was the voice and the spirit of this character much in the way George Sanders inspired Shere Khan—but on the complete opposite end of the spectrum. Frank Thomas and Ollie Johnston recalled that "Prima became so emotionally involved in the creation of his animated counterpart that he regularly called the Disney Animation staff from Lake Tahoe, where he was performing with his band, to offer his thoughts on the character and plot development."

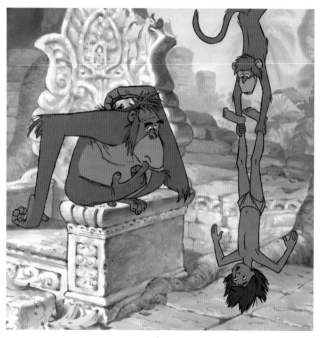 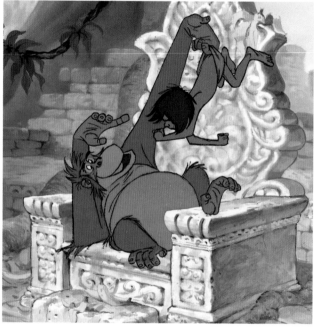

THIS PAGE: Final frames of Kaa and King Louie from *The Jungle Book*, 1967. OPPOSITE: (SIDEBAR, LEFT) Sterling Price Holloway, Jr. and Kaa palling around in the jungle. (SIDEBAR, TOP RIGHT) Holloway and Sebastian Cabot recording their roles as Kaa and Bagheera. (SIDEBAR, BOTTOM RIGHT) Holloway and Walt Disney. (FUN FACT): Final frame of the Cheshire Cat from *Alice in Wonderland*, 1961.

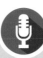

# Sterling Price Holloway, Jr.: The Man of Many Voices

Sterling Price Holloway, Jr.'s voice can be heard in more than twenty Walt Disney full-length feature films, shorts, and television specials, but he originally got his start in silent films in the late 1920s. Even with a brief hiatus from 1928 through 1933, Holloway found work in eighty films (sometimes uncredited) before he made his way to the magical world of Disney with an uncredited role as Stork in *Dumbo* (1941). It was a match made in heaven; after that, Holloway's unique high raspy voice became a familiar one for audiences during, and well after, Disney's golden age of animation.

Holloway was often cast as a narrator, as heard in Disney's 1952 animation shorts *Lambert, the Sheepish Lion*, and *Susie, the Little Blue Coupe*. In the Disney universe, Holloway is probably best known for his portrayal of everyone's favorite silly ol' bear. He voiced Winnie the Pooh in several of the original animated shorts, including the Academy Award–winning *Winnie the Pooh and the Blustery Day* (1968). During the 1950s and 1960s, Holloway found himself on the smaller screen and had television guest appearances on classic favorites of the time like *The Andy Griffith Show*, *Hazel*, and *Gilligan's Island*, as well as a permanent role on *The Baileys of Balboa*, which ran from 1964–1965. For an actor who got his start being silent, Holloway sure found his voice—and has since made many fans happy that he brought it to the Walt Disney Studio.

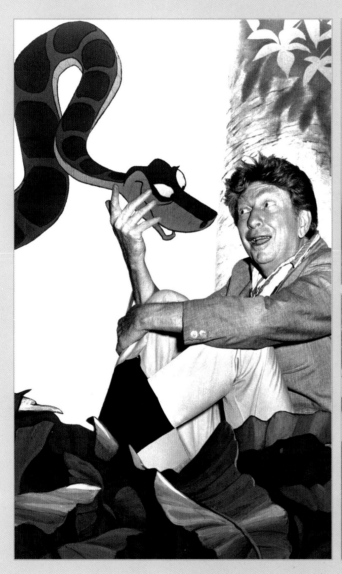

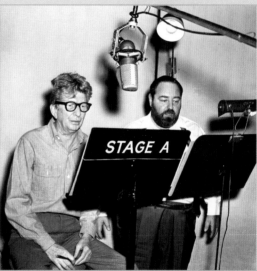

# FUN FACT

Sterling Price Holloway, Jr. got to spend plenty of time in Wonderland. He voiced the Frog in Paramount's *Alice in Wonderland* (1933) and then almost twenty years later voiced the Cheshire Cat in Walt Disney's 1951 animated version of the film.

# Heffalumps, Woozles

## WINNIE THE POOH AND THE BLUSTERY DAY

**RELEASE DATE:** December 20, 1968

**DIRECTOR:** Wolfgang "Woolie" Reitherman

**MUSICAL TALENT:** Sherman brothers song, "Heffalumps and Woozles"

**ANIMATORS:** Ollie Johnston, Frank Thomas

Oh, silly ol' bear: the Heffalumps and Woozles are not going to steal your honey! Poor Winnie the Pooh, however, finds himself having a horrible nightmare in which the Heffalumps and Woozles are coming for his favorite snack. The Hundred Acre Wood is just experiencing a patch of horrible weather, and the tumult of the thunderstorm instigates Pooh's bad dream. The "Heffalumps and Woozles" song, written by the Sherman brothers, was originally featured in the 1968 animated short *Winnie the Pooh and the Blustery Day*, which later became part of the package feature film *The Many Adventures of Winnie the Pooh* that was released by Walt Disney Productions almost ten years later in 1977.

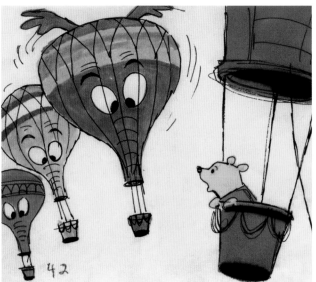

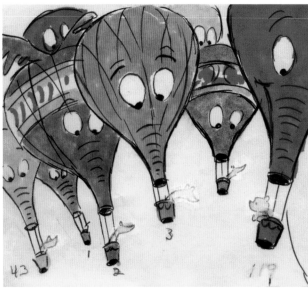

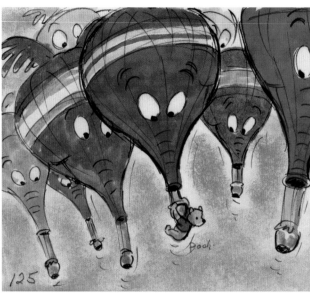

THIS PAGE: Story sketches of Heffalumps and Woozles. Artist: Disney Studio Artist. Medium: ink, colored pencil, watercolor, and marker. OPPOSITE: (TOP) Preliminary study of a Heffalump bee with Winnie the Pooh. Artist: Disney Studio Artist. Medium: watercolor. (CENTER SEQUENCE) Cleanup animation drawings of Heffalumps and Woozles. Artists: Ollie Johnston and Frank Thomas. Medium: graphite, colored pencil. (FUN FACT) Final frame of the pink elephants from *Dumbo*, 1941.

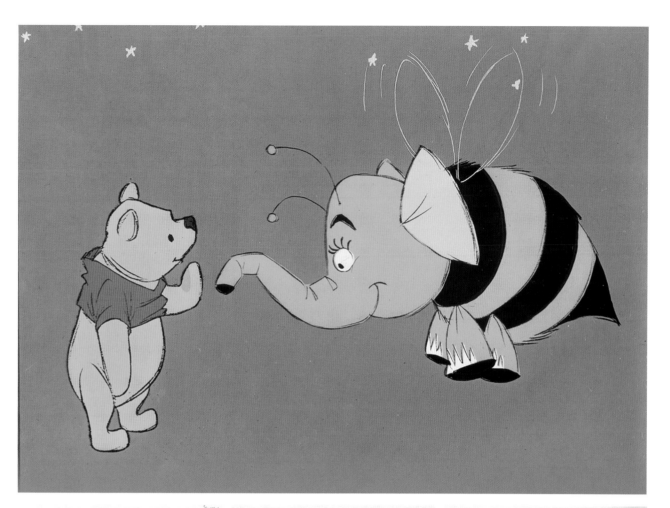

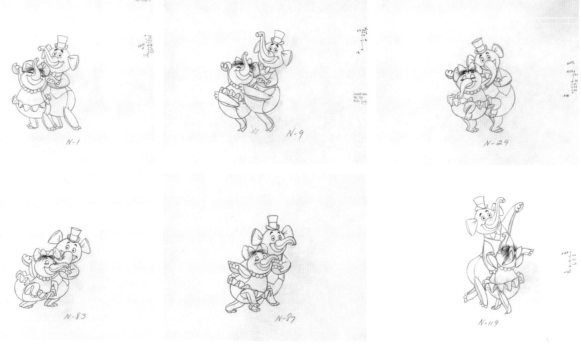

N-1   N-9   N-29

N-83   N-87   N-119

# FUN FACT

A few of the dancing elephant scenes, including the two elephants dancing the waltz, mirror the dancing elephant scenes from the hallucinogenic waking nightmare "Pink Elephants on Parade" segment in *Dumbo*.

# Sweet Voices—Evil Villains

The Walt Disney Studio often used the same voice actors in various and far different roles, giving some of our favorite heroes (or at least their voices) in one film the voices of some of the most dastardly of villains in another (and vice versa). Here are a few examples of these fun, yet sometimes confusing, crossovers.

Sterling Price Holloway, Jr.

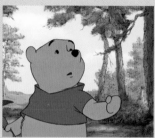

Winnie the Pooh
*The Many Adventures of Winnie the Pooh*

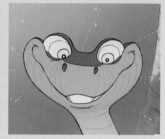

Kaa
*The Jungle Book*

Flower
*Bambi*

Narrator
*Make Mine Music*, "Peter and the Wolf" segment

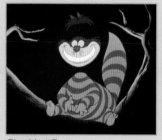

Cheshire Cat
*Alice in Wonderland*

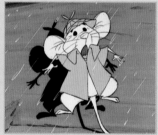

Roquefort (the mouse)
*The Aristocats*

Verna Felton

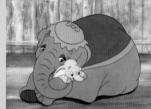

Mrs. Jumbo
*Dumbo*

Fairy Godmother
*Cinderella*

Queen of Hearts
*Alice in Wonderland*

Flora
*Sleeping Beauty*

Sebastian Cabot

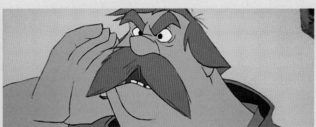

Sir Ector
*The Sword in the Stone*

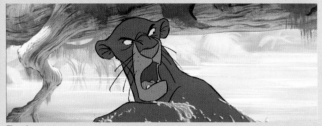

Bagheera
*The Jungle Book*

Bill Thompson

White Rabbit
*Alice in Wonderland*

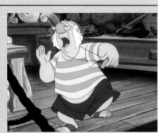

Mr. Smee
*Peter Pan*

Jock
*Lady and the Tramp*

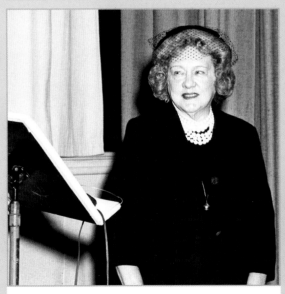

Martha Wentworth

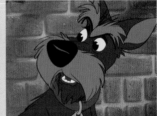

Nanny/Queenie/Lucy
*One Hundred and One Dalmatians*

Madam Mim
*The Sword in the Stone*

# Mor'du

*BRAVE*

**RELEASE DATE:** June 22, 2012

**DIRECTORS:** Mark Andrews, Brenda Chapman; Steve Purcell (co-director)

**VOICE TALENT:** No voice

**ANIMATORS:** Alan Barillaro, Steven Clay Hunter (supervising animators); David DeVan, Kureha Yokoo (directing animators)

According to the legend of Mor'du, the villain of Disney•Pixar's *Brave* was the eldest of four brothers who wanted to defy his father's wish that all four brothers rule the kingdom equally. In his quest to win the kingdom and crush his brothers, he chooses strength and power over healing his relationship with his brothers when a magical enchantress gives him the option between the two. Mor'du is then turned into a horrible black bear that is able to defeat his brothers, yet loses his kingdom and his humanity in the process.

Animators wanted to capture the sense that this "bear" has been around for a long time and has seen a lot of battles, so they paid great attention to the small details by including spears in his back and giving him a split ear, a dead eye, scars, arrow shafts, and burned hair. Mark Andrews directed the animators to make Mor'du move less like a bear and more like an "alien." He explained of Mor'du that "it has a form of corrupted intelligence. It's gone past what it has turned into. I mean, it's a cursed thing."

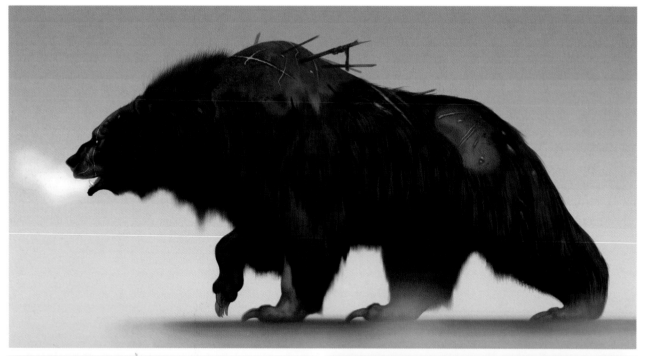

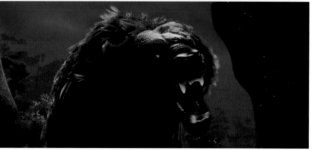

THIS PAGE: (CENTER AND BOTTOM LEFT) Concepts of Mor'du. Artist: Steve Pilcher. Medium: digital and oil, digital. (BOTTOM RIGHT) Final frame of Mor'du from *Brave*, 2012. OPPOSITE: (TOP) Concept of Mor'du. Artist: Tia Kratter. Medium: acrylic, digital. (CENTER AND BOTTOM) Final frames of Mor'du.

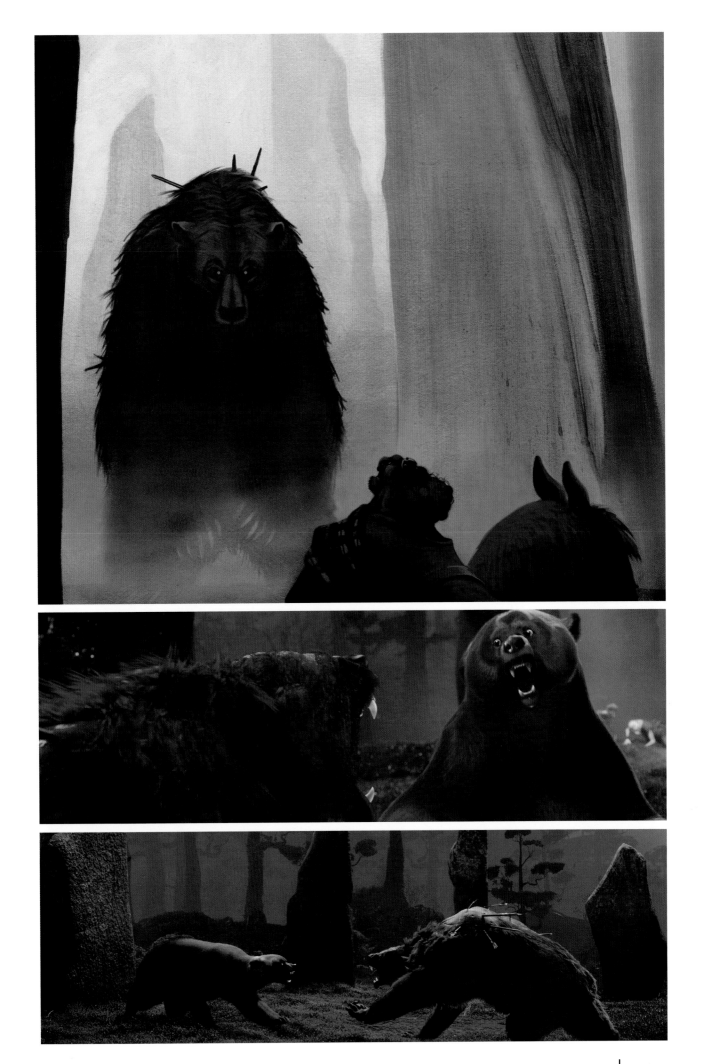

# Mr. Whiskers

*FRANKENWEENIE*

**RELEASE DATE:** October 5, 2012

**DIRECTOR:** Tim Burton

**VOICE TALENT:** No voice

**ANIMATORS:** Mark Waring (animation supervisor), Trey Thomas (animation director)

"Mr. Whiskers had a dream about you last night. . . . If Mr. Whiskers dreams about you, then it means something big is going to happen," announces Weird Girl, Mr. Whiskers's cat mom. Move over Grumpy Cat, Miss Cleo, and Boris Karloff: Mr. Whiskers is in town, and he is determined to kill all of the dogs in the neighborhood. Prior to becoming the evil kitty on the block, Mr. Whiskers was a psychic white cat that could predict the gloomy fates of the neighborhood children by producing litter box gems that were symbols of their eventual pitfalls. Mr. Whiskers's transformation is a result of the Weird Girl trying to bring a dead bat back to life after Victor is able to resurrect his dog, Sparky (after Sparky was hit by a car and killed). Mr. Whiskers is the only animal that undergoes mutation while alive, as opposed to dying and being reanimated. The animators used stop-motion animation to create this dark, endearing comedy, where just one blink can take up to five days to shoot—and Mr. Whiskers blinks a lot.

THIS PAGE AND OPPOSITE: Final frames from *Frankenweenie*, 2012.

# Creature Feature

These other pets were brought back from the dead in 2012's *Frankenweenie* to become parodies of classic monsters and creatures of the night.

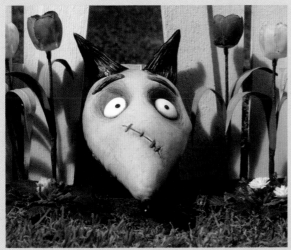
Sparky—Frankenstein

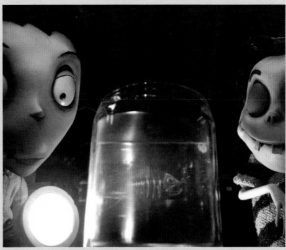
Edgar's goldfish—Ghosts and The Invisible Man

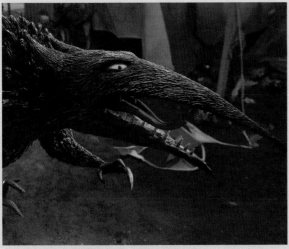
Edgar's rat—Werewolf

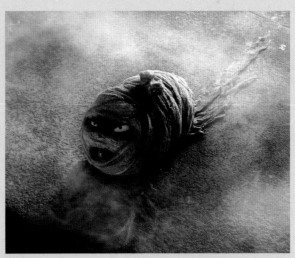
Nassor's hamster, Colossus—Mummy

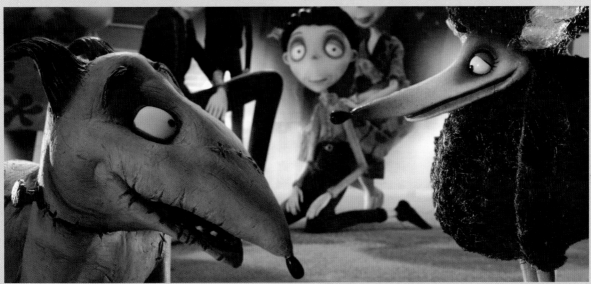
Elsa's poodle, Persephone—Bride of Frankenstein

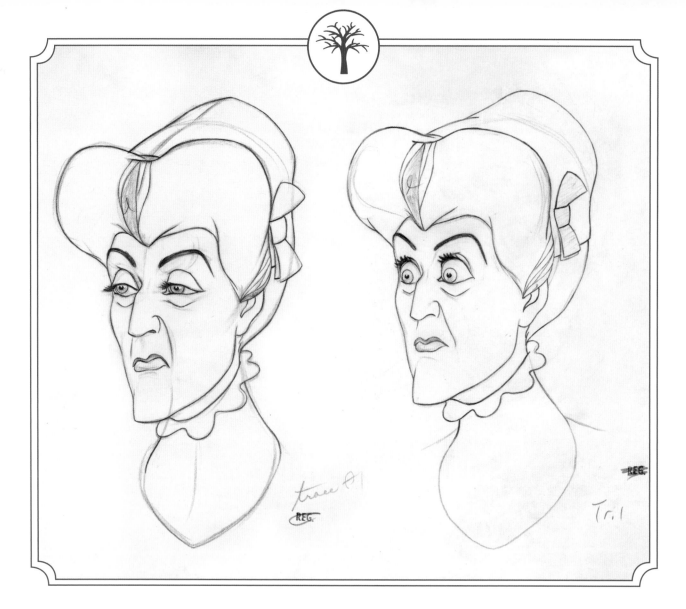

# CHAPTER

# ALL IN THE FAMILY

Family dynamics can sometimes be complicated, but when there is a true villain in the role of a mother, father, or sibling, *complicated* does not even begin to describe it. Audiences love family drama, especially when it is not their own, and Disney does not disappoint. Bringing familiar fantasy themes to life is a time-honored tradition, like a tyrannical mother who is never satisfied, a father who is blindly determined to mold his son into something he is not, or a brother who hunts his younger brother once that brother has been magically transformed into a bear . . . well, maybe that last one is not *so* familiar.

THIS PAGE: Cleanup animation drawing of Lady Tremaine from *Cinderella*, 1950. Artist: Frank Thomas. Medium: graphite, colored pencil. OPPOSITE: Final frame of Scar from *The Lion King*, 1994.

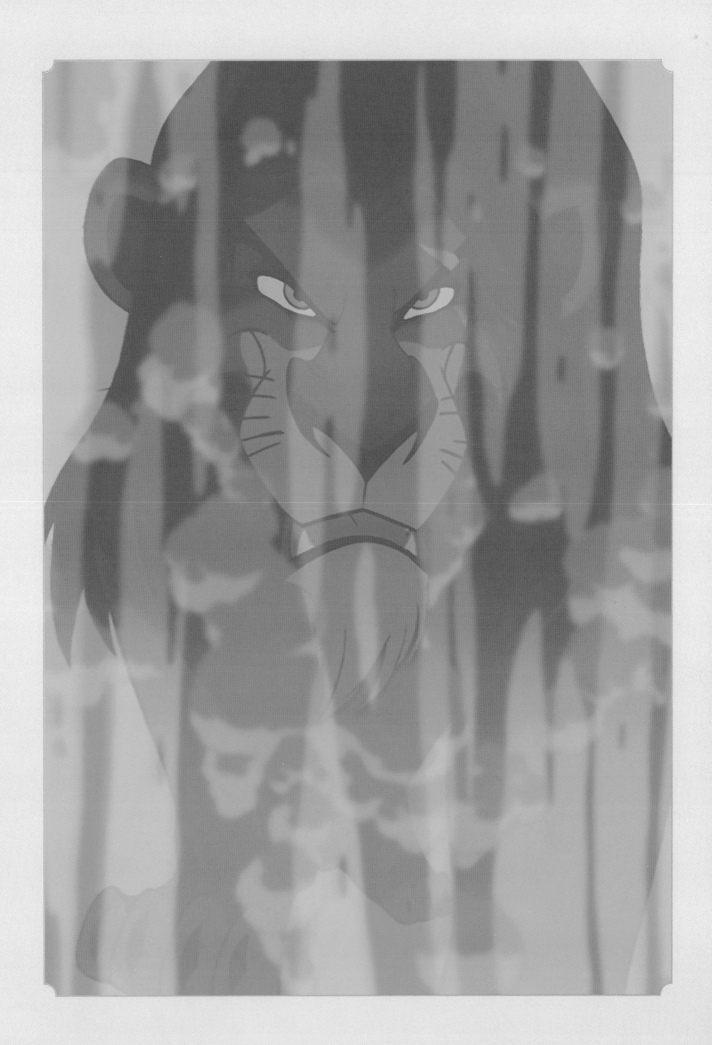

# Lady Tremaine

*CINDERELLA*

**RELEASE DATE:** February 15, 1950

**DIRECTORS:** Wilfred Jackson, Hamilton Luske, Clyde Geronimi

**VOICE TALENT:** Eleanor Audley

**ANIMATORS:** Les Clark, Marc Davis, Norm "Fergy" Ferguson, Ollie Johnston, Milt Kahl, Ward Kimball, Eric Larson, John Lounsbery, Wolfgang "Woolie" Reitherman, Frank Thomas

"Ev'ry time she finds a minute, that's the time when they begin it," bemoans the little mouse Jaq of Cinderella's plight. Poor Cinderella; it is not everyone that gets to live side by side with the villain in their life. One of the most hated and well-thought-out villains in Disney animation history, Lady Tremaine tries to tear Cinderella down with endless chores, false promises, cruel criticisms, and those cold, judging eyes. Walt Disney wanted her to "be a heavy," and she was. There is no magic involved in Lady Tremaine's maliciousness. She is just a human woman with an insatiable hunger for power and fortune, making her the most haunting villain—the kind you could run into on the street, or, even worse, have to live with after losing a parent.

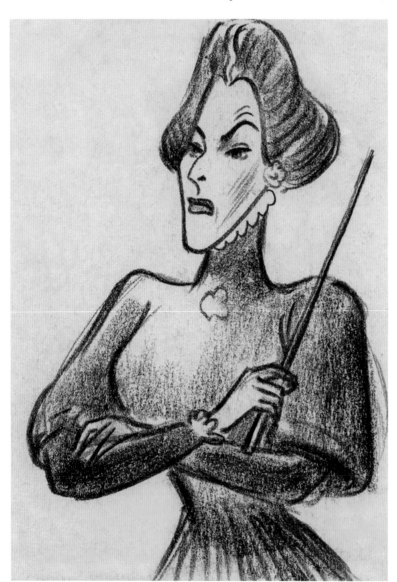

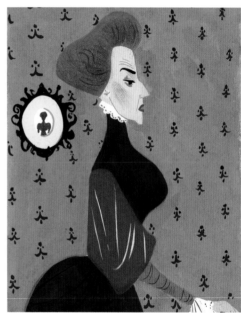

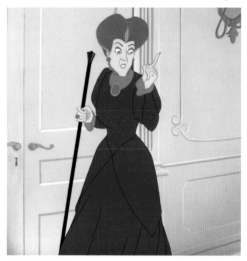

THIS PAGE: (LEFT) Story sketch of Lady Tremaine. Artist: Disney Studio Artist. Medium: charcoal and conte crayon. (TOP RIGHT) Concept art of Lady Tremaine. Artist: Mary Blair. Medium: gouache. (BOTTOM RIGHT) Final frame of Lady Tremaine from *Cinderella*, 1950.

# Nine Old Men

During the 1950s, Walt Disney had a group of core directing animators that he called the "Nine Old Men," a reference to former President Franklin D. Roosevelt's Nine Old Men on the Supreme Court. Even though they only worked on three animated full-length feature films as a collective group (*Cinderella*, 1950; *Alice in Wonderland*, 1951; and *Peter Pan*, 1953), individually they were present in films and animated shorts from the 1940s until the 1980s. They were:

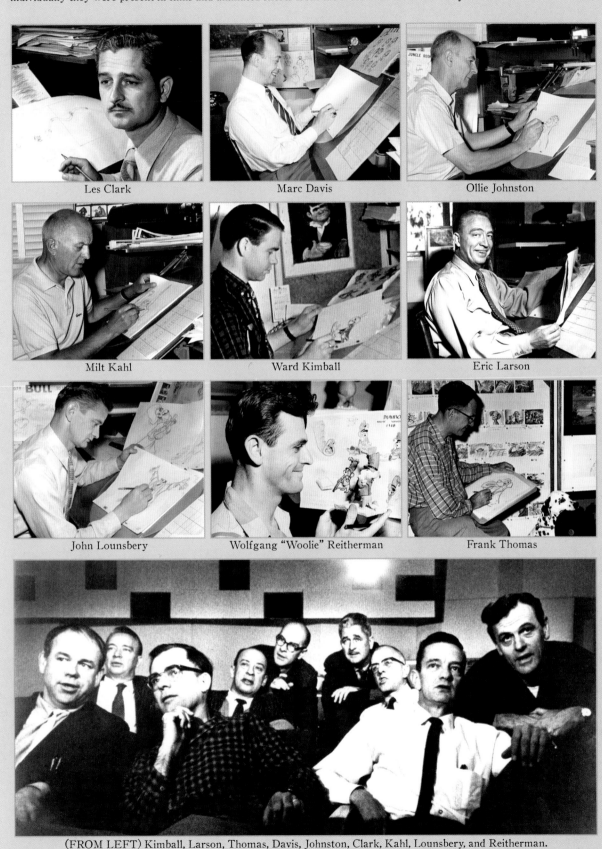

|  |  |  |
| --- | --- | --- |
| Les Clark | Marc Davis | Ollie Johnston |
| Milt Kahl | Ward Kimball | Eric Larson |
| John Lounsbery | Wolfgang "Woolie" Reitherman | Frank Thomas |

(FROM LEFT) Kimball, Larson, Thomas, Davis, Johnston, Clark, Kahl, Lounsbery, and Reitherman.

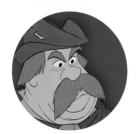

# Sir Ector, Sir Kay

*THE SWORD IN THE STONE*

**RELEASE DATE:** December 25, 1963

**DIRECTOR:** Wolfgang "Woolie" Reitherman

**VOICE TALENT:** Sebastian Cabot (Sir Ector), Norman Alden (Sir Kay)

**ANIMATORS:** Milt Kahl (Sir Ector, Sir Kay), Eric Larson (Sir Kay)

Sir Ector was Arthur's foster father, the biological father to Sir Kay (one of the other minor villains in *The Sword in the Stone*), and the master of handing out demerits! Sir Ector does not see Arthur as anything more than an obligation and does not grasp any value in the boy because Arthur is not very good at any of his squire duties. Alas, Sir Ector's wish for Sir Kay to become the king of England does not come to fruition. Instead, he is forced to bow and apologize to his ward, who he has treated so unkindly.

Sir Kay, Arthur's adoptive brother, is even less caring and more cruel than Arthur's foster father, Sir Ector. In the course of the film, Kay is knighted and becomes Sir Kay, but there is nothing knightly or honorable about him. He is constantly yelling at Arthur, calling him Wart, and is incredibly unhappy—and almost abusive to Arthur—after his own squire comes down with the mumps and must be replaced by Arthur.

THIS PAGE: Final frame of Sir Kay and Sir Ector from *The Sword in the Stone*, 1963.

# Scar

## *THE LION KING*

**RELEASE DATE:** June 24, 1994

**DIRECTORS:** Roger Allers, Rob Minkoff

**VOICE TALENT:** Jeremy Irons

**ANIMATORS:** Andreas Deja (supervising animator), Ruben A. Aquino

Don't turn your back for a second on this lion! Like a weak and scared bully who knows he will not win a fight based only on physicality, Scar must wait until his victims aren't looking and are unprepared for the attack in order to win his battles. He is more of a thinking man's cat, if that man were the most evil and jealous individual in all the land. Scar sums it up well in the film: "As far as brains go, I got the lion's share. But when it comes to brute strength, I'm afraid I am at the shallow end of the gene pool." Andreas Deja, who also animated the villainous Gaston in *Beauty and the Beast,* had to figure out how to animate a lion that was weaker and smaller than even the female lions but still had the powerful presence of a classic Disney villain. According to Deja, via his blog "Deja View," he also had a lot of help from Scar's voice actor, Jeremy Irons: "Working with Jeremy Irons was a joy. The man can read anything, and you'd want to animate it, I swear. What an inspiring voice! It was a privilege to be assigned to this character." Deja also had real lions at the studio to use as models. The one movie Deja tried to avoid, however, was . . . *The Jungle Book*. He did not want to be influenced by that smooth, refined villain Shere Khan (who was voiced by actor George Sanders).

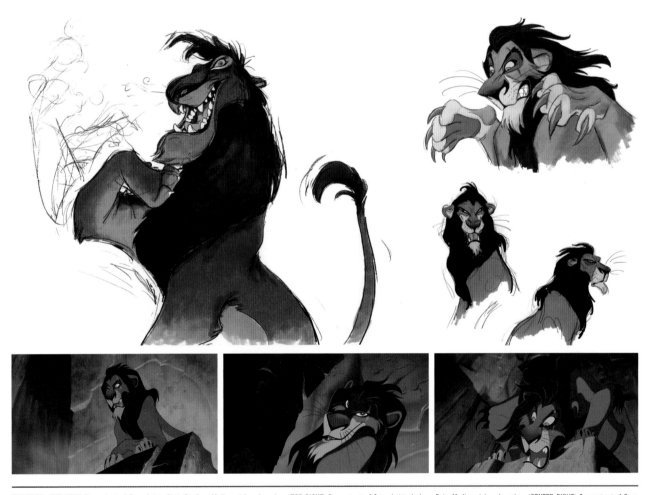

THIS PAGE: (TOP LEFT) Concept art of Scar. Artist: Chris Sanders. Medium: ink and marker. (TOP RIGHT) Concept art of Scar. Artist: Andreas Deja. Medium: ink and marker. (CENTER RIGHT) Concept art of Scar. Artist: Andreas Deja. Medium: colored pencil, ink, marker. (BOTTOM) Final frames of Scar from the "Be Prepared" scene in *The Lion King*, 1994.

# Disney Villains on Broadway

"There's no business like show business," even for some of the most popular villains in the history of Disney animation. It only makes sense that great animated musical movies like *Beauty and the Beast* and *The Lion King* would make a natural transition to that oh-so-famous musical road in New York City, Broadway. With twenty-eight Tony Award nominations, the Broadway community's highest award, and eight wins, Disney animated classics have left their mark on the theater scene.

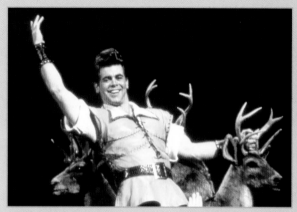

Gaston played by Burke Moses—*Beauty and the Beast*. Opened on Broadway April 18, 1994—nominated for nine Tony Awards in 1994; won one Tony Award.

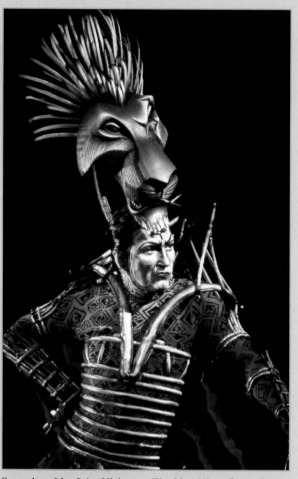

Coming soon to a theater near you: Dom Claude Frollo played by Patrick Page—*The Hunchback of Notre Dame*. Started out at the La Jolla Playhouse in San Diego in the fall of 2014, and then opened spring 2015 at the Paper Mill Playhouse in Millburn, New Jersey.

Scar played by John Vickery—*The Lion King*. Opened on Broadway November 13, 1997—nominated for eleven Tony Awards in 1998 and won six Tony Awards, including Best Musical.

Clayton played by Donnie R. Keshawarz—*Tarzan*. Opened on Broadway on May 10, 2006—nominated for one Tony Award in 2006.

Ursula played by Sherie Rene Scott— *The Little Mermaid*. Opened on Broadway January 10, 2008—nominated for two Tony Awards in 2008.

Jafar played by Jonathan Freeman (the original voice of Jafar in the movie)— *Aladdin*. Opened on Broadway March 20, 2014—nominated for five Tony Awards; won one Tony Award in 2014.

# Aunt Spiker, Aunt Sponge

*JAMES AND THE GIANT PEACH*

**RELEASE DATE:** April 12, 1996

**DIRECTOR:** Henry Selick

**VOICE TALENT:** Joanna Lumley (Aunt Spiker), Miriam Margolyes (Aunt Sponge)

**ANIMATOR:** Paul Berry (animation supervisor)

Poor James has been left to live with his two relatives, Aunt Spiker and Aunt Sponge, after the death of his parents. Truly a horrible team of caretakers who terrorize and emotionally torture James, the sisters are mainly live-action characters, though they have their moment in stop-motion animation when they appear as ghostly versions of the human faces on top of ghastly bodies (if you could call them bodies) in a nightmare James has while inside a peach that is floating in the Atlantic Ocean. Even though James has found a new "family" of sorts with the insects who share the giant peach home with him, the aunts are still able to reach him at times throughout his adventure.

THIS PAGE: Final frame of Aunt Spiker and Aunt Sponge from *James and the Giant Peach*, 1996.

# It Takes Two to Make a Thing Go Right!

James's Aunt Spiker and Aunt Sponge are not the only devilish duo in Disney films. In the Disney animation family, there are enough pairs to fill Noah's Ark. Unlike the aunts, most of these teams are out there supporting their villains in their devious schemes and plots. They are not the stars of the sinister show, but without them, the journey would not be half as fun or entertaining. Everyone's grateful that all good things (or in this case, bad things) come in pairs.

J. Worthington Foulfellow (aka Honest John) and Gideon
*Pinocchio*

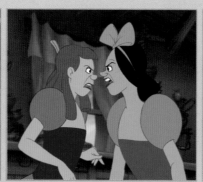
Anastasia and Drizella Tremaine
*Cinderella*

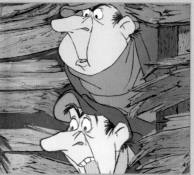
Jasper and Horace
*One Hundred and One Dalmatians*

Si and Am
*Lady and the Tramp*

Nutsy and Trigger
*Robin Hood*

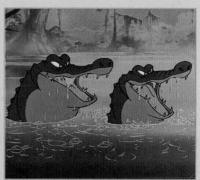
Brutus and Nero
*The Rescuers*

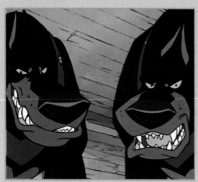
Roscoe and DeSoto
*Oliver & Company*

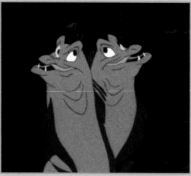
Flotsam and Jetsam
*The Little Mermaid*

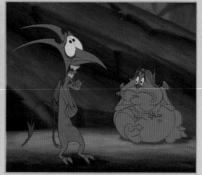
Panic and Pain
*Hercules*

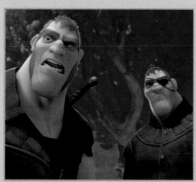
Stabbington brothers
*Tangled*

Acer and Grem
*Cars 2*

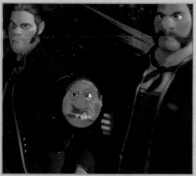
Duke of Weselton's bodyguards
*Frozen*

# Denahi

*BROTHER BEAR*

**RELEASE DATE:** November 1, 2003

**DIRECTORS:** Aaron Blaise, Robert Walker

**VOICE TALENT:** Jason Raize

**ANIMATOR:** Ruben A. Aquino

So much for brotherly love. The middle brother of three, Denahi, is determined to hunt down the bear that killed his little brother, Kenai, in the movie *Brother Bear*. In all fairness, Denahi has no idea that the bear he is hunting is really Kenai, but transformed (from human to bear). Completely overcome by the grief and anger that often comes with losing a loved one, Denahi believes he is hunting the bear that killed both of his brothers, Sitka and Kenai. In a way, Denahi is right; Kenai the bear has replaced Kenai the human, at least temporarily. Once

Denahi realizes the bear is his brother and vice versa, the anger consuming him dissipates, and he is able to see his little brother for the man he has become. *Brother Bear* was the last movie to come out of Walt Disney's Orlando, Florida, animation studio, the same studio where *Lilo & Stitch* was created. Both movies were hand-drawn, but after the success of Pixar's *Finding Nemo*, with its wonderful computer-animated aquatic world, Disney Feature Animation was looking to start making more computer-animated features.

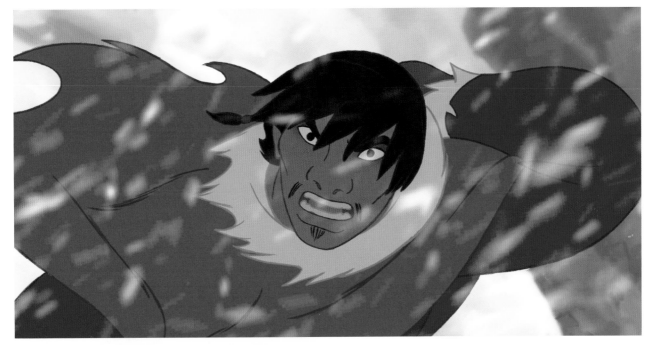

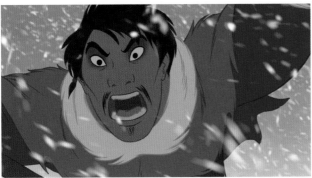

THIS PAGE: Final frames of Denahi from *Brother Bear*, 2003.

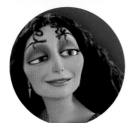

# Mother Gothel

*TANGLED*

**RELEASE DATE:** November 24, 2010

**DIRECTORS:** Nathan Greno, Byron Howard

**VOICE TALENT:** Donna Murphy

**ANIMATOR:** Nik Ranieri

Flower power! The rare flower that provides Mother Gothel with her youth and beauty is also the same flower that eventually saves the Queen, who is pregnant with Rapunzel and on her deathbed. Mother Gothel must come up with a strong plan B now that the flower's magical properties are no longer her own little secret; after all, she doesn't want to return to the old, haggard woman she really is. Her idea to keep Father Time at bay: kidnap the baby princess who seems to have inherited the powers and lock her away from the world just as she once did the flower.

Mother Gothel slips into a matronly role and joins the ranks of horrible cinematic mothers like Joan Crawford (from *Mommie Dearest*) and Mrs. Taggart (from *The Anniversary*). Mother Gothel is vain and has only her own well-being in mind; she is emotionally abusive to Rapunzel, repeatedly telling the young girl how horrible and cruel people can be. It is only a matter of time, however, before Rapunzel figures out that the worst person out there has been the one raising her in a tower separated from others all her life.

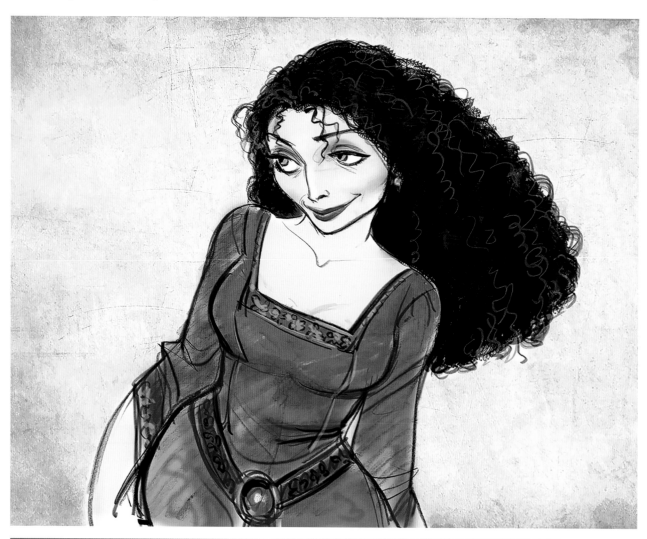

THIS PAGE: Concept art of Mother Gothel. Artist: Jin Kim. Medium: graphite, marker, digital. OPPOSITE: (TOP) Concept art of Mother Gothel holding Rapunzel's hair. Artist: Dan Cooper. Medium: digital. (BOTTOM) Concept art of Mother Gothel aging. Artist: Jin Kim. Medium: graphite.

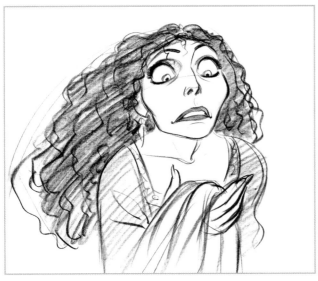

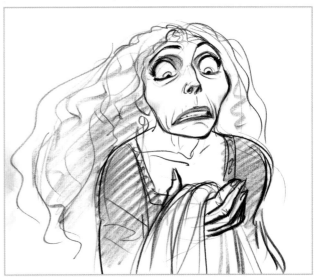

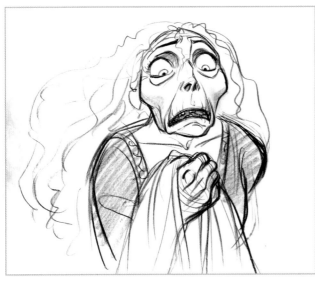

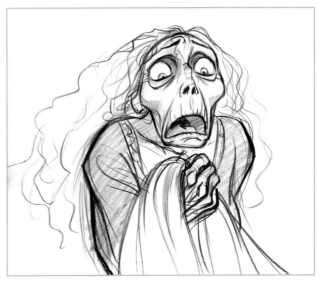

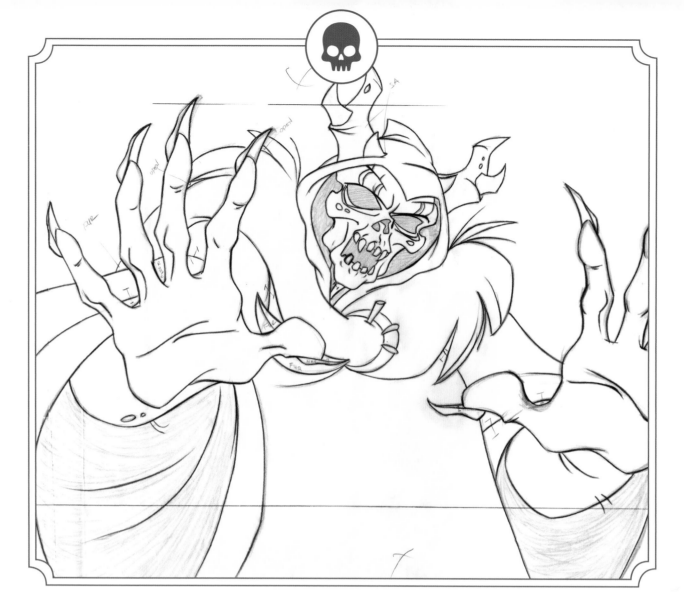

# CHAPTER

# WORST OF THE WORST

These villains are the worst! No, really. Throughout the history of the Walt Disney Animation and Pixar Animation Studios, there have been some bad villains, but this vile collection of otherworldly beings, power-hungry guys, and crazed robots makes other villains look like the good guys. But just like an adolescent girl in a 1950s film, audiences cannot help but become seriously smitten with the bad boy—or lady, or even demon, as the case may be. Just try to stop them!

THIS PAGE: Cleanup animation drawing of The Horned King from *The Black Cauldron*, 1985. Artist: Phil Nibbelink. Medium: graphite, colored pencil. OPPOSITE: Concept art of Sid Phillips from *Toy Story*, 1995.

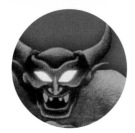

# Chernabog

## FANTASIA, "NIGHT ON BALD MOUNTAIN"

**RELEASE DATE:** November 13, 1940

**DIRECTORS:** Samuel Armstrong, James Algar, Bill Roberts, Paul Satterfield, Hamilton Luske, Jim Handley, Ford Beebe, T. Hee, Norm "Fergy" Ferguson, Wilfred Jackson ("Night on Bald Mountain")

**MUSICAL TALENT:** Modest Moussorgsky's "Night on Bald Mountain" piece

**ANIMATOR:** Vladimir "Bill" Tytla

A frenzy of violins play as Chernabog, the black god of Slavonic mythology, unfolds his massive wings and sets his glowing, smoldering eyes on the night sky. He has become one of the most fearsome villains in Walt Disney history without speaking a word. Chernabog simply casts his long, shadowy fingers over the landscape and onto the town below to call forth and command all of the skeletal spirits residing in the ground for a night of dancing and mischief. Thank goodness for the morning light that painfully forces Chernabog to cocoon himself back into his wings, making it safe for all once again.

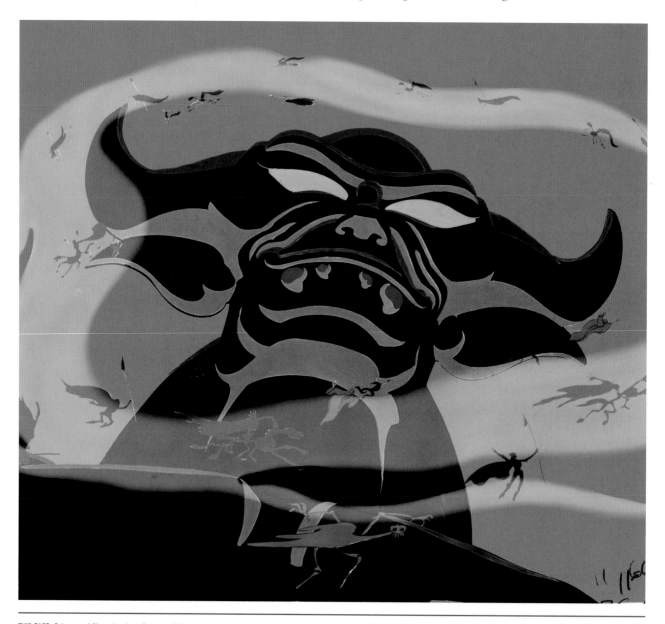

THIS PAGE: Cel setup of Chernabog from *Fantasia*, 1940. Artist: Disney Studio Artists. Medium: ink, acrylic, gouache. OPPOSITE: (TOP) Vladimir "Bill" Tytla studying Chernabog maquettes. (CENTER) Concept art of Chernabog. Artist: Disney Studio Artist. Medium: pastel. (BOTTOM) Cleanup animation drawings. Artist: Vladimir "Bill" Tytla. Medium: graphite, colored pencil.

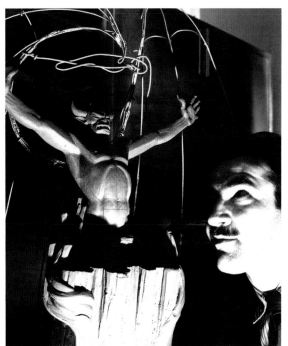
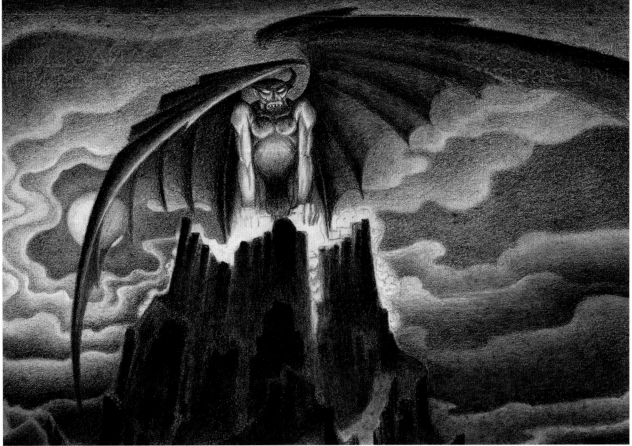

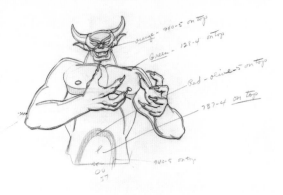

# Maleficent

*SLEEPING BEAUTY*

**RELEASE DATE:** January 29, 1959

**DIRECTOR:** Clyde Geronimi (supervising director)

**VOICE TALENT:** Eleanor Audley

**ANIMATORS:** Marc Davis, Ollie Johnston, Milt Kahl, John Lounsbery, Frank Thomas

A quick Internet search of the "Most Popular Disney Villain" leads to one name: Maleficent. The masterful combination of Eleanor Audley's smooth and powerful voice talents and Marc Davis's creative and well-thought-out animation makes Maleficent almost unbeatable on the screen and off. Though her motivations for her evil actions are unclear most of the time (no one questions why she has it out for Aurora and her family simply for not being invited to a party), audiences just accept it and sit back to enjoy the ride.

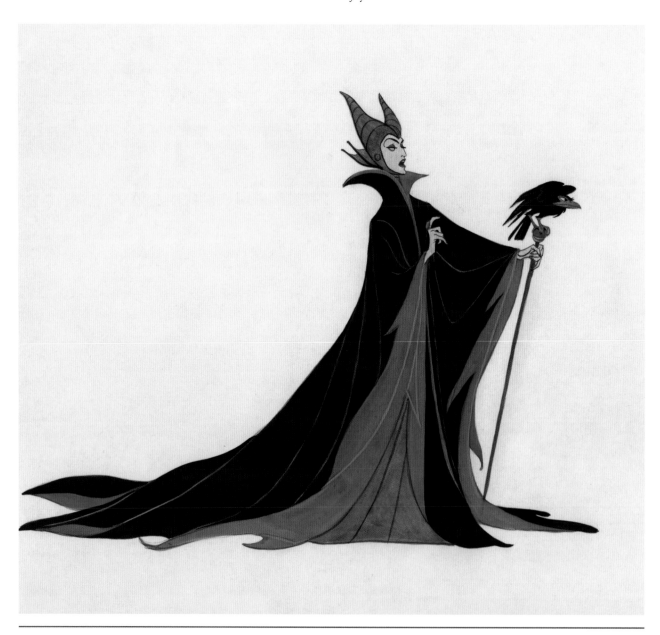

THIS PAGE: Concept art of Maleficent and her raven. Artist: Marc Davis. Medium: graphite, ink, colored pencil. OPPOSITE: (TOP) Cleanup animation drawing of Maleficent in dragon form. Artist: Eric Cleworth. Medium: graphite, colored pencil. (CENTER) Final frames of Maleficent from *Sleeping Beauty*, 1959. (BOTTOM) Concept art of Maleficent in dragon form. Artist: Disney Studio Artist. Medium: gouache.

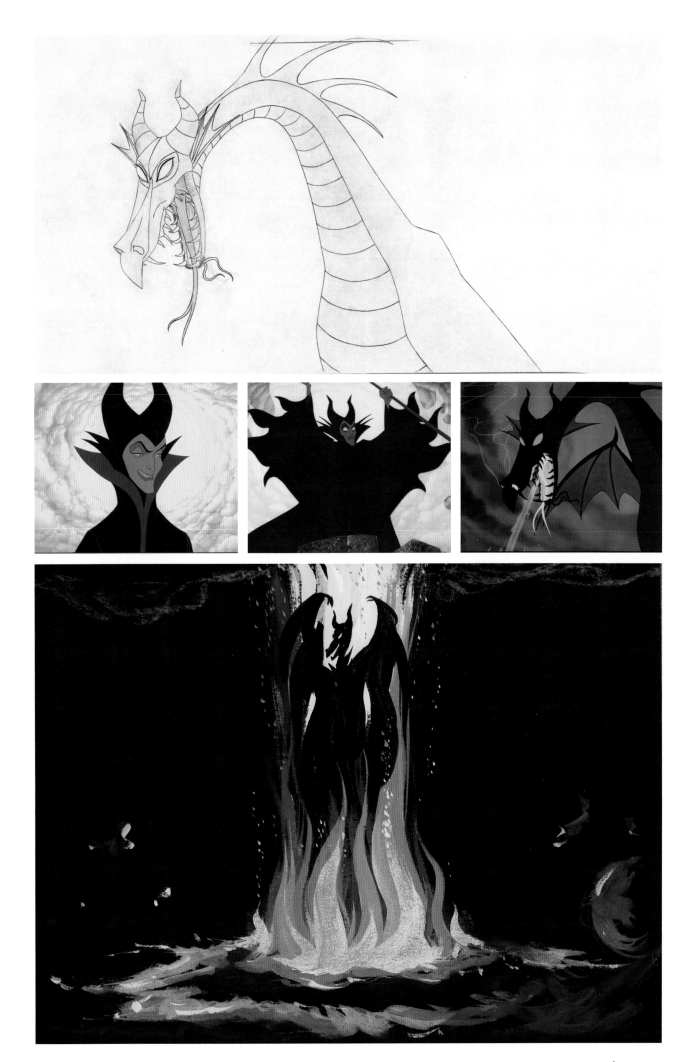

# Maleficent and Other Animated-Turned-Live-Action Villains

On May 30, 2014, Walt Disney Studios released *Maleficent*, the origin story of one of Disney's most popular villains, with Angelina Jolie in the title role and first-time director Robert Stromberg at the helm. Audiences were introduced to a powerful young fairy full of mischief and joy who fell in love with a human boy and later grew into the protector of her magical land, the moors. In this version of the story, it is King Henry who is the true villain: enraged after Maleficent wounds him in a battle that he started in order to conquer the moors, the current king declares that the man who kills Maleficent will become his successor.

Enter the human boy Stefan, now a grown man, who Maleficent once loved. Stefan betrays Maleficent, taking off her wings with a metal chain, to earn himself the throne. And there she is: the angry Maleficent audiences have loved for more than fifty-five years. Angelina Jolie has said in several interviews that she loved Maleficent as a little girl; she was also afraid of her, but still Maleficent remained her favorite character. Jolie seemed to be perfect casting for the role, and she was most definitely committed to making the movie, stepping into an executive producer role as well as having her daughter cast as a young Aurora.

In addition to Maleficent, other animated Disney villains have made the transition to live action.

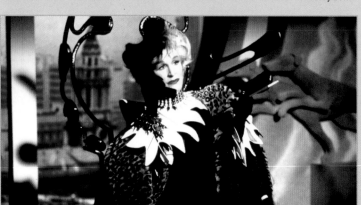

Angelina Jolie's natural beauty was enhanced with prosthetics, makeup, and contact lenses in order to re-create the animated villain for 2014's *Maleficent*.

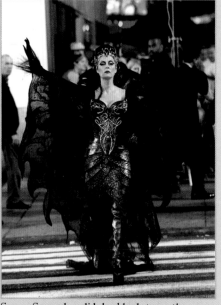

Susan Sarandon did double duty as the animated and live-action evil queen, Queen Narissa, in Walt Disney Studios' modern musical *Enchanted* (2007).

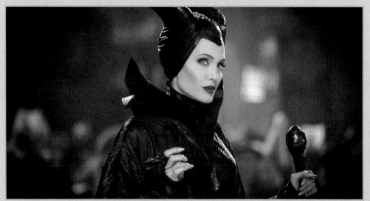

Glenn Close was the first to step out as Cruella De Vil (twice!) in *101 Dalmatians* (1996) and the sequel, *102 Dalmatians* (2000).

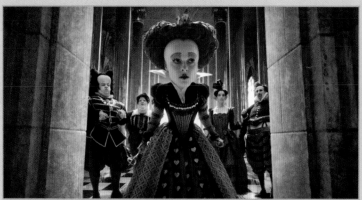

A live-action *Alice in Wonderland* (2010) would not be complete without the Red Queen played by Helena Bonham Carter.

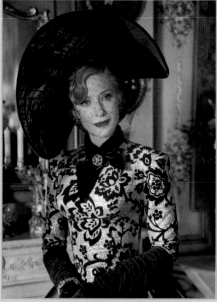

Cate Blanchett starred as the most evil stepmother a girl could have in *Cinderella* (2015).

# Eleanor Audley

Eleanor Audley was born November 19, 1905, in New York City as Eleanor Zellman. Prior to her voicing two of the most sinister and popular Disney villains, Lady Tremaine from *Cinderella* and Maleficent from *Sleeping Beauty*, Audley had a career as a Broadway actress, performing in nine productions from 1926–1944. She also had recurring or guest roles on several of the most popular television shows of the time while working at Disney, including *I Love Lucy* (in 1957), *The Twilight Zone* (in 1960), *The Beverly Hillbillies* (from 1962–1964), *Green Acres* (from 1965–1969), and *My Three Sons* (from 1969–1970). Audley's Walt Disney connection did not end with *Cinderella* and *Sleeping Beauty*, however. Audley, commanding a dark incantation as the voice of Madame Leota, welcomed Guests visiting the Haunted Mansion's Séance Room at Disneyland when the attraction opened there in 1969.

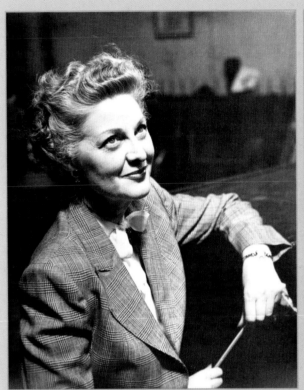

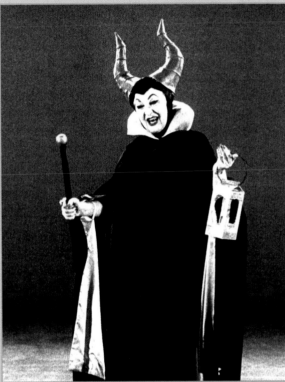

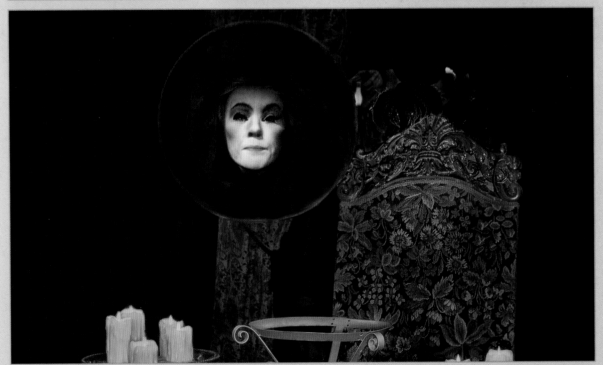

(TOP LFFT) Portrait of Eleanor Audley. (TOP RIGHT) Eleanor Audley dons a Maleficent costume complete with staff as live action reference model for the animators working on the film. (BOTTOM) Madame Leota hovers over her table and awakens the spirits visiting Disneyland's Haunted Mansion.

# The Horned King

*THE BLACK CAULDRON*

**RELEASE DATE:** July 24, 1985

**DIRECTORS:** Ted Berman, Richard Rich

**VOICE TALENT:** John Hurt

**ANIMATOR:** Walt Stanchfield (key coordinating animator)

"Oh, my soldiers, how long I have thirsted to be a god among mortal men," laments The Horned King. While The Horned King is one of the lesser-celebrated villains, he is easily one of the most evil. His no-good desires far outweigh any of the villains before him, with maybe the exception of Chernabog. True, The Horned King doesn't long for a coat made up of puppies' skins (though that really is pretty evil) or to be the "fairest in the land" (maybe not quite as evil as wanting a puppy coat). But he still wants to rule the world with his skeleton army of death and to control mortals as a god. The Horned King is definitely more a big-picture kind of villain. And yet according to Ollie Johnston and Frank Thomas, "The Horned King, who should have been mysterious, was as ordinary as the leader of a street gang."

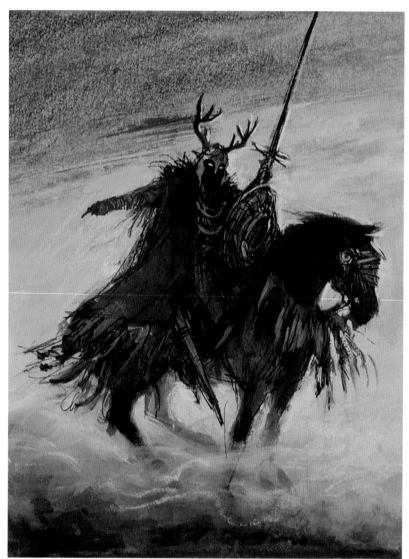

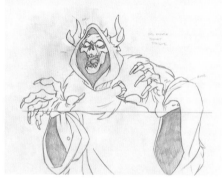

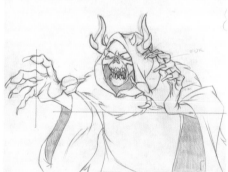

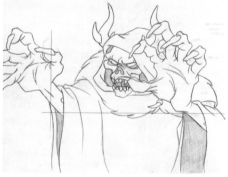

THIS PAGE: (LEFT) Concept art of The Horned King on horse. Artist: Mel Shaw. Medium: pastel. (RIGHT COLUMN) Cleanup animation drawings of The Horned King. Artist: Steven Gordon. Medium: graphite, colored pencil. OPPOSITE: (TOP LEFT) Concept art of The Horned King in his lair. Artist: Disney Studio Artist. Medium: mixed. (RIGHT COLUMN) Rough models of The Horned King. Artist: Disney Studio Artist. Medium: black line. (BOTTOM) Final frames of The Horned King from *The Black Cauldron*, 1985.

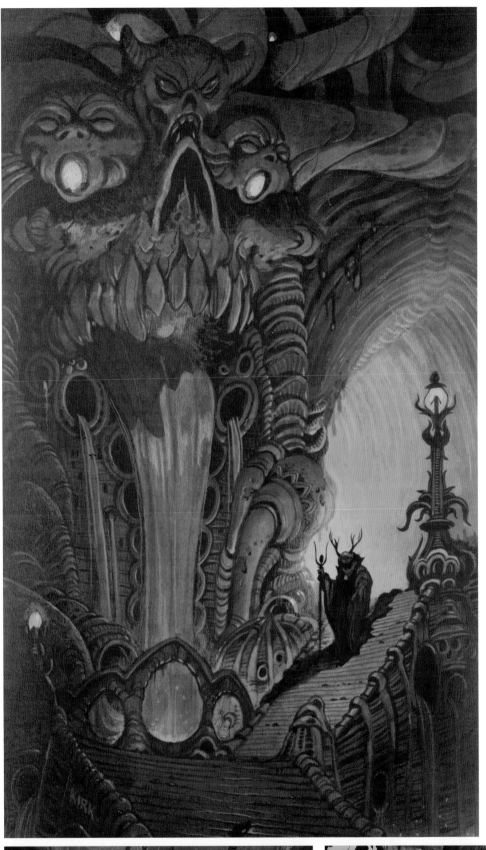

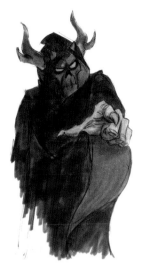

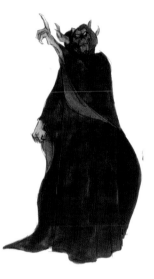

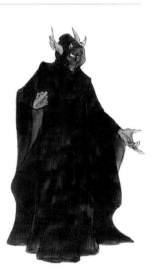

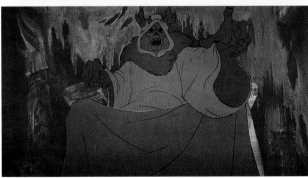

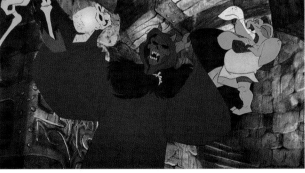

# Stand by Your Man . . . or Your Yzma

Every good villain needs an evil sidekick to help them with their evil plotting. Many times a Disney animated villain will maybe even have a team of loyal helpers. Here are a few of the solitary sidekicks who seem to worship, fear, love, and hate the villains they support.

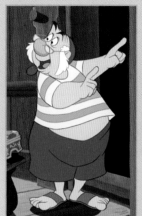

**Mr. Smee**
Companion: Captain Hook
(*Peter Pan*)
"O Captain! My Captain!"

Mr. Smee is Captain Hook's constant companion. He is always there to try to take care of the Captain after duels with Peter Pan or interactions with that hungry crocodile, to share a shred of useful gossip from the cook, or to simply row the dinghy to shore.

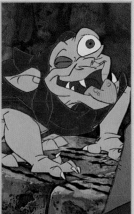

**Creeper**
Companion: The Horned King
(*The Black Cauldron*)
"Which one of these things is not like the other?"

Creeper was the only character not based on anyone from Lloyd Alexander's *Chronicles of Prydain*, the work which *The Black Cauldron* is based on. Creeper knows The Horned King so well that he knows his punishment for losing Taran (and chokes himself) even before The Horned King can even respond to the news.

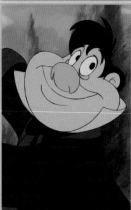

**Le Fou**
Companion: Gaston
(*Beauty and the Beast*)
"Sing, sing a song."

When Gaston is feeling sad about Belle not wanting to marry him, who is there to sing a song all about how great he thinks his friend is? Le Fou, that's who! Who is there to wait for Maurice to return home so they can throw him in the asylum? Le Fou again!

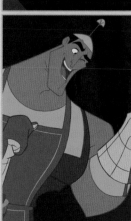

**Kronk**
Companion: Yzma
(*The Emperor's New Groove*)
"Squeaky, uh, squeak, squeaker, squeakin'."

While Kronk may not be the smartest of henchmen, he has a certain childlike sweetness and caring nature that everyone can appreciate. (Well, maybe not Yzma.) As Patrick Warburton, the voice of Kronk, so aptly puts it, "He's about as sharp as a marble."

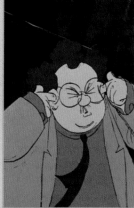

**Mr. Snoops**
Companion: Madame Medusa
(*The Rescuers*)
"Luck be a lady, tonight!"

Mr. Snoops is Madame Medusa's lackey and the one out there doing the dirty work, like trying to coerce Penny into finding the Devil's Eye diamond for them or killing a mouse while Madame Medusa leaps onto a chair and screams "*Aaahhh!* SNOOPS! SNOOPS, A MOUSE! OH, KILL IT! KILL IT!"

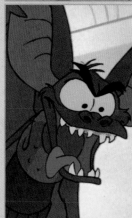

**Fidget**
Companion: Ratigan
(*The Great Mouse Detective*)
"Where's the list?!?!"

Why do people say "you bat-brained fool"? Fidget might provide a little insight into that hurtful phrase. He is the catalyst to Basil, our Sherlock, solving the mystery when he leaves his beret and the list behind for Basil to find. Despite Ratigan trying to feed Fidget to his overgrown cat, Felicia, there is still a strong bond there, and Fidget is ever ready to be part of the plan.

**Wiggins**
Companion: Governor Ratcliffe
(*Pocahontas*)
"And he came so highly recommended. . . ."

Wiggins is like every other lackey, eager to please his villain. He is almost overeager to please, but is usually way off the mark. Just like Governor Ratcliffe, Wiggins likes the finer things in life and does not seem to have any useful skills—unless creating decorative topiaries while trying to settle a new colony is useful.

**Chet Alexander**
Companion: Johnny Worthington
(*Monsters University*)
"Johnny, you're my hero."

Chet Alexander is the Chip Diller (*Animal House*) to Johnny Worthington's Greg Marmalard. He worships at the temple of Johnny, the leader of the Roar Omega Roar (RΩR), and is always ready to do whatever it takes to please his god. As far as Chet is concerned, what Johnny wants, Johnny gets. BFFs 4-eva!!

# Sykes

## OLIVER & COMPANY

**RELEASE DATE:** November 18, 1988

**DIRECTOR:** George Scribner

**VOICE TALENT:** Robert Loggia

**ANIMATOR:** Glen Keane

Sometimes the scariest villains are the ones we never see. Often in the shadows of his car or his desk, with only the glowing ember of his cigar or clouds of yellow smoke to signal he is there, Sykes was originally intended to be completely unseen; a fancy black car was supposed to represent this unforgiving villain. However, animators had to abandon that idea when it became clear that the story called for more of Sykes to be seen. In the end, audiences got a closer look at a large foreboding figure who wants his money at any cost—even if it means kidnapping a little girl. This is a pretty terrifying guy reminiscent of a character straight out of *The Godfather* or *Goodfellas*.

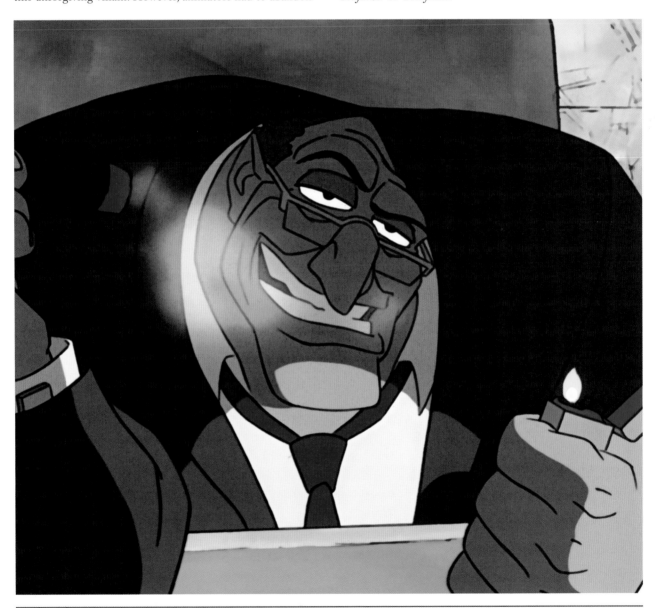

THIS PAGE: Final frame of Sykes from *Oliver & Company*, 1988.

# Oogie Boogie

**RELEASE DATE:** October 22, 1993

**DIRECTOR:** Henry Selick

**VOICE TALENT:** Ken Page

**ANIMATOR:** Eric Leighton (animation supervisor)

"Well, well, well, what have we here?" Oogie Boogie calls out. There's no clear motivation as to why Oogie Boogie feels compelled to kidnap Santa Claus. It may be that the giant sack of scary does not want to be outdone, or maybe he just cannot handle all of that holiday cheer. Ken Page, the voice of Oogie Boogie, almost did not get the role that he has gone on to play in every Disney spin-off and incarnation of the character since the original movie.

He said in an interview that it was because he and Danny Elfman, the movie's composer and the singing voice of Jack Skellington, shared the same lawyer that he got the job; the lawyer suggested him to Elfman. Originally, they wanted Page to just sing "Oogie Boogie's Song," but after Page explained that he saw Oogie Boogie as a cross between Bert Lahr (the Cowardly Lion from *The Wizard of Oz*) and the demon in *The Exorcist*, Page was in!

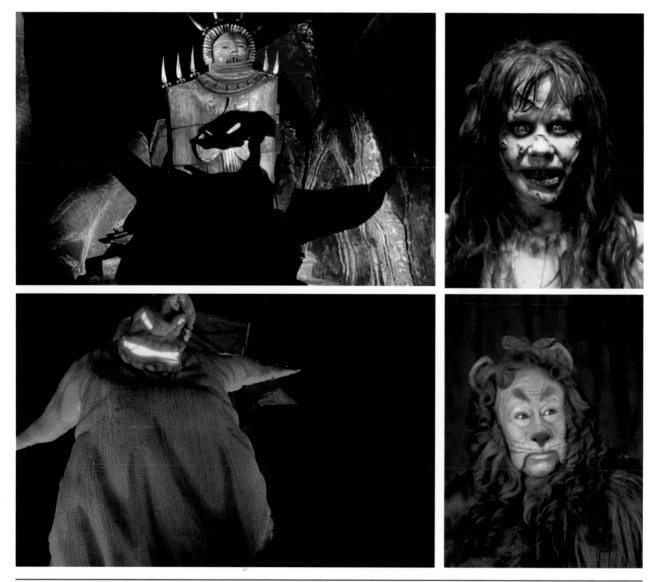

THIS PAGE: (LEFT COLUMN) Final frames of Oogie Boogie from *Tim Burton's The Nightmare Before Christmas*, 1993. (TOP RIGHT) Linda Blair as Regan, the girl possessed in *The Exorcist*. (BOTTOM RIGHT) Bert Lahr as the Cowardly Lion from *The Wizard of Oz*.

# Sid Phillips

*TOY STORY*

**RELEASE DATE:** November 22, 1995

**DIRECTOR:** John Lasseter

**VOICE TALENT:** Erik von Detten

**ANIMATORS:** Ash Brannon, Rich Quade

"I have been chosen," says a little green alien as Sid Phillips picks him up out of a vending machine game at Pizza Planet. "Farewell, my friends. I go on to a better place." Clearly the sweet alien has no idea what kind of place he is going to when "the claw" comes for him. Sid is possibly the angriest, most horrible child to ever exist in an animated movie—and Sid's home is not a happy place. Animators worked in references to the Overlook Hotel from *The Shining* to really add to the creepiness of the atmosphere, as if the baby head missing an eye on top of a mechanical set of spider legs wasn't unnerving enough. Sid is feared by all of the toys who know him, and rightfully so; he burns Woody with a magnifying glass and tries to blow up Buzz Lightyear by attaching him to a rocket. This kid clearly needs a time-out.

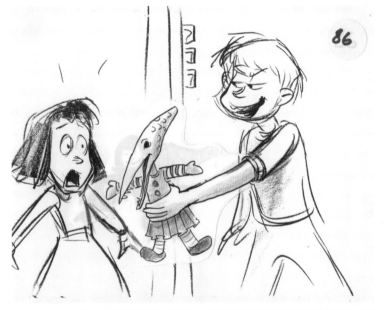

THIS PAGE: (TOP LEFT) Storyboard sketch of Sid giving his sister Hannah a mutilated version of her doll Janie. Artists: Andrew Stanton and Joe Ranft. Medium: pencil. (BOTTOM LEFT) Final frame of the resulting scene from *Toy Story*, 1995. (RIGHT) Preliminary study of Sid. Artist: Dan Haskett. Medium: pencil.

# Shan-Yu

*MULAN*

**RELEASE DATE:** June 19, 1998

**DIRECTORS:** Barry Cook, Tony Bancroft

**VOICE TALENT:** Miguel Ferrer

**ANIMATOR:** Pres Romanillos (supervising animator)

Scaling the Great Wall of China, or digging out of a giant avalanche: these are easy feats for Shan-Yu. Defeating Mulan and taking over China—now that may be a different story. Special effects animator Joseph Gilland once said that it took over a year and dozens of people working on the avalanche sequence before it was ready for the final production. He and Garrett Wren, another special effects animator, switched from CGI to hand-drawn animation scene to scene for the close-up sequences that involved the horses, allowing them to capture every hoofprint in the snow. Just think about having to create horse prints for the thousands of horses coming down that mountain in the avalanche. These special effects animators had their own "Great Wall" to get over, and did it beautifully!

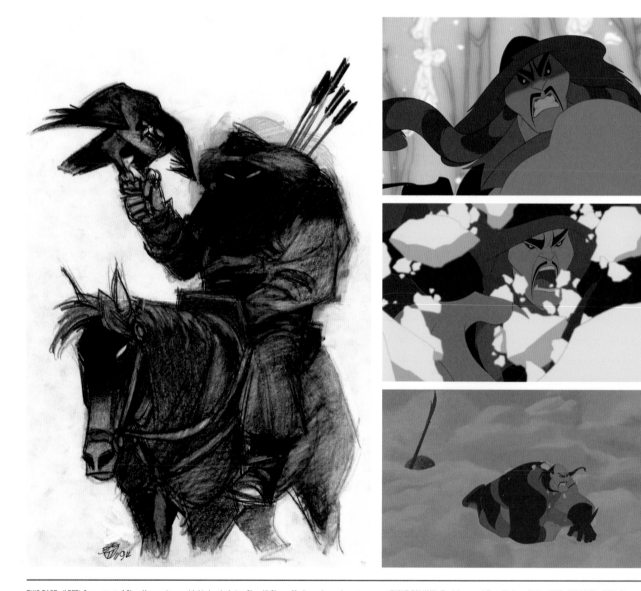

THIS PAGE: (LEFT) Concept art of Shan-Yu on a horse with his hawk. Artist: Chen-Yi Chang. Medium: charcoal, conte crayon. (RIGHT COLUMN) Final frames of Shan-Yu from *Mulan*, 1998. OPPOSITE: (TOP) Concept art of Shan-Yu and Mulan. Artist: Marcelo Vignali. Medium: graphite.

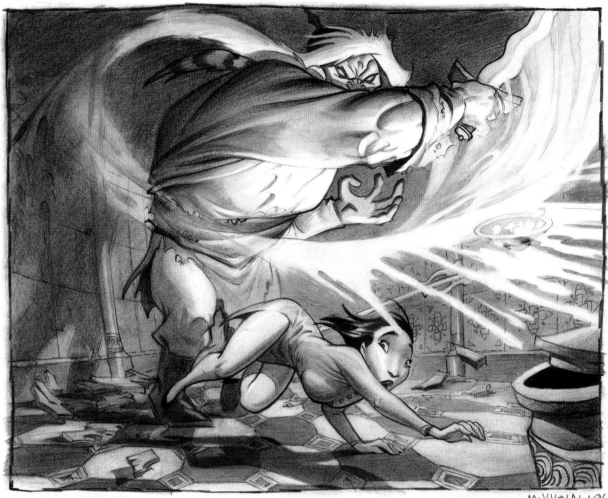

M.VIGNALI 96

# Villains on Horses

Horses have appeared in full-length Disney animated features since *Snow White and the Seven Dwarfs*, but how often do we see a villain riding one? Not often. Of the close to seventy animated features from Disney and Pixar, there are only a handful of villains who appear on horseback.

**Headless Horseman**
*The Adventures of Ichabod and Mr. Toad*

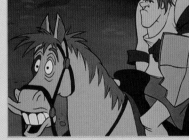

**Sir Kay**
*The Sword in the Stone*

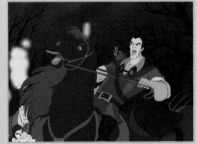

**Gaston**
*Beauty and the Beast*

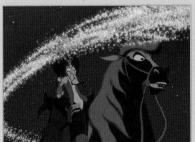

**Jafar**
*Aladdin*

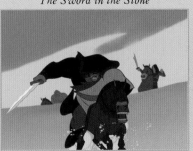

**Shan-Yu**
*Mulan*

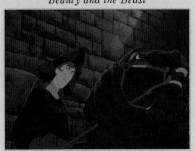

**Minister of Justice Frollo**
*The Hunchback of Notre Dame*

# Doris

**RELEASE DATE:** March 30, 2007

**DIRECTOR:** Stephen Anderson

**VOICE TALENT:** Ethan Sandler

**ANIMATOR:** Dick Zondag

Hats off to you, Doris!

One of Cornelius Robinson's inventions, Doris was originally intended by the adult Lewis to be a "Helping Hat," aiding the wearer with small tasks. But it would not be a life of servitude for Doris, oh no. She began to use mind control on the wearer, and so she was in charge! This obviously was not Cornelius's intention when he created her, so she was deactivated and put in storage. When she is reactivated, she finds a broken Bowler Hat Guy and his pathetic roll of toilet paper—and thus hatches a plan to get her revenge on the Robinson clan and do what all good "Helping Hats" want to do: take over the world, one mind-controlled person at a time.

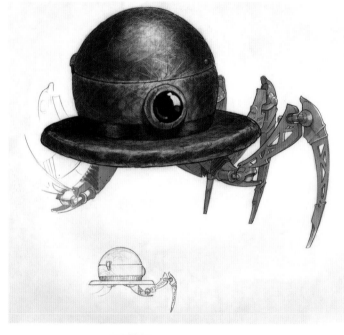

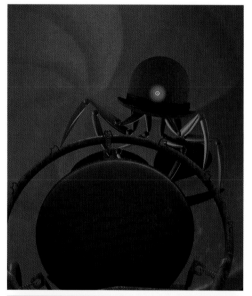

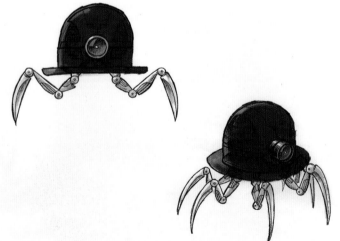

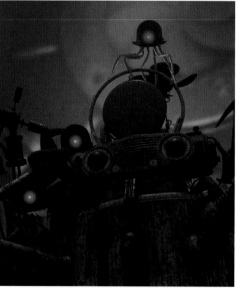

THIS PAGE: (TOP LEFT) Concept art of Doris. Artist: Dennis Greco. Medium: graphite and marker. (BOTTOM LEFT) Concept art of Doris. Artist: Jeff Ranjo. Medium: marker and ink. (RIGHT COLUMN) Final frames of Doris from *Meet the Robinsons*, 2007.

# Auto

*WALL·E*

RELEASE DATE: June 27, 2008

DIRECTOR: Andrew Stanton

VOICE TALENT: MacInTalk

ANIMATORS: Alan Barillaro, Steven Clay Hunter (supervising animators); Angus MacLane (directing animator)

Auto is like a not-too-distant cousin of H.A.L. from *2001: A Space Odyssey*; the audience is almost waiting to hear Auto refer to Captain McCrea as "Dave" and let him know that he will not be able to open the bay doors in Auto's MacInTalk-created voice. Auto, like H.A.L., is following instructions: the A113 directive from seven hundred years ago to "not return to Earth." If A113 looks familiar, it should. The number appears in almost every Pixar film, and sometimes even in the Walt Disney Animation Studios productions. It is the number of the old classroom at the California Institute of the Arts in Valencia, California, where many of the animators working on these animated movies learned and studied their craft.

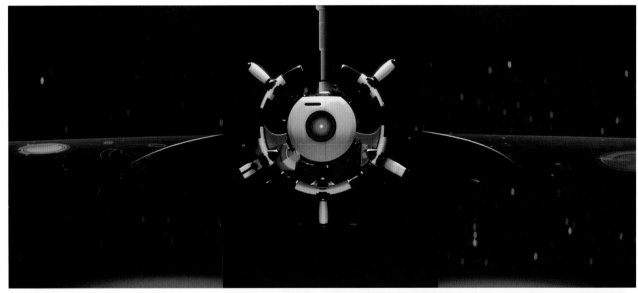

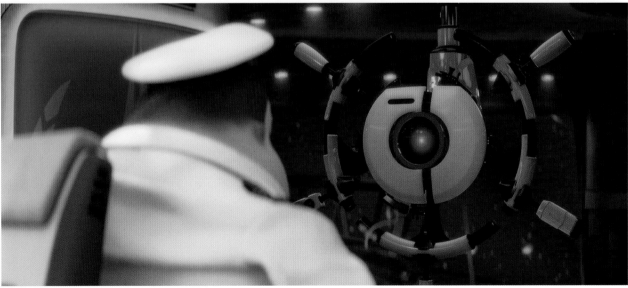

THIS PAGE: Final frames of Auto from *WALL·E*, 2008.

# A113

It is one of the most used animated inside references by Walt Disney Animation Studios and Pixar Animation Studios—next to the Hidden Mickey and the Pizza Planet truck. Here are a handful of other times an A113 reference is used in movies. (To try to capture them all could be a chapter in itself!)

License plate on the truck that almost hits the alien Stitch
*Lilo & Stitch*

Front of the trolley
*The Princess and the Frog*

Camera used by the scuba diver
*Finding Nemo*

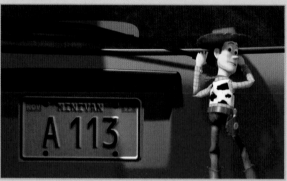

Andy's mom's license plate on her van
*Toy Story 2*

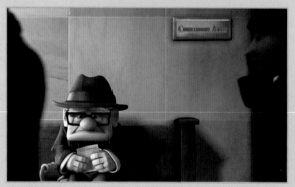

Courtroom number
*Up*

Tag on rat's ear
*Ratatouille*

License plate on the fire truck
*Lilo & Stitch*

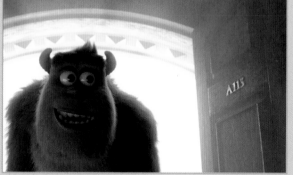

Door Sulley walks through
*Monsters University*

# Duke of Weselton

*FROZEN*

**RELEASE DATE:** November 27, 2013

**DIRECTORS:** Chris Buck, Jennifer Lee

**VOICE TALENT:** Alan Tudyk

**ANIMATOR:** Shiyoon Kim

"Ah, Arendelle, our most mysterious trade partner. Open those gates so I may unlock your secrets and exploit your riches. . . . Did I say that out loud?" Yes, you did, Duke of *Weaseltown* . . . err . . . Weselton. This dignitary from one of Arendelle's trade partners causes Elsa and Anna a lot more pain beyond just stepping on their toes with his sweet dance moves. The Duke, voiced by Alan Tudyk in his second consecutive villainous Disney role (spoiler alert: the first being King Candy in *Wreck-It Ralph*), is ruled by his fear of the unknown and his desire for power and wealth. At one point in the film, he orders his guards to kill Elsa if they get the chance. It is as though he's stepped straight out of a scene from the Salem Witch Trials.

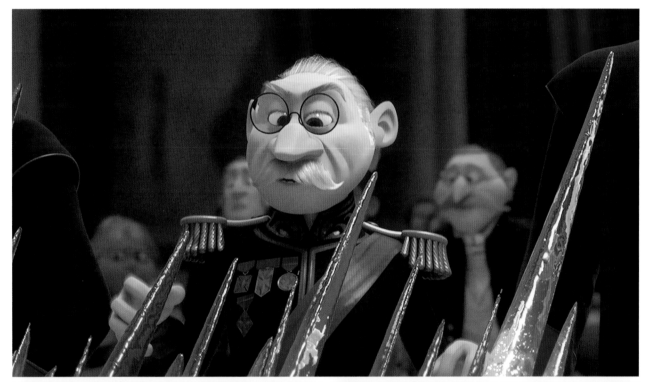

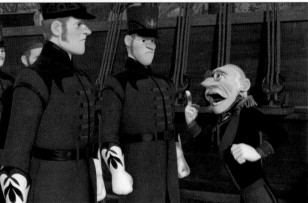
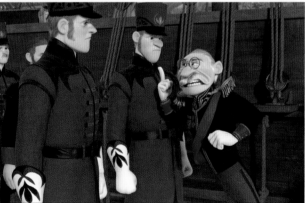

THIS PAGE: Final frames of the Duke of Weselton from *Frozen*, 2013.

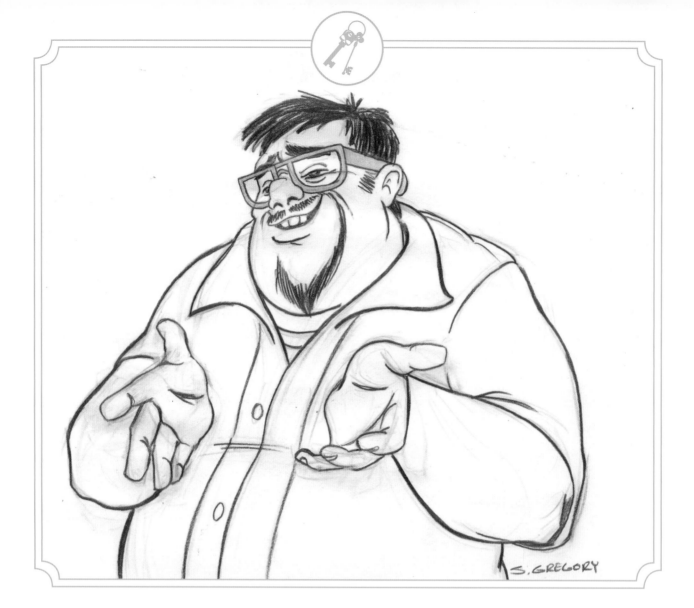

S. GREGORY

# CHAPTER

**5**

# BE OUR GUEST

Ah, to be in the service of others; well, it is not an easy life. The pressure of making sure that the show is going to be hit, or that the dinner will be delicious, or that you're stocked with the right toys to make a child's dream come true can sometimes be too great. These burdens can do things to a person (or a cat); they can make someone less patient or more high-strung; they can make them do things they wouldn't normally do, like steal a child's toy. Watching everyday, hardworking people pushed to the brink and then make bad choices still leads to a good time for moviegoers, however, who are just grateful they aren't confronted with such moral ambiguity.

THIS PAGE: Preliminary study of Al McWhiggin from *Toy Story 2*, 1999. Artist: S. Gregory. Medium: graphite, colored pencil. OPPOSITE: Shading study of Chef Skinner from *Ratatouille*, 2007. Artist: Bill Zahn. Medium: digital paint over a sculpt by Greg Dykstra.

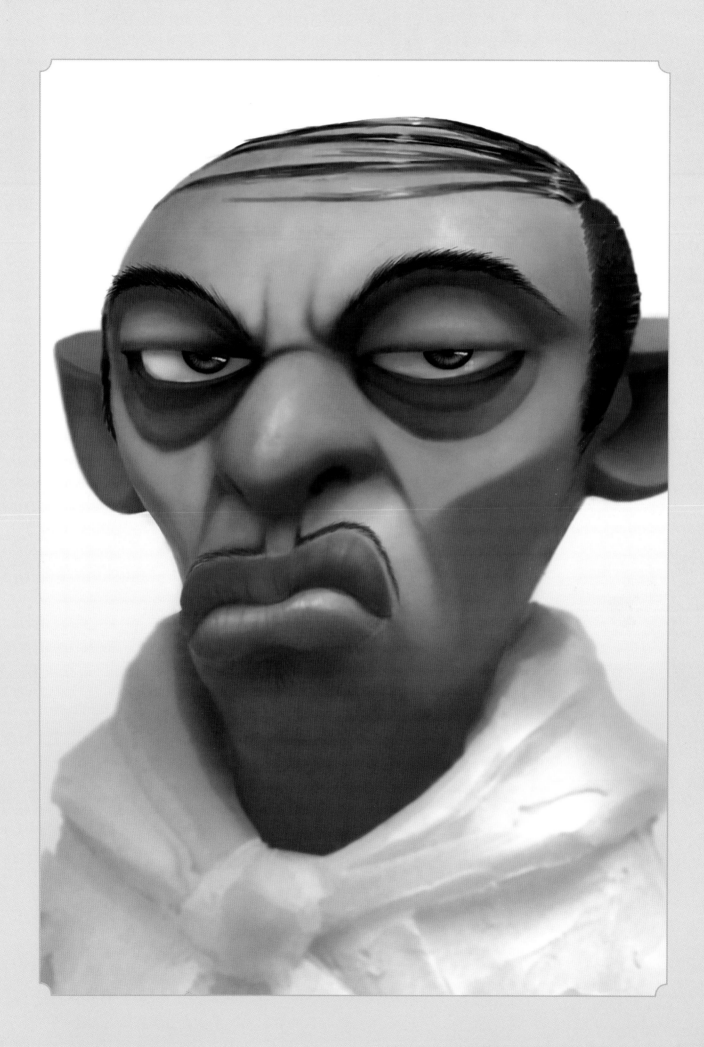

# Stromboli, Coachman, J. Worthington Foulfellow (aka Honest John), Gideon

*PINOCCHIO*

**RELEASE DATE:** February 23, 1940

**DIRECTORS:** Ben Sharpsteen, Hamilton Luske (supervising directors)

**VOICE TALENT:** Charles Judels (Stromboli, Coachman), Walter Catlett (J. Worthington Foulfellow), and Mel Blanc (Gideon's hiccup)

**ANIMATORS:** Norm Ferguson, John Lounsbury (Honest John and Gideon); Vladimir "Bill" Tytla (Stromboli); Norm Ferguson (Coachman)

"You will make lots of money. For me!" bellows Stromboli. "And when you are growing too old, you will make good firewood!" Show business is not for everyone, especially if someone like Stromboli is in charge of your career. This sometimes goofy, greedy puppet proprietor was the first in a long line of villains in this movie to teach Pinocchio to listen to his conscience. Which is just good advice, especially if your conscience is Jiminy Cricket!

The Coachman, with a face and physique that remind one a little of Santa Claus, is not a happy, jolly man here to deliver toys. Instead he is "collecting stupid little boys" to deliver to Pleasure Island—which sounds like a wonderful place. But as Pinocchio and his friend Lampwick find out, everything isn't always what it seems on the surface.

Not unlike the Coachman or Stromboli, Honest John and Gideon are motivated by making money and have no scruples about how they earn their "pay." Gideon, the short and stout cat with low intelligence and a slight hiccup problem, was the first major character animated by John Lounsbery. Fellow animator Shamus Culhane animated the scene where Honest John and Gideon get together at the Red Lobster Inn; Culhane wrote that Honest John's mannerisms were inspired by Roy and Walt Disney's brother Ray, a car insurance agent often seen around the studio with an expensive cigar in his mouth. Culhane noted of Ray, "Even when he said, 'Good morning,' it was as if he were fomenting a conspiracy."

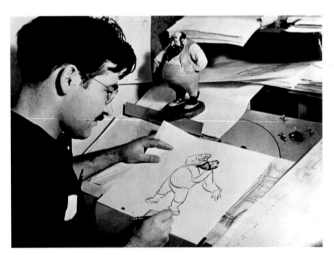

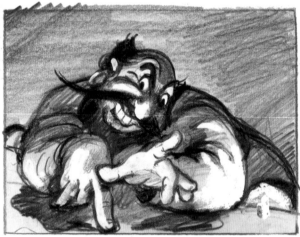

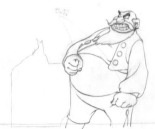

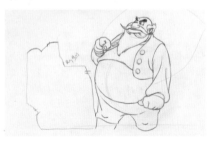

THIS PAGE: (TOP LEFT) Vladimir "Bill" Tytla working on a sketch of Stromboli. (TOP RIGHT) Story sketch of Stromboli. Artist: Disney Studio Artist. Medium: charcoal. (BOTTOM) Cleanup animation drawings of Stromboli. Artist: Vladimir "Bill" Tytla. Medium: graphite, colored pencil.

# Villains at the Parks

You cannot keep a good villain down, or only on-screen. Walt Disney Imagineering knew they had something good, or bad (it is all how one looks at it), when they began to incorporate Walt Disney Animation and Pixar Animation Studios villains into their theme park attractions. Some of these have long been closed, but many of them still exist today. Please use the key to the right to see if you can still visit some of your favorite villains, or if you will just have to settle for a picture.

### Alice in Wonderland

DLR opened June 14, 1958; closed September 6, 1982–April 13, 1984 for major remodeling; updated in 2014

Villain: Queen of Hearts (*Alice in Wonderland*)

Guests enter the fanciful world of Wonderland on board this Disneyland dark ride, but it is not all smooth laid-back caterpillars and crazy tea parties. The Queen of Hearts is there too, with her army of playing cards, threatening like always, "Off with their heads!" Disneyland Paris also amazes with a Queen of Hearts castle at *Le Labyrinthe d'Alice* (Alice's Curious Labyrinth), which opened April 12, 1992. And Tokyo Disneyland's Fantasyland nods to her majesty with the Queen of Hearts Banquet Hall restaurant.

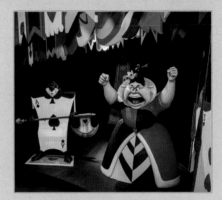

### Alice in Wonderland Maze

SHDR open upon park's grand opening

Villain: Red Queen (*Alice in Wonderland*)

As a centerpiece of this massive, mixed-up garden, the bulbous head of the Red Queen from the live-action *Alice in Wonderland* presides over the attraction as a stone sculpture. In addition, look for her regal throne.

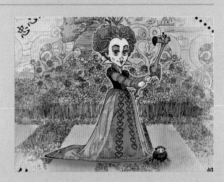

### Buzz Lightyear's Space Ranger Spin

WDW opened October 7, 1998
TDR (Buzz Lightyear's Astro Blasters) opened April 15, 2004
DLR (Buzz Lightyear Astro Blasters) opened May 5, 2005
HKDR (Buzz Lightyear Astro Blasters) opened September 12, 2005
DLP (Buzz Lightyear Laser Blast) opened April 8, 2006
SHDR (Buzz Lightyear Planet Rescue) open upon park's grand opening

Villain: Zurg (*Toy Story 2*)

Each version of this modern-day dark ride has its own unique twist, but a common factor is that Guests team up with Buzz Lightyear to take on the evil emperor Zurg in an effort to save the little green Pizza Planet aliens and, of course, the galaxy.

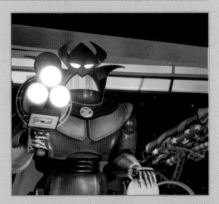

### Cinderella Castle Mystery Tour

TDR opened July 11, 1986; closed April 5, 2006

Villains: Maleficent (*Sleeping Beauty*), The Horned King (*The Black Cauldron*), Chernabog (*Fantasia*, "Night on Bald Mountain" sequence), Lady Tremaine (*Cinderella*), Stromboli (*Pinocchio*), and the Witch (*Snow White and the Seven Dwarfs*)

Guests had an opportunity to walk through this villainous cast of characters, whether they were paintings on the wall or real-life enemies: one lucky Guest per tour had the opportunity to face down The Horned King with a sword.

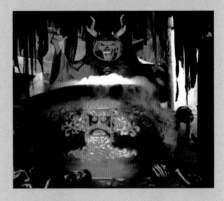

## Fantasmic!

DLR opened May 13, 1992; updated in 2009
WDW opened October 15, 1998
TDR opened April 28, 2011

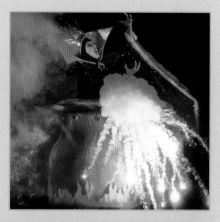

Villains: Captain Hook (*Peter Pan*), Chernabog (*Fantasia*, "Night on Bald Mountain" segment), Cruella De Vil (*One Hundred and One Dalmatians*), Queen/the Witch (*Snow White and the Seven Dwarfs*), Frollo (*The Hunchback of Notre Dame*), Hades (*Hercules*), Jafar (*Aladdin*), Kaa and King Louie (*The Jungle Book*), Maleficent (*Sleeping Beauty*), Monstro (*Pinocchio*), Governor Ratcliffe (*Pocahontas*), Scar (*The Lion King*), Ursula (*The Little Mermaid*), and more

This villain-filled nighttime thirty-minute fireworks, water, and live-characters show is jam-packed with assorted scoundrels and differs slightly from park to park, as not all versions showcase the same ones.

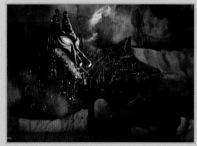

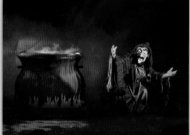

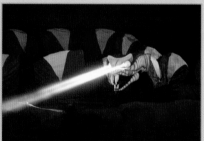

## Festival of the Lion King

WDW opened April 22, 1998; theater enclosed in 2003; closed January 5, 2014 (reopened in alternate location June 1, 2014)
HKDR opened September 12, 2005

Villain: Scar (*The Lion King*)

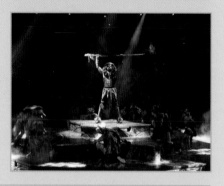

Scar gets his moment center stage in this live-actor musical retelling of *The Lion King*. Scar's signature song, "Be Prepared," begins with a bright white flash of lightning before the actors are bathed in a deep red light. Near the dramatic end, a fire dancer appears to heighten anxieties and foreshadow the "unfortunate" events to soon befall Mufasa and Simba.

## Finding Nemo Submarine Voyage

DLR opened June 11, 2007

Villain: Darla (*Finding Nemo*)

After leaving port, the captain announces on the loudspeaker that the bright yellow submarine is now passing an area popular with divers. Unfortunately for the fish in those waters, one young diver is Darla—who's sporting a black and hot-pink diving suit with the ironic message Friend of the Reef and holding an unhappy-looking fish captive.

## Haunted Mansion Holiday

DLR transformation tradition began October 5, 2001
TDR (Haunted Mansion Holiday Nightmare) transformation tradition began September 15, 2004

Villains: Jack Skellington, Oogie Boogie, Lock, Shock, and Barrel (*Tim Burton's The Nightmare Before Christmas*)

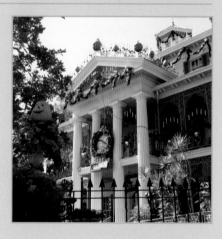

As with several annual holiday transformation traditions at various park attractions, this festive re-theming takes place for a limited time throughout the year (usually starting in September or October and lasting through February). Nearly all elements of the Haunted Mansion are redecorated, music is redone, and classic characters are replaced with the likes of Jack Skellington, Oogie Boogie, Lock, Shock, Barrel, and many more from the film—filling the mansion with macabre merriment of the season.

### It's Tough to Be a Bug!

WDW opened April 22, 1998
DLR opened February 8, 2001

Villain: Hopper (*a bug's life*)

Audience members of this nine-minute 3-D film short get to experience what it is like to be a bug, like Flik, with a very angry Hopper yelling about how humans have been allowed to join the insect world.

### The Little Mermaid ~ Ariel's Undersea Adventure

DLR opened June 3, 2011
WDW (Under the Sea~Journey of the Little Mermaid) opened December 6, 2012

Villain: Ursula (*The Little Mermaid*)

A clamshell vehicle takes Guests through the most memorable scenes of the animated feature film, and includes a dive into Ursula's secret lair. But it's not Ursula's only claim to park fame. Another attraction opened back on January 7, 1992, in the now-named Disney's Hollywood Studios Park; the multimedia stage show, called Voyage of the Little Mermaid, also gives this belter baddie a chance to share her signature song with "underwater" audiences.

### The Many Adventures of Winnie the Pooh (or similar)

WDW opened June 5, 1999
TDR (Pooh's Hunny Hunt) opened September 1, 2000
DLR opened April 11, 2003
HKDR opened September 12, 2005
SHDR open upon park's grand opening

Villains: Heffalumps and Woozles (*Winnie the Pooh and the Blustery Day*)

Guests get to take a trip through the Hundred Acre Wood in a beehive cart dripping with Winnie the Pooh's favorite treat: HONEY! As everyone knows, Heffalumps and Woozles are honey hungry, too, so Guests should "beware!" as their honey hive turns into a room filled with them.

### Mr. Toad's Wild Ride

DLR opened July 17, 1955; updated in 1983
WDW opened October 1, 1971; closed September 7, 1998

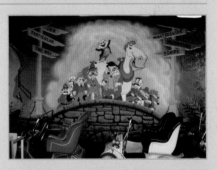

Villains: District Attorney and Winkie (*The Adventures of Ichabod and Mr. Toad*)

Hop into a motorcar, and live the dream—well, at least Mr. Toad's dream of riding around in a motorcar. Be aware that the motorcar may be considered stolen in this topsy-turvy dark ride. It's one of the original attractions of Disneyland, and is still there today, with some modifications and updates of course.

### Monsters, Inc. Mike & Sulley to the Rescue! (or similar)

DLR opened December 2005 (with a grand opening January 23, 2006)
TDR (Monsters, Inc. Ride & Go Seek!) opened April 15, 2009

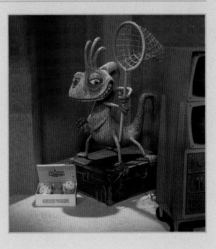

Villain: Randall Boggs (*Monsters, Inc.*)

At the Disneyland Resort, Guests board a taxicab for an up-close view of the chaos that ensues when a little girl named Boo escapes to Monstropolis—with only Mike and Sulley to protect her from a horrid fate. At Tokyo Disneyland Resort, Guests armed with special flashlights look for hiding monsters in the dark, all while Randall plots to kidnap Boo.

**Once Upon a Time Adventure**

SHDR open upon park's grand opening

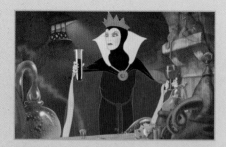

Villain: Queen/the Witch (*Snow White and the Seven Dwarfs*)

This walk-through experience reveals an eerie cauldron scene that's highlighted by the Queen reciting her incantation and transforming into a haggard old witch.

**Peter Pan's Flight**

DLR opened July 17, 1955; updated in 1983 and again in 2015
WDW opened October 3, 1971
TDR opened April 15, 1983
DLP opened April 12, 1992
SHDR open upon park's grand opening

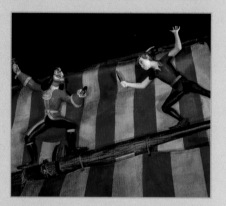

Villain: Captain Hook (*Peter Pan*)

You *can* fly! Similar versions of this suspended dark ride allow Guests to board ships and soar through the magical world of *Peter Pan*, traveling past "the second star to the right" and going "straight on 'til morning." At the new Shanghai Disneyland Resort, look for the Captain and Mr. Smee first as statues in the exterior queue before boarding the ship.

**Pinocchio's Daring Journey**

TDR opened April 15, 1983
DLR opened May 25, 1983
DLP (*Les Voyages de Pinocchio*) opened April 12, 1992

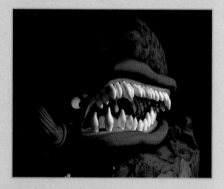

Villains: Stromboli, Coachman, J. Worthington Foulfellow (aka Honest John), Gideon, and Monstro (*Pinocchio*)

This may be one exciting trip backstage, especially when the venue is Stromboli's theater, where Pinocchio and other puppets have been placed in cages. Guest better hope they do not end up in their own cage with a one-way ticket to Pleasure Island, or, worse, inside Monstro's belly.

**Ratatouille: L'Aventure Totalement**

*Toquée de Rémy*/Ratatouille the Adventure
DLP opened July 10, 2014

Villain: Chef Skinner (*Ratatouille*)

Ever wonder what it would be like to experience the world from Remy the rat's point of view? Guests aboard this modern-day dark ride find out, as Remy and friends (including Guests aboard rat-shaped vehicles) tangle with Chef Skinner in the ultimate game of cat-and-mouse.

**Sleeping Beauty Castle Walkthrough**

DLR dedication ceremony with Shirley Temple April 28, 1957; opened April 29, 1957; expanded in 1968; redesigned in November 1977; closed October 7, 2001; reopened November 26, 2008
DLP (*Le Château de la Belle au Bois Dormant*) opened April 12, 1992

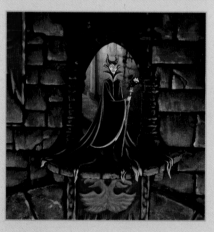

Villain: Maleficent (*Sleeping Beauty*)

While this walk-through experience has evolved through the years, it's consistently conveyed the story of *Sleeping Beauty*—including the fierce and powerful Maleficent (both as an evil fairy and a dragon).

### Snow White's Scary Adventures (or similar)

DLR (Snow White's Adventures) opened July 17, 1955; updated to Snow White's Scary Adventures, May 25, 1983
WDW (Snow White's Adventures) opened October 1, 1971; updated to Snow White's Scary Adventures, December 16, 1994; closed May 31, 2012
TDR (Snow White's Adventures) opened April 15, 1983
DLP (*Blanche-Neige et les Sept Nains*) opened April 12, 1992

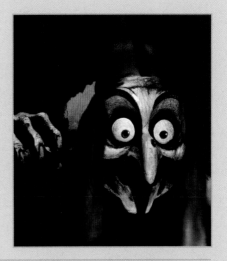

Villain: Queen/the Witch (*Snow White and the Seven Dwarfs*)

Stuck in a mining car with the Queen popping out at them at every turn, Guests probably wouldn't want to stay past their welcome, as they travel through the Queen's castle and beyond. Thank goodness there are seven friends and a giant boulder there to help out in the end. In Disneyland, look for the Queen peering through the attraction's upper exterior window. In Walt Disney World, the *Seven Dwarfs Mine Train*, the roller coaster–like thrill ride that opened May 28, 2014, made use of some props and figures from Florida's original *Snow White* dark ride—the Witch included.

### Sorcerers of the Magic Kingdom

WDW opened February 22, 2012

Villains: Chernabog (*Fantasia*, "Night on Bald Mountain" sequence), Cruella De Vil (*One Hundred and One Dalmatians*), Dr. Facilier (*The Princess and the Frog*), Hades (*Hercules*), Jafar (*Aladdin*), Maleficent (*Sleeping Beauty*), Governor Ratcliffe (*Pocahontas*), Scar (*The Lion King*), Ursula (*The Little Mermaid*), and Yzma (*The Emperor's New Groove*)

An interactive role-playing game in which Guests seek out and battle with various Disney villains using spell cards. Guests, indoctrinated into the game-play by Merlin from *The Sword in the Stone*, discover that Hades is on the move for a hostile takeover of the Magic Kingdom—and only they have the power to stop him.

### Splash Mountain

DLR opened July 17, 1989
WDW opened July 17, 1992
TDR opened October 1, 1992

Villains: Brer Fox and Brer Bear (*Song of the South*)

Have you found your laughin' place? Guests float along in hollow logs down and around the bayou on this water ride, but it is not all calm and gently moving along at a leisurely pace. It is not called *Splash* Mountain for nothing.

### Stitch's Great Escape!

WDW opened November 16, 2004
HKDR opened July 13, 2006
DLP (Stitch Live!) opened March 22, 2008
TDR opened summer 2015

Villain: Stitch (*Lilo & Stitch*)

A once-imprisoned Stitch makes his great escape from the Galactic Federation and wreaks havoc on spectating Walt Disney World Guests in this attraction. Stitch's mayhem goes worldwide, too, as he offers a real-time conversation to Guests in Space Traffic Control at an attraction show called Stitch Encounter.

### Storybook Land Canal Boats

DLR (Canal Boats of the World) opened July 17, 1955; updated to Storybook Land Canal Boats, with Monstro, on June 16, 1956; updated in 1994 and 2014
DLP (*Le Pays des Contes de Fées*, with Chernabog) opened April 1994

Villains: Monstro (*Pinocchio*) and Chernabog (*Fantasia*, "Night on Bald Mountain" segment)

Another one of the original Disneyland attractions that is still in existence is the Storybook Land Canal Boats with Monstro; and just like Pinocchio and Geppetto, Guests pass through the giant whale with no problems. In Disneyland Paris, Chernabog stands high up in a tower and shields his eyes from the sun.

# Ringmaster

*DUMBO*

**RELEASE DATE:** October 31, 1941

**DIRECTOR:** Ben Sharpsteen

**VOICE TALENT:** Herman Bing

**ANIMATOR:** Art Babbitt (directing animator)

The Ringmaster is one of the lesser villains in Disney film history. His only crime is being focused on putting on a show and not recognizing, or caring, what the best path is for a special little elephant named Dumbo. Throughout this film, sweet, sensitive Dumbo is trying to find his place in this world, and instead finds adversity and cruelty at every turn. It is hard to say who the real villain is in this film, but Dumbo is most assuredly a victim who breaks hearts and brings on the tears.

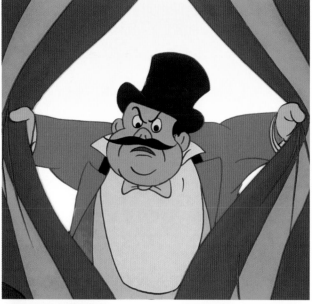

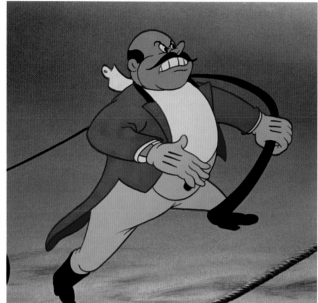

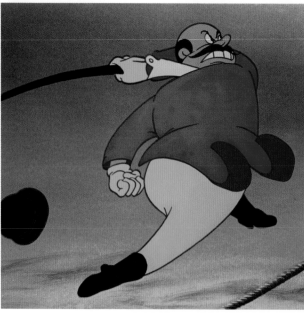

THIS PAGE: Final frames of the Ringmaster from *Dumbo*, 1941.

# Edgar

*THE ARISTOCATS*

**RELEASE DATE:** December 24, 1970

**DIRECTOR:** Wolfgang "Woolie" Reitherman

**VOICE TALENT:** Roddy Maude-Roxby

**ANIMATOR:** Milt Kahl

Just ship 'em off to Timbuktu! This greedy butler is unwilling to wait for the regal Duchess and her three kittens (Toulouse, Berlioz, and Marie) to go through their "nine lives" while they inherit Madame Bonfamille's fortune. Roddy Maude-Roxby, the voice talent behind Edgar, was described at the time of the movie's release by director Wolfgang "Woolie" Reitherman as "the snobby sort of Englishman who was on [the television show *Rowan & Martin's*] *Laugh-In* two years ago." The story of *The Aristocats* was originally intended to be a two-part live-action special for *Walt Disney's Wonderful World of Color*, but Walt Disney later decided it should be an animated feature. It was the first full-length animated feature to be made by the studio after his death.

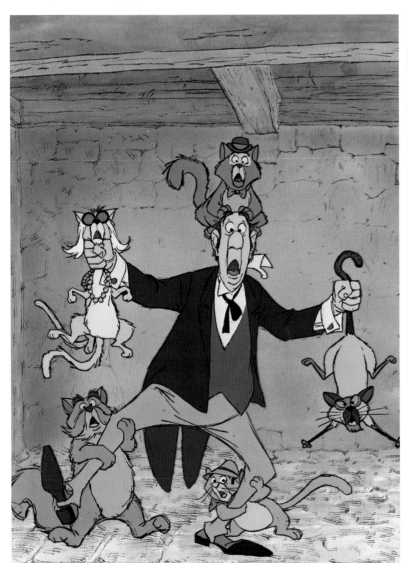

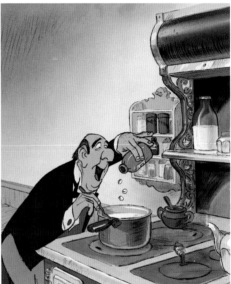

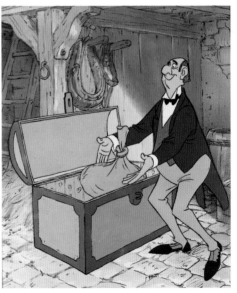

THIS PAGE: Final frames of the Edgar from *The Aristocats*, 1970.

# Al McWhiggin (the Toy Collector)

*TOY STORY 2*

**RELEASE DATE:** November 24, 1999

**DIRECTORS:** John Lasseter; Ash Brannon, Lee Unkrich (co-directors)

**VOICE TALENT:** Wayne Knight

**ANIMATORS:** Kyle Balda, Dylan Brown (directing animators); Glenn McQueen (supervising animator)

Why did the chicken cross the road? To get to cry on television after losing the most "root'-ness, toot'-ness cowboy in the wild, wild west" as well as the profit that Woody and a complete collection of toys from *Woody's Roundup* would have brought him. Al McWhiggin is so focused on completing his collection (rather than what it really means to have a toy and truly enjoy that toy) that he steals Woody from a tag sale after Andy's mom has told him repeatedly that Woody is not for sale. *Toy Story 2* was inspired by John Lasseter's own experience as a toy collector. Lasseter once said, "I have five sons, and my four little ones love to come to Daddy's office and play with my toys. A lot of them are antiques and one-of-a-kind items. I love my boys, and I wanted them to play with these toys, but I found myself saying, 'No, no, you can't play with that one. Oh, here, play with this one instead.' And as I looked at myself, I began laughing because toys are manufactured and put on this earth to be played with by a child." See, Al, John Lasseter gets it!

THIS PAGE: Preliminary studies and final character pose of Al in his chicken suit. OPPOSITE: (LEFT SEQUENCE) Al on the phone, from story sketch through final frame from *Toy Story 2*, 1999. (RIGHT SEQUENCE) Al sleeping while Woody and Bullseye attempt to retrieve Woody's missing arm, depicted in story sketches and final frames.

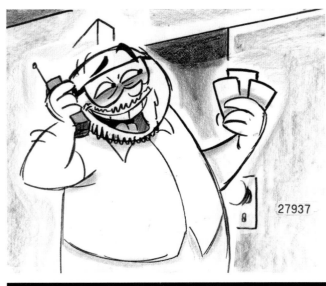

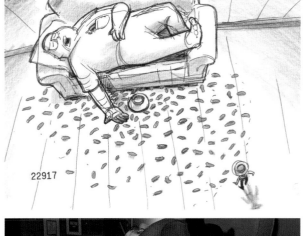

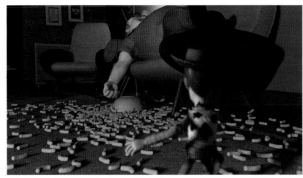

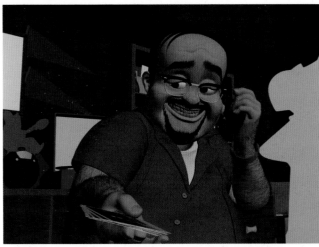

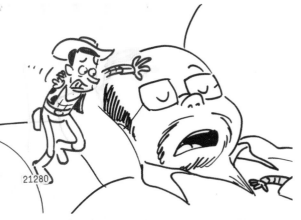

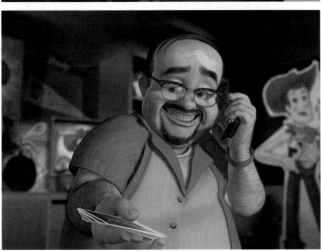

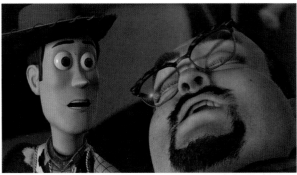

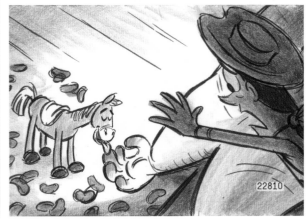

# John Silver

## *TREASURE PLANET*

**RELEASE DATE:** November 27, 2002

**DIRECTORS:** Ron Clements, John Musker

**VOICE TALENT:** Brian Murray

**ANIMATORS:** Glen Keane, Eric Daniels

"Beware: the Cyborg." John Silver is a pirate: a cyborg pirate in space, but a pirate nonetheless. And what do all pirates want? No, not a cask of rum or the *Black Pearl*. They want treasure! So it is only natural that John Silver—the cook aboard the *RLS Legacy*—is going to figure out a way (even if it means hurting those he may have come to care about) to find a whole planet filled with treasure. The character John Silver was the first time animators would combine hand-drawn animation and CGI. And who better to pioneer that process than Glen Keane and Eric Daniels, Walt

Disney treasures in their own right. Both talented men worked together for more than three years, trying out approximately five hundred versions of the character in order to flawlessly create the John Silver that came to life in the film. The pair even took trips to Travel Town Museum in Los Angeles's Griffith Park to find inspiration—and to a Benihana restaurant to study the human mechanics of cooking. As Keane said in an interview in the *Los Angeles Times*, "The challenge was to connect the mechanical to Silver's heart and soul, as though it was attached to the nerves."

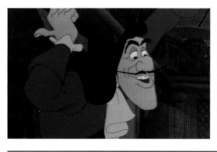

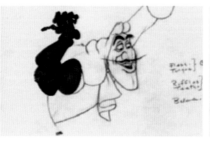

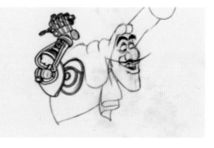

THIS PAGE: (TOP LEFT) Concept art of Silver. Artist: Disney Studio Artist. Medium: pen and marker. (TOP RIGHT) Concept art of Silver. Artist: Glen Keane. Medium: charcoal, conte crayon. (BOTTOM) Final frame of Captain Hook from *Peter Pan* and an early cyborg arm test illustrated on top of the pirate.

# Chef Skinner

*RATATOUILLE*

**RELEASE DATE:** June 29, 2007

**DIRECTORS:** Brad Bird; Jan Pinkava (co-director)

**VOICE TALENT:** Ian Holm

**ANIMATORS:** David DeVan, Michael Venturini (animation directors); Dylan Brown, Mark Walsh (supervising animators)

What chef would be happy about having a rat in the kitchen? If this was Chef Skinner's only issue, then there would be no reason for him to be included in a collection of villains. There is also his need, however, to control the kitchen and to order everyone to work as he thinks they should. Again, almost any executive chef works like this, so it is hard to see Chef Skinner as a villain. Brad Bird, the film's codirector, describes Chef Skinner as "a little dictator of the kitchen." What about his desire to have a line of frozen and premade foods? A crime against the delicious food coming out of Gusteau's restaurant, perhaps, but it's still not true villainous behavior. Just like when creating the perfect dish (a ratatouille, maybe?), the balance of the ingredients is key. Add a dash of crimes against food; a sprinkle of kitchen dictator; a pinch of Napoleonic complex; then toss in paranoia, envy, and an inability to accept anyone else having talent in his kitchen. Bring to a boil and, voilà, you have the perfect culinary villain in Chef Skinner!

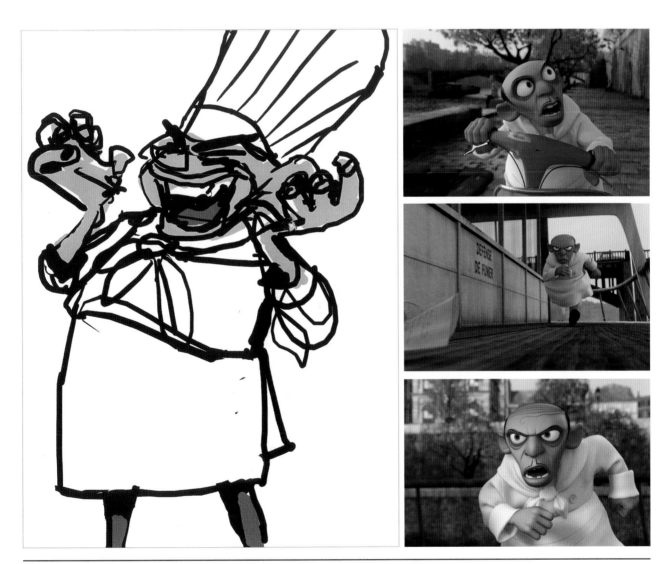

THIS PAGE: (LEFT) Preliminary study of Chef Skinner. Artist: Dan Lee. Medium: digital. (RIGHT SEQUENCE) Final frames of Chef Skinner from *Ratatouille*, 2007.

# GAME OF THRONES

"Everybody wants to rule the world," or so the song goes. Since the beginning of time, there have been people struggling to gain power; it seems there is never enough to satiate their appetites. And for as long as people have been on a journey to the top, audiences have been enthralled to watch their climb to get there. The more treacherous and sinister the rise and the more disappointing (for them) and justified the fall, the better!

THIS PAGE: Cleanup animation drawing of Hades from *Hercules*, 1997. Artist: Nik Ranieri (lead animator). Medium: graphite, colored pencil. OPPOSITE: Final frame of Queen of Hearts from *Alice in Wonderland*, 1951.

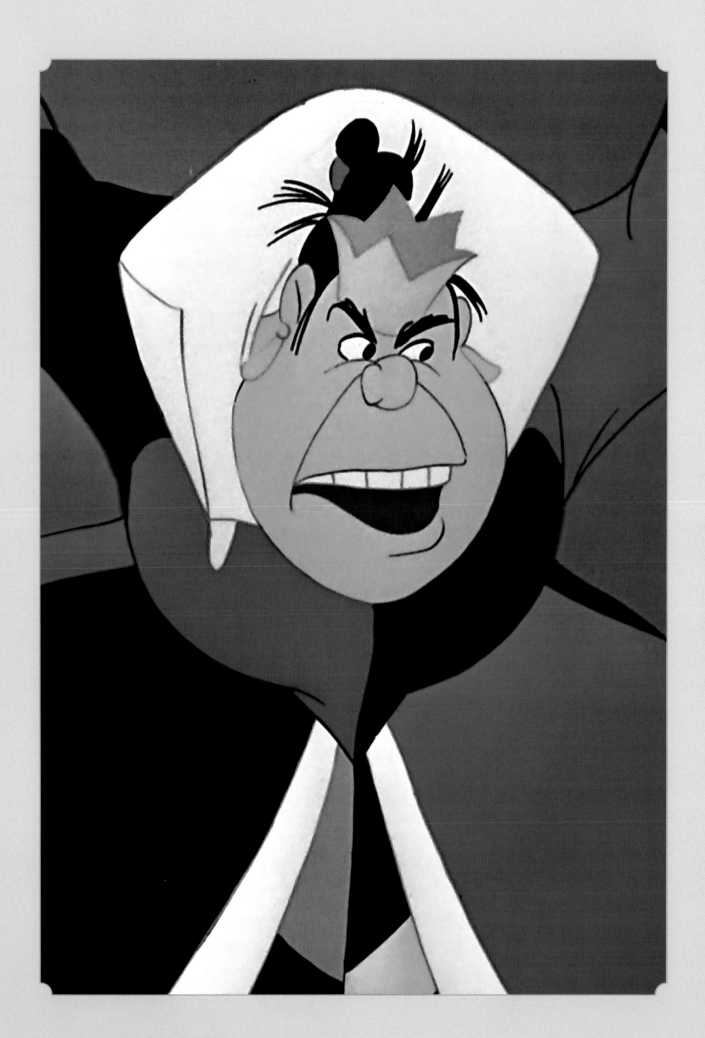

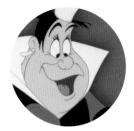

# Queen of Hearts

*ALICE IN WONDERLAND*

**RELEASE DATE:** July 28, 1951

**DIRECTORS:** Wilfred Jackson, Hamilton Luske, Clyde Geronimi

**VOICE TALENT:** Verna Felton

**ANIMATORS:** Les Clark, Marc Davis, Norm "Fergy" Ferguson, Ollie Johnston, Milt Kahl, Ward Kimball, Eric Larson, John Lounsbery, Wolfgang "Woolie" Reitherman, Frank Thomas

"Off with their heads!" The Queen of Hearts is all over the map when it comes to her emotions, but her subjects get to experience only one: fear. Whether she is cheating at croquet or screaming in a full rage about her roses, she controls her kingdom, including her king, by creating an erratic and unpredictable atmosphere where the only thing everyone can count on is that someone will lose their head. Due to the not-so-warm critical reviews and modest box office receipts upon the film's initial release, the animators of the film "felt [they] had failed." It would later become a cult classic during the 1960s at universities and colleges all over the country. Madness!

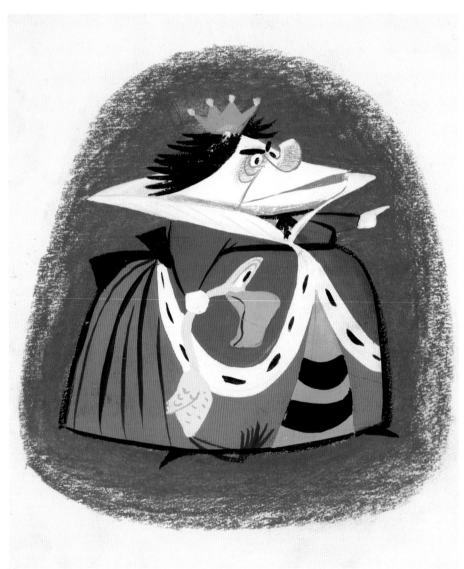

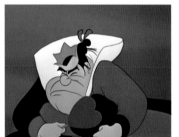

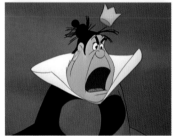

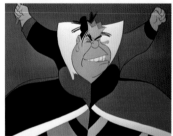

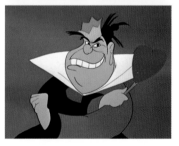

THIS PAGE: (LEFT) Concept art of Queen of Hearts. Artist: Mary Blair. Medium: gouache. (RIGHT COLUMN) Final frames of Queen of Hearts from *Alice in Wonderland*, 1951. OPPOSITE: (TOP) Preliminary study of Queen of Hearts. Artist: Mary Blair. Medium: gouache. (CENTER) Story sketches of Queen of Hearts created by British artist David Hall, who only worked on the project from May 1939 through June 1940. Medium: (left) graphite; (center and right) watercolor, gouache. (BOTTOM LEFT) Cleanup animation drawing. Artist: Frank Thomas. Medium: graphite, colored pencil. (BOTTOM RIGHT) Final frame.

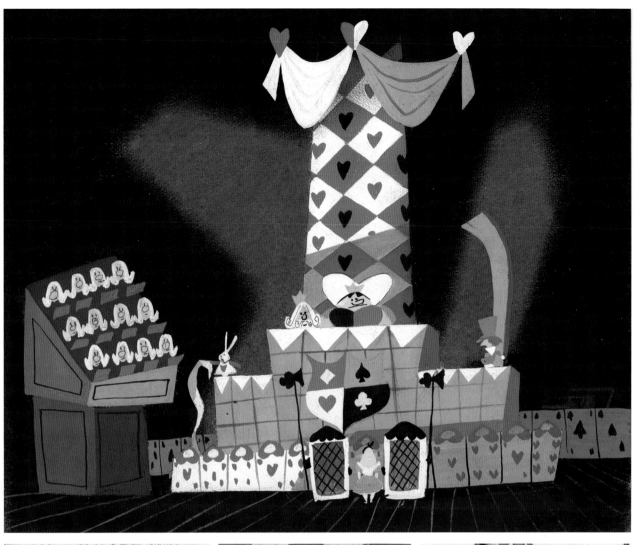

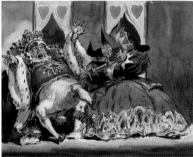

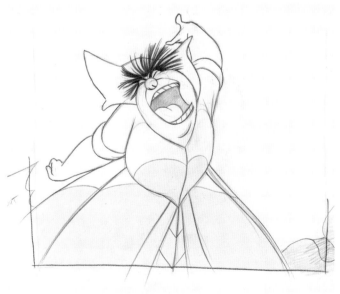

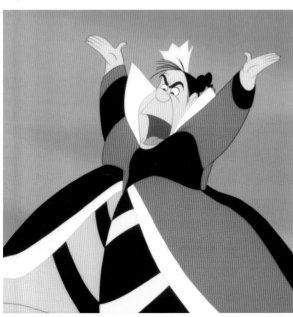

# Prince John, Sir Hiss

*ROBIN HOOD*

**RELEASE DATE:** November 8, 1973

**DIRECTOR:** Wolfgang "Woolie" Reitherman

**VOICE TALENT:** Peter Ustinov (Prince John), Terry-Thomas (Sir Hiss)

**ANIMATORS:** Ollie Johnston (Prince John, Sir Hiss)

"This crown gives me a feeling of power. POWER!" roars Prince John. Lions are supposed to be kings, but unfortunately, the power of the crown of England is all in Prince John's head. He is constantly finding himself powerless against the quick-witted hero, Robin Hood. According to Ollie Johnston and Frank Thomas, Peter Ustinov's performance as Prince John (he also was the voice of King Richard) "helped the animators capture the shallowness of the prince's personality in an entertaining way." Sucking one's thumb while holding their ear is no way to try to rule England!

THIS PAGE: (TOP) Concept art of Sir Hiss and Prince John. Artist: Disney Studio Artist. Medium: ink and marker. (BOTTOM) Final frames of Prince John and Sir Hiss from *Robin Hood*, 1973. OPPOSITE: (TOP) Concept art of Sir Hiss and Lady Cluck. Artist: Disney Studio Artist. Medium: ink and marker. (CENTER) Final frames of Prince John and Sir Hiss. (FUN FACT) Peter Ustinov as the legendary pirate Blackbeard in the 1968 Disney live-action film *Blackbeard's Ghost*.

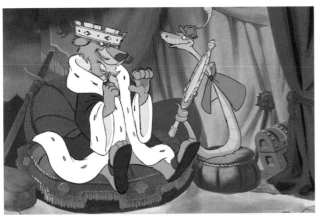

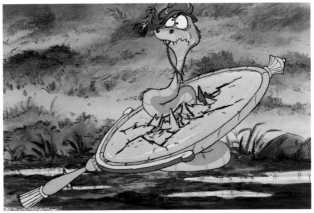

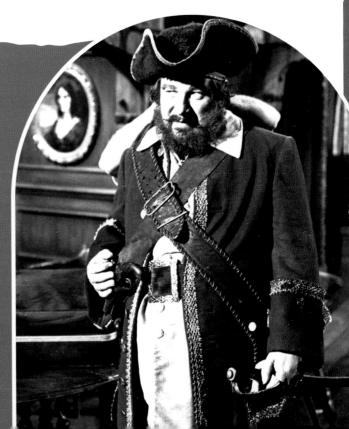

# FUN FACT

Peter Ustinov spoke several languages, including Russian, French, and German. He voiced Prince John in both its original English and the German dub. He also played the title role in the 1968 Disney live-action film *Blackbeard's Ghost*.

Unlike Kaa from *The Jungle Book*, Sir Hiss is a little less reptile and a little more human. With his ridiculous cape and feathered cap, Sir Hiss seems to inch along instead of slither like a snake. When creating Sir Hiss, the animators said, "We were no longer restricted by a snake's anatomy or construction, because with this character development we were caricaturing a personality more than a reptile." The other component to creating this unique reptilian personality, which audiences had never really experienced before, was the very talented Terry-Thomas. The animators even gave Sir Hiss the same gapped teeth the actor voicing him had to add even more to Sir Hiss's presence in the movie.

# Ratigan

*THE GREAT MOUSE DETECTIVE*

**RELEASE DATE:** July 2, 1986

**DIRECTORS:** John Musker, Ron Clements, Dave Michener, Burny Mattinson

**VOICE TALENT:** Vincent Price

**ANIMATOR:** Glen Keane

Don't call Ratigan a rat! Vincent Price, who at seventy-five years old was the voice of this rodent Moriarty in the Sherlockian movie adaptation *The Great Mouse Detective*, discussed his character's disdain in an *Orlando Sentinel* article: "Everybody who calls him a rat is just immediately eaten by his cat, because he just thinks of himself as a very large mouse. This is logic!" Inspired by a photograph Glen Keane found when looking through an old book of a man smoking a cigar and wearing a top hat in the 1800s, Ratigan is the classiest rat . . . um, we mean, mouse . . . to hit the silver screen.

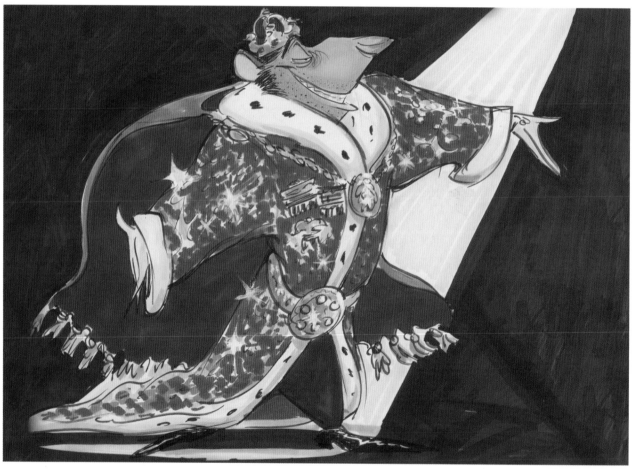

THIS PAGE: (TOP) Concept art of Ratigan. Artist: Disney Studio Artist. Medium: ink and marker. (BOTTOM) Rough animation of Ratigan's dance. Artist: Glen Keane. Medium: graphite and charcoal. OPPOSITE: (TOP LEFT) Final frame of Ratigan from *The Great Mouse Detective*, 1986. (TOP RIGHT COLUMN) Vincent Price recording his role as Ratigan and really getting into character. (BOTTOM) Final cleanup model sheet. Artist: Disney Studio Artist. Medium: black line.

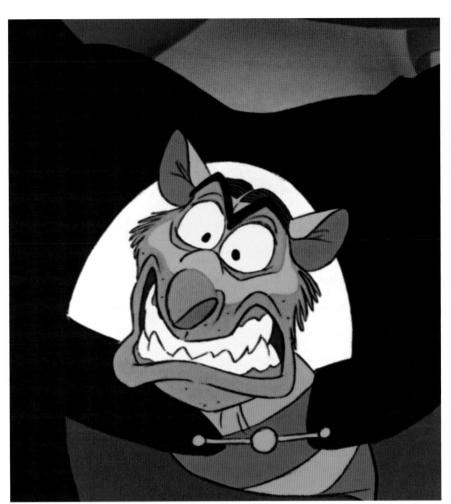

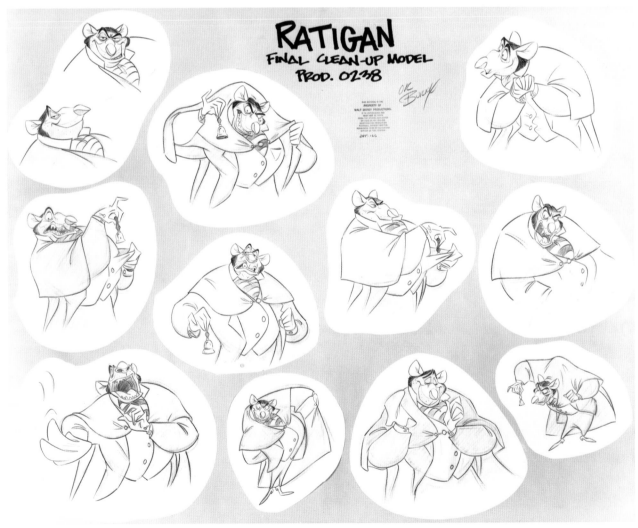

# RATIGAN
## FINAL CLEAN-UP MODEL
### PROD. 0238

# Ursula

## *THE LITTLE MERMAID*

**RELEASE DATE:** November 17, 1989

**DIRECTORS:** John Musker, Ron Clements

**VOICE TALENT:** Pat Carroll

**ANIMATOR:** Ruben A. Aquino (directing animator)

Can anyone imagine *The Little Mermaid*'s fabulous villainous sea witch, Ursula, as anything other than an octopus? Animators did! When they began work on the character, early sketches show her as a fish with long, thin, clawlike fingers. The directors also considered other voice actors for Ursula before Pat Carroll finally got the role, including Bea Arthur (*Maude*, *The Golden Girls*), Roseanne Barr (*Roseanne*), and Elaine Stritch

(*Two's Company*). In the end, everything seems to be just as it should be. Ursula is an octopus voiced by the talented Carroll. It is impossible to imagine Ursula as anything other than the larger-than-life, tough, and crass villain that audiences have all come to know, love, and maybe fear—the Ursula of the 1989 movie that put Disney animation back on the map and instantly became a classic and part of our world.

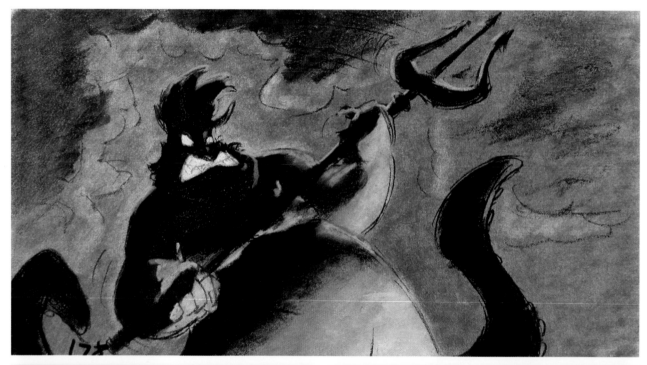

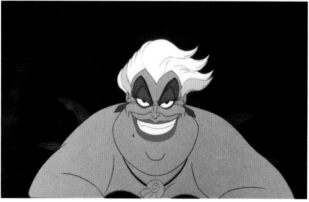
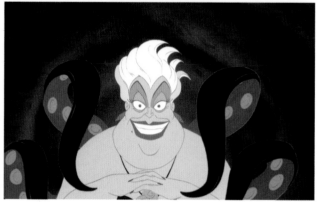

THIS PAGE: (TOP) Concept art of Ursula. Artist: Ruben A. Aquino. Medium: ink and marker. (BOTTOM) Final frames of Ursula from *The Little Mermaid*, 1989. OPPOSITE: Concept art of Ursula. (TOP) Artist: David Cutler. Medium: ink and watercolor. (BOTTOM LEFT) Artist: Dave Cutler. Medium: marker. (RIGHT COLUMN) Artist: Ruben Aquino. Medium: ink and marker.

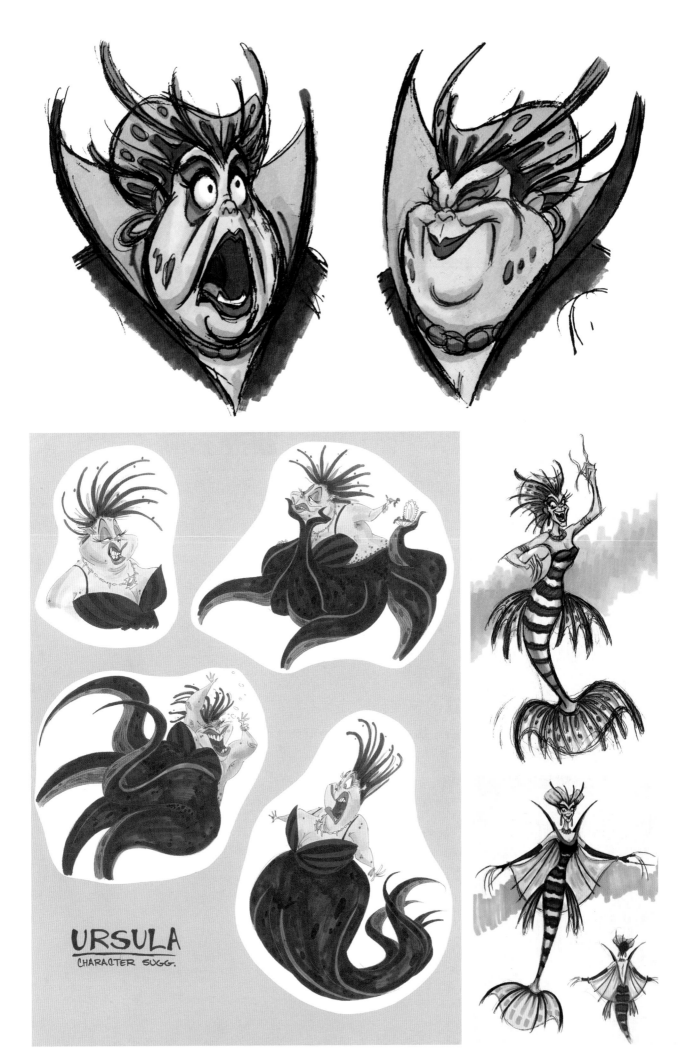

URSULA
CHARACTER SUGG.

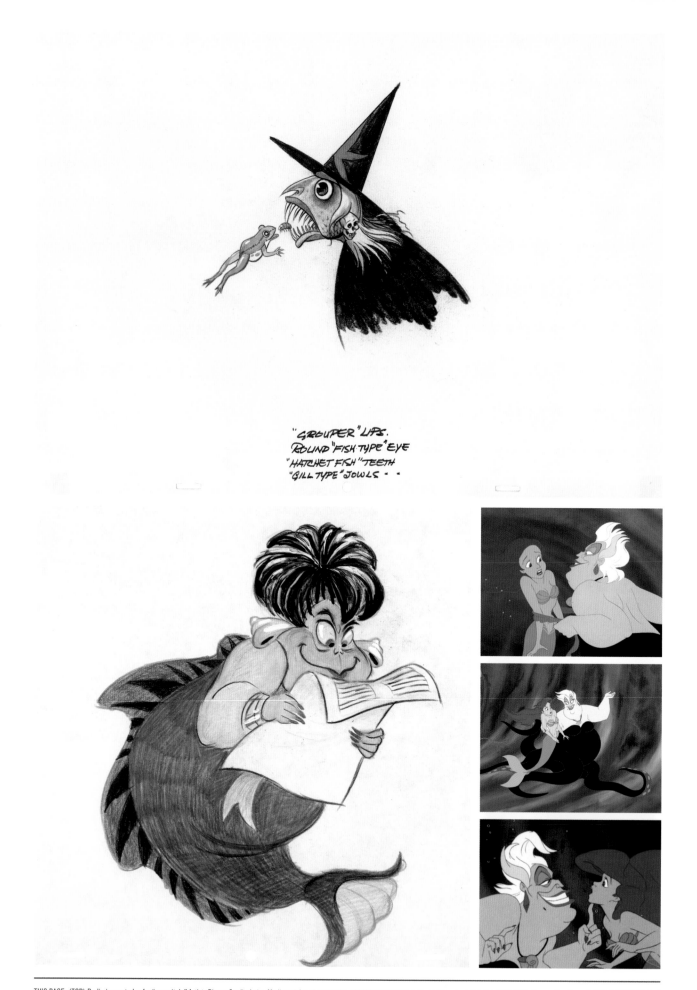

"GROUPER" LIPS.
ROUND "FISH TYPE" EYE
"HATCHET FISH" TEETH
"GILL TYPE" JOWLS · ·

THIS PAGE: (TOP) Preliminary study of a "sea witch." Artist: Disney Studio Artist. Medium: ink and watercolor. (BOTTOM LEFT) Concept art of Ursula. Artist: Rob Minkoff. Medium: colored pencil. (RIGHT COLUMN) Final frames of Ursula and Ariel. OPPOSITE: (TOP) Concept art of Ursula. Artist: Glen Keane. Medium: ink and watercolor. (SIDEBAR) Pat Carroll gives Ursula her larger-than-life voice.

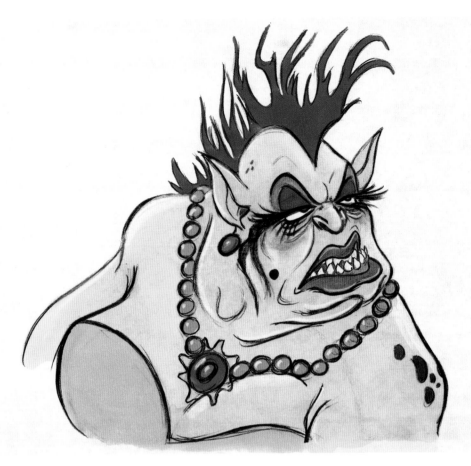

# Lady Sings the Blues . . . with a Little Help from Her Friends

Ursula's "Poor Unfortunate Souls" was ranked by the *Entertainment Weekly* staff in 2014 as "not just the best song in *The Little Mermaid*—[but] it may be the best villain anthem in Disney history, period. (Well, at least the best anthem sung *by* the villain; 'Cruella De Vil' is pretty tough to beat.)"

Before Pat Carroll got her chance to perform the song, Howard Ashman performed the song for her. Carroll recounted the meeting later in an interview in the book *Makin' Toons*: "I said, 'I got you, Howard. I know exactly what you want.' He gave me that performance! Come on, I'm honest enough to say that I got the whole attitude from him . . . and his shoulders would twitch in a certain way, and his eyes would go a certain way . . . I got more about the character from Howard singing that song than from anything else." Ashman's version of this song, maybe not this specific version, along with others can be heard on *Walt Disney Records The Legacy Collection: The Little Mermaid* (available on two CDs).

# Jafar

## *ALADDIN*

**RELEASE DATE:** November 25, 1992

**DIRECTORS:** Ron Clements, John Musker

**VOICE TALENT:** Jonathan Freeman

**ANIMATOR:** Andreas Deja

Roy E. Disney once said, "We're right back to Mr. Evil himself in *Aladdin*, you know. Jafar is just pure evil. He wants to take over the kingdom and kill everyone in sight or enslave them, or whatever suits his fancy." Jafar *is* pure evil! (That is, if evil wore a long cape and loved snakes and tolerated pet parrots.) Jafar is out to find his "diamond in the rough," so he can find the real jewel of the desert: a genie's magic lamp. Unfortunately, Jafar's desire to reign over Aladdin, the kingdom, the universe (!) will blind him to everything that comes with all of that power and magic: "phenomenal cosmic powers . . . itty-bitty living space."

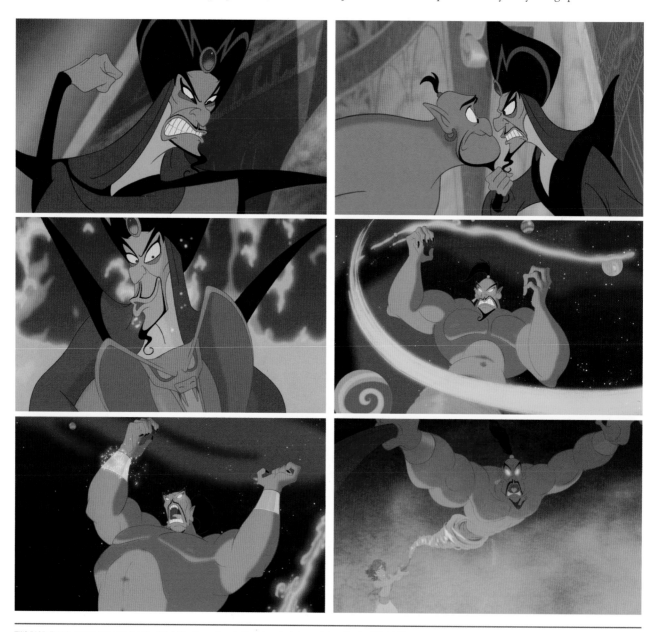

THIS PAGE: Final frames of Jafar depicting his original vizier form and eventual transformation into a genie from *Aladdin*, 1992. OPPOSITE: (FUN FACT, LEFT) Jonathan Freeman, the voice of Jafar from *Aladdin*. (FUN FACT, RIGHT) Pat Carroll, the voice of Ursula from *The Little Mermaid*, 1989, recording the sea witch's sinister and sassy lines.

# For the Birds!

Who doesn't need a companion who can also fly and check out the scene? Goodness knows these villains would not get very far in their evil plans without these winged companions to get the bird's-eye view of the situation at hand.

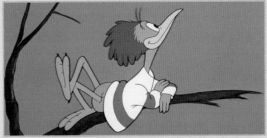

### Aracuan Bird

Companion: flies solo (*Melody Time, The Three Caballeros*)

This bothersome birdie shows up not once, but three times to pester Donald Duck in the package feature films *The Three Caballeros* (1945) and *Melody Time* (1948), as well as the short *Clown of the Jungle* (1947).

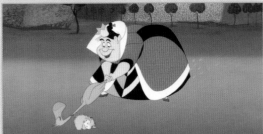

### Flamingos

Companion: Queen of Hearts (*Alice in Wonderland*)

All is fair in love and croquet? Not really, when the flamingo mallets are the Queen of Hearts' obedient subjects.

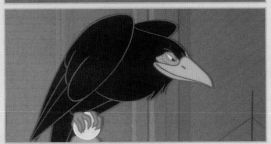

### Raven

Companion: Maleficent (*Sleeping Beauty*)

Maleficent's raven is always there by her side, whether she's at home at her castle, out for a walk, or cursing an infant princess at her christening.

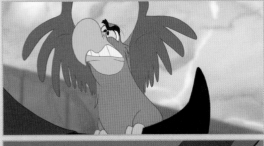

### Iago

Companion: Jafar (*Aladdin*)

This wisecrackin' parrot is looking for more than a cracker. He wants to help Jafar in his evil plans to take over the kingdom.

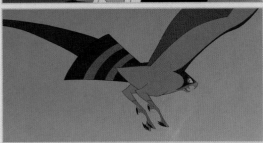

### Falcon

Companion: Shan-Yu (*Mulan*)

When Shan-Yu needs a scout to find his enemies or potential next victims, he can always count on his trusty feathered friend to fly ahead and lead the way.

# FUN FACT

Jonathan Freeman, who was the voice of Jafar from *Aladdin*, and Pat Carroll, who was the voice of Ursula in *The Little Mermaid*, were both judges of a costume contest at a Disney Villains convention in 1997.

# Hades

## *HERCULES*

**RELEASE DATE:** June 27, 1997

**DIRECTORS:** Ron Clements, John Musker

**VOICE TALENT:** James Woods

**ANIMATOR:** Nik Ranieri

Jack Nicholson and John Lithgow were both considered for the role of Hades, but James Woods was the actor finally chosen to voice the role. Instead of treating the character like a serious, menacing God of the Underworld, Woods went more with the sarcastic and somewhat sadistic car-salesman approach. In an article from the *Spartanburg Herald Journal*,

Woods said Hades was inspired by a group of friends he had growing up in Rhode Island: "I grew up with these guys who were slick. 'Hey, hey, how ya doin'?' petty gangsters. They would consider Hades an homage." That fresh take on the character was what impressed the people at Woods's audition and got him the role of Hades.

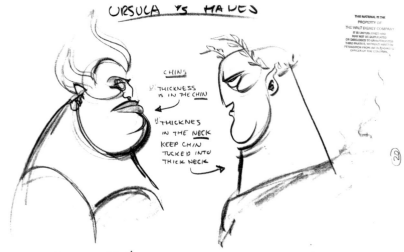

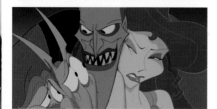

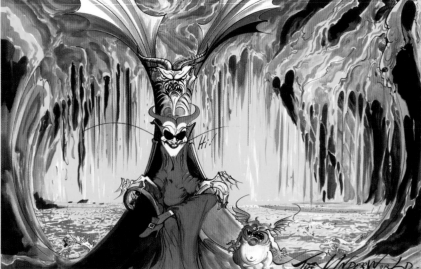

THIS PAGE: (TOP LEFT) Concept study of Ursula from *The Little Mermaid*, 1989, vs. Hades. Artist: Disney Studio Artist. Medium: black line. (BOTTOM LEFT) Concept art of Jack Nicholson as Hades, from when Nicholson was being considered for the role. Artist: Gerald Scarfe. Medium: ink and marker. (TOP RIGHT) James Woods bringing his unique approach to the Lord of the Underworld. (BOTTOM RIGHT) Final frames of Hades from *Hercules*, 1997.

# Home Sweet Home: Villain Abodes

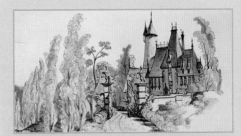

### Lady Tremaine's château

While there is only a brief glimpse of Lady Tremaine and Cinderella's home from the outside, audiences get to be quite well acquainted with the inside as they watch Cinderella clean it from top to bottom, or taking plates of food balanced on her head up the grand staircase. Just like Lady Tremaine, the château looks beautiful and put together, but it lacks the warmth and comfort that a home should have.

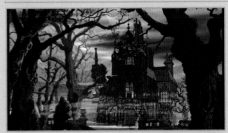

### Cruella De Vil's Hell Hall

"Colonel, Colonel Sir, I just remembered. Two nights past, I heard puppy barking over at Hell Hall," Sergeant Tibs reports. Cruella De Vil's secret hiding place for the puppies is not as secret as she thinks. The run-down mansion looks just as dark and sinister as the woman who barks orders for her fancy Dalmatian puppy coats to be made "TONIGHT!" Is it a coincidence that Cruella's last name is De Vil (looking a lot like "devil") and that she is at a place called Hell Hall? Hmmm . . .

### Madam Mim's cottage

Arthur has no idea who he has dropped in on when he falls through Madam Mim's filthy chimney and into a cottage that resembles a witch's hat. Seems like an appropriate dwelling for a wacky witch living alone. The dark and dingy little home covered in dirt and cobwebs is also the perfect place for a woman who claims to hate sunshine: "Horrible wholesome sunshine!!!"

### Ursula's ocean home

Home is where the heart is! Or, in the case of Ursula's underwater fish skeleton den, home is where the lost souls with broken hearts are. In fact, the entryway to the heart of the cave is littered with moaning and sad lost souls who "could not pay the toll" reaching out to warn Ariel as she swims past, soon putting her own soul on the line in the name of love.

### Al's Toy Barn

Al McWhiggin has a subdued blue-and-gray apartment, but what is the fun in showcasing his actual home when he owns a toy store? One would think the owner of this toy emporium, especially one with shelves stocked with so many different items (including Buzz Lightyear's intergalactic nemesis, Zurg) that our heroes require help from Tour Guide Barbie to find their way around, would be a fun-loving guy. But as everyone knows, Al McWhiggin is not a good guy. Production designer Jim Pearson and his team designed all of the toys and games at Al's Toy Barn.

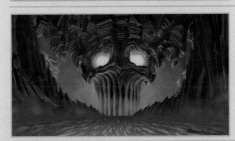

### Hades and the Underworld

Of course the Underworld is going to be dark and foreboding with a giant skull entrance. It is the Underworld after all! Hades is not going to be living in a sunny field of flowers (or really in light of any kind, unless you count the low glow that comes from the luminous souls trapped there for all time). And it requires a slow boat ride over the River Styx manned by a skeleton boat master. This is no Disney cruise!

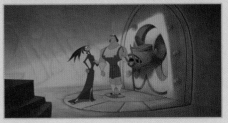

### Yzma's Secret Lab

"Pull the lever, Kronk. Wrong *leverrrrr*!" yells Yzma. Hidden below Kuzco's giant golden ornate palace lies Yzma's secret lab where she concocts all her many potions in an Incan-inspired pink-and-purple chemistry set that any scientist would envy. With a quick trip through several doors and a roller-coaster–like chute, Yzma and Kronk are transported to the lab—complete with an unseen costume change into lab coats and goggles. Take that, Mr. Wizard!

# Yzma

## THE EMPEROR'S NEW GROOVE

**RELEASE DATE:** December 15, 2000

**DIRECTOR:** Mark Dindal

**VOICE TALENT:** Eartha Kitt

**ANIMATOR:** Dale Baer (supervising animator)

Yzma is a vibrant, excitable, angry villain who is hard not to admire just a little. Dale Baer, the supervising animator of Yzma, had this to say of actress Eartha Kitt: "Well, you just start watching her face, and you just start seeing Eartha's face and the expression she gets into, and you hope you can capture some of that." Kitt seems to love her character as much as the animators loved her voicing the role. "I adore her because she goes after what she wants," Kitt said on the DVD extra.

And that she does! On her journey to poisoning Kuzco, the eighteen-year-old spoiled emperor, there is a slight mishap, and instead of killing him, she turns him into a llama. Yet another spoiled, selfish ruler to make a strange transformation thanks to an old witch. Yzma will end up making a transition herself at the end of the movie: she is turned into a cat by one of her own potions, a nod to Kitt's days as Catwoman (from TV's *Batman*) . . . maybe.

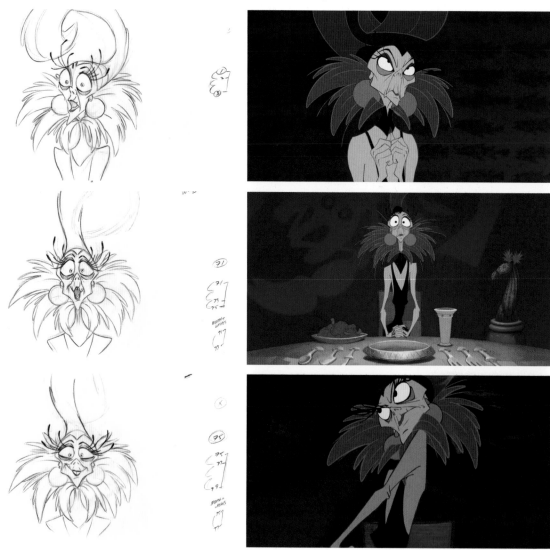

THIS PAGE: (LEFT COLUMN) Cleanup animation of Yzma. Artist: Dale Baer. Medium: graphite, colored pencil. (RIGHT COLUMN) Final frames of Yzma from *The Emperor's New Groove*, 2000.

# Dr. Facilier

## THE PRINCESS AND THE FROG

**RELEASE DATE:** December 11, 2009

**DIRECTORS:** Ron Clements, John Musker

**VOICE TALENT:** Keith David

**ANIMATOR:** Bruce W. Smith (supervising animator)

Bruce W. Smith, the animator of Dr. Facilier, the voodoo villain in *The Princess and the Frog*, said that it was the subtle things that actor Keith David brought to the character that he used to really bring people in. Dr. Facilier is commonly known as "Shadow Man." In fact, Dr. Facilier is the only character in the movie to refer to himself as Dr. Facilier; everyone else just calls him the Shadow Man. He is a bokor (or witch doctor), who is looking to rule Louisiana by using his dark magic and help from "his friends on the other side." *The Princess and the Frog* was the first Disney animated film since *Beauty and the Beast* where all of the voice actors also did their own singing, and Keith David brought a sinister sound to his character's song, "Friends on the Other Side." While David does not really look like his character in real life, they both share a gap between their teeth and the same maniacal mannerisms.

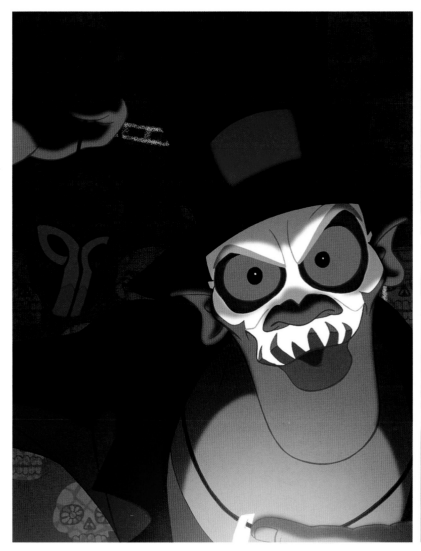

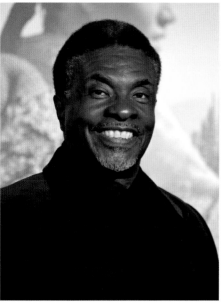

THIS PAGE: (LEFT AND TOP RIGHT) Final frames of Dr. Facilier from *The Princess and the Frog*, 2009. (BOTTOM RIGHT) Keith David brought depth and fun to the role of Dr. Facilier.

# CHAPTER

# LAW AND ORDER

These villains are in a position "to serve and protect," but they are only interested in serving and protecting their own agendas for fortune or control. These characters should be part of the good guys group, but there is always a twist. (Isn't that what audiences love?!) Rules do not apply or are altered to fit the needs of their schemes, and there is no one out there to stop them since they are the authority . . . or is there? In the worlds of Walt Disney Animation and Pixar Animation Studios, it seems that while these corrupt characters exist, justice and good will always prevail in the end—and defeat them.

# District Attorney and the Headless Horseman

## *THE ADVENTURES OF ICHABOD AND MR. TOAD*

**RELEASE DATE:** October 5, 1949

**DIRECTORS:** James Algar, Clyde Geronimi, Jack Kinney

**VOICE TALENT:** John McLeish (as John Ployardt)

**ANIMATORS:** Ollie Johnston, Milt Kahl, Wolfgang "Woolie" Reitherman (directing animators)

There is definitely no order in the court during the case of Mr. Toad and the stolen motorcar. It is the district attorney's job to prove to the jury or the judge that a defendant is guilty without a doubt. They say if you love your job, then you will never work a day in your life. If that's true, the District Attorney must feel like he is on permanent vacation. Animator Ollie Johnston based the District Attorney, who is a cruel, angry man determined to prosecute Mr. Toad for his supposed crimes, on bullies that he knew in school.

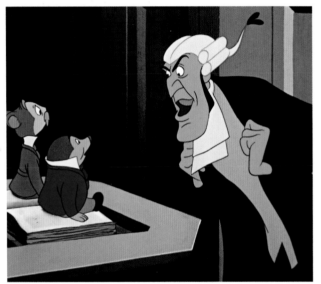

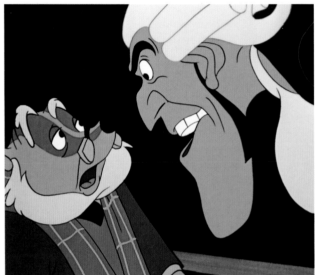

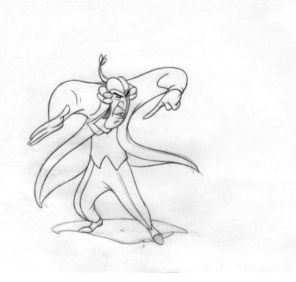

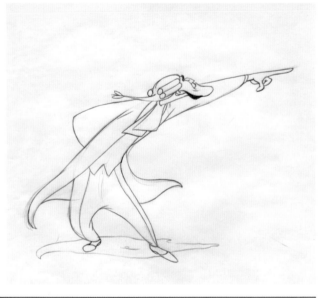

THIS PAGE: (TOP ROW) Final frames showing the District Attorney questioning Mr. Toad's friends from *The Adventures of Ichabod and Mr. Toad*, 1949. (BOTTOM ROW) Cleanup animation drawings of the Prosecutor; also known as the District Attorney. Artist: Ollie Johnston. Medium: graphite, colored pencil. OPPOSITE: (TOP AND CENTER) Final frames of the Headless Horseman. (FUN FACT) Illustration of Washington Irving.

Just a figment of Ichabod's imagination, or is this demon with a detached flaming pumpkin instead of a head the real deal? Ichabod's story was supposed to be a full-length feature prior to World War II. But the cost of making it when Walt Disney was finally able to turn to the project postwar was deemed too high. The studio decided it would be a short film and packaged it with Mr. Toad's tale.

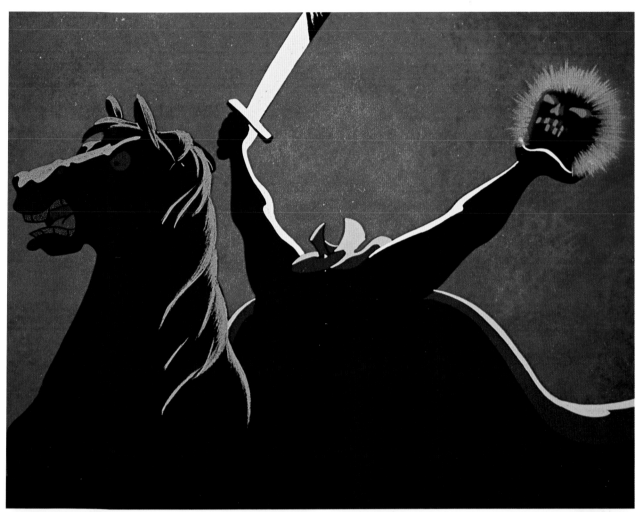

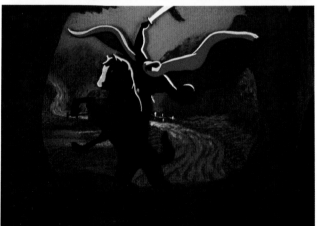

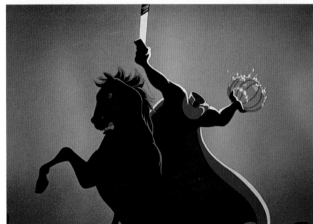

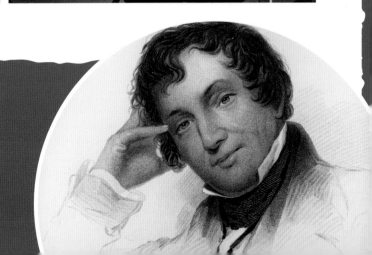

# Sheriff of Nottingham

*ROBIN HOOD*

**RELEASE DATE:** November 8, 1973

**DIRECTOR:** Wolfgang "Woolie" Reitherman

**VOICE TALENT:** Pat Buttram

**ANIMATOR:** Milt Kahl

What do they say about death and taxes? For the peasants in *Robin Hood*, it is certain that the Sheriff of Nottingham will show up and expect them to pay their taxes. A large, intimidating figure who clearly loves his job as tax collector, the Sheriff of Nottingham is feared by almost everyone he comes across as he travels around the English countryside.

Animator Milt Kahl took great care to make sure that the Sheriff of Nottingham's swinging arms and upbeat spring in his step was consistent throughout the film. Kahl stated, "A model sheet was made from the scene [of the Sheriff of Nottingham walking], so that the same walk could be used throughout the picture."

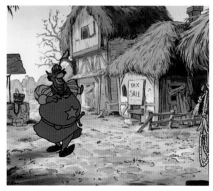
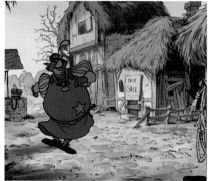
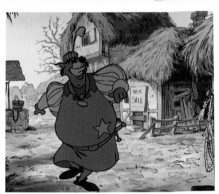

THIS PAGE: (TOP) Cleanup animation drawing of Sheriff of Nottingham from *Robin Hood*, 1973. Artist: John Lounsbery. Medium: graphite, colored pencil. (BOTTOM ROW) Final frames of the Sheriff on his way to collect taxes. OPPOSITE: Cleanup animation drawings of Sheriff of Nottingham from *Robin Hood*, 1973. Artist: John Lounsbery. Medium: graphite, colored pencil.

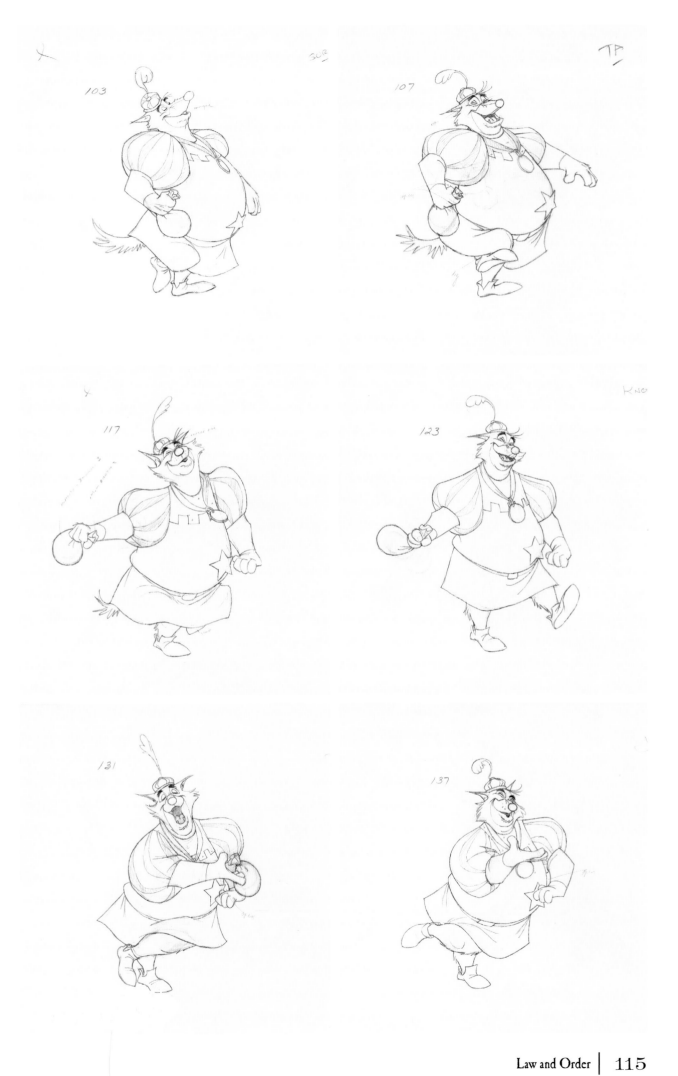

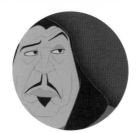

# Governor Ratcliffe

## *POCAHONTAS*

**RELEASE DATE:** June 23, 1995

**DIRECTORS:** Mike Gabriel, Eric Goldberg

**VOICE TALENT:** David Ogden Stiers

**ANIMATOR:** Duncan Marjoribanks

This is one of the few times that the Walt Disney Feature Animation used a real person from history as a villain in one of their movies. John Ratcliffe was one of the original 110 passengers to land at and settle what is now known as Jamestown, Virginia, in 1607. John Smith, Pocahontas's love interest in the movie, along with Ratcliffe were both named by the Virginia Company of London as appointees of a royal council to oversee the newly discovered colony. But enough with the history lesson; in the animated world of *Pocahontas*, Governor Ratcliffe is a gluttonous, self-serving, corrupt politician who is consumed with finding riches in this "new world" like other explorers before him. He is in charge of the colony of Jamestown and uses his power over the people to have them do his exploring for him, while he stays cozy, safe, and work-free. In the end, when he tries to shoot Powhatan, Pocahontas's father, the settlers finally see him for the monster he really is and send him on the first boat back to England. Governor Ratcliffe should be grateful; it is a much better ending than that of his real-life counterpart.

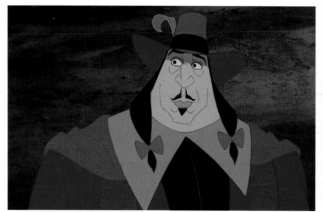 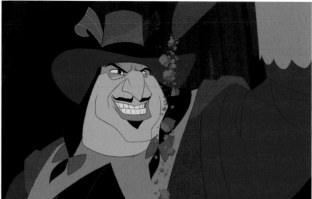

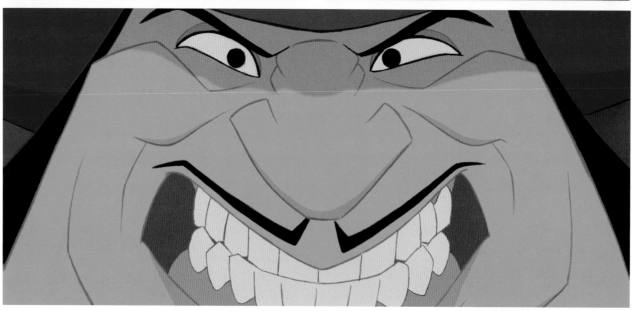

THIS PAGE: Final frames of Governor Ratcliffe from *Pocahontas*, 1995. OPPOSITE: (FUN FACT) David Ogden Stiers in the recording room.

# Disney Villain Pets—Dogs vs. Cats

It is not uncommon for people to have a pet, whether it is a cat, dog, goldfish, or rock. Pets bring comfort when times are tough, or provide companionship when a friend is needed. People love their pets, so it is no surprise that these villains have a furry creature by their side to see them through the exhaustion of plotting their horrible plans or, sometimes, even participate in their schemes.

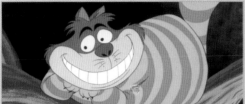

**Lucifer**
Companion: Lady Tremaine (*Cinderella*)
Lucifer really lived up to the name—being almost as evil and hateful as his owner, Lady Tremaine. It does not help his character that when this lazy, spoiled cat does decide to move, it is only to try to catch and eat Cinderella's friends Jaq and Gus.

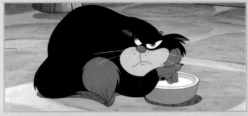

**Cheshire Cat**
Companion: solo (*Alice in Wonderland*)
This kooky pink-and-purple striped cat is his own master. The character's a showboat who likes to disappear, leaving only a large smile and set of footprints behind. Unfortunately for Alice, he also enjoys reappearing and causing her trouble with the Queen of Hearts—resulting in Alice going on trial. Bad cat!

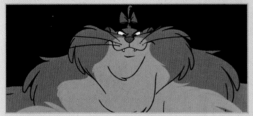

**Felicia**
Companion: Ratigan (*The Great Mouse Detective*)
Just like Pavlov's dog in psychology circles, this enormous cat comes to find her dinner every time she hears Ratigan ring the bell. It is unusual for a rat to have a cat as a pet, but she is Ratigan's one-cat cleanup crew, eating his enemies. Hopefully, Felicia never turns on her owner and bites (or *eats*) the hand that feeds her.

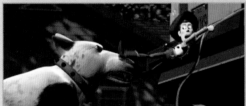

**Scud**
Companion: Sid Phillips (*Toy Story*)
Here is a dog that truly lives up to his name, Scud, a type of military missile that causes major destruction. Sid has found his perfect partner in crime against the toys of the world in Scud, who loves to destroy them as much as his owner.

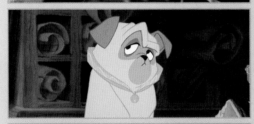

**Percy**
Companion: Governor Ratcliffe (*Pocahontas*)
This little pup starts out a tried-and-true friend to Governor Ratcliffe, and they seem to love all the same things: good food, fine things, lying about while others do the work. It seems as though this is a match made in heaven, but all good things must come to an end, and Percy finds redemption with the help of some new friends, Meeko and Grandmother Willow.

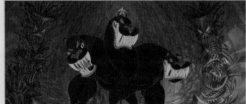

**Cerberus**
Companion: Hades (*Hercules*)
They say a dog is a man's best friend. Does that mean that Cerberus, with three heads, is three times the friend? Hades would probably say no, since all it took was a single steak from Hercules to tame the beast.

# FUN FACT

Actor David Ogden Stiers voiced Governor Ratcliffe's right-hand man, Wiggins, as well.

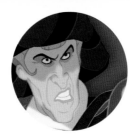

# Minister of Justice Frollo

*THE HUNCHBACK OF NOTRE DAME*

**RELEASE DATE:** June 21, 1996

**DIRECTORS:** Gary Trousdale, Kirk Wise

**VOICE TALENT:** Tony Jay

**ANIMATOR:** Kathy Zielinski

Supervising animator Kathy Zielinski "loves her character" Minister of Justice Frollo. "He's the best villain I have ever worked on. I am just so tickled to be doing such an evil person." Evil is right! Audiences are first introduced to Frollo as he hunts down a family of gypsies, a group he blindly hates. He imprisons the father, plays a part in the mother's death on the famous church's steps, and then attempts to throw their baby down the well until the Archdeacon cries out for him to stop.

Frollo tries to sway the Archdeacon: "This is an unholy demon. I'm sending it back to hell where it belongs. . . . I'm guiltless. She ran. I pursued. My conscience is clear." In the end, the Archdeacon stops Frollo, and Quasimodo is saved. In Victor Hugo's book *Notre-Dame de Paris*, which the movie is based on, Frollo is the Archdeacon. Good thing the story folks made that change! Frollo definitely would not have stopped himself from throwing that baby down a well.

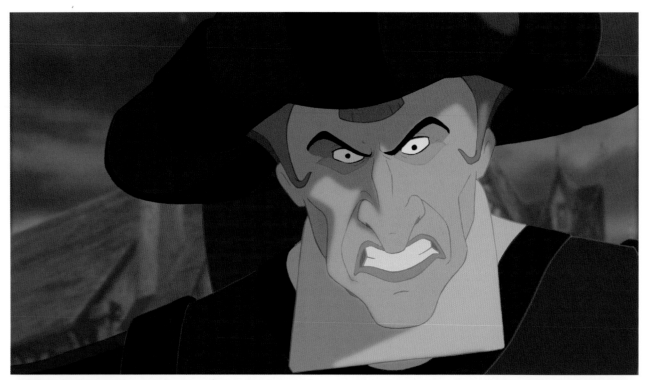

THIS PAGE: Final frames of Frollo from *The Hunchback of Notre Dame*, 1996.

# Put a Ring on It

Disney villains love their jewels, whether it be Jafar's snake brooch to keep his turban in place or Madame Medusa's two-toned green earrings to really bring out the crazy in her green eyes. Here are a few of our favorite dark souls who are embracing their inner Liberace and flashing those fancy-finger accessories.

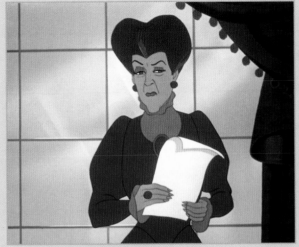

Lady Tremaine—*Cinderella*

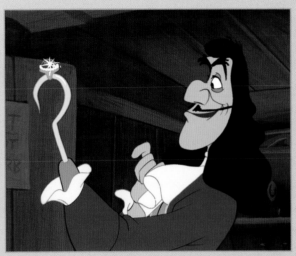

Captain Hook—*Peter Pan*

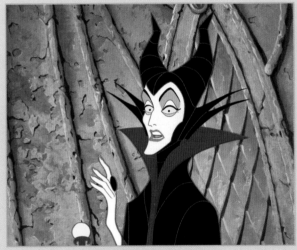

Maleficent—*Sleeping Beauty*

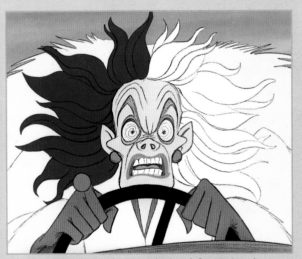

Cruella De Vil—*One Hundred and One Dalmatians*

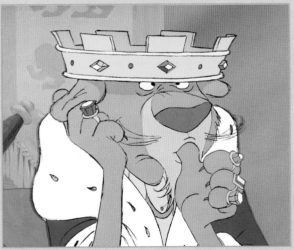

Prince John—*Robin Hood*

Minister of Justice Frollo—*The Hunchback of Notre Dame*

# Hopper

## *A BUG'S LIFE*

**RELEASE DATE:** November 25, 1998

**DIRECTORS:** John Lasseter, Andrew Stanton

**VOICE TALENT:** Kevin Spacey

**ANIMATORS:** Glenn McQueen, Rich Quade (supervising animators)

"It's a bug-eat-bug world out there, princess. One of those 'circle of life' kind of things. Now let me tell you how things are supposed to work: the sun grows the food, the ants pick the food, the grasshoppers eat the food," Hopper expounds—prompting Molt, Hopper's not-as-intelligent brother, to further explain, "And the birds eat the grasshoppers." Yes, yes they do, Molt. Much like Captain Hook has his crocodile, Hopper has his blue jays. Hopper is too focused on making sure there is not an ant revolt and on destroying Flik, the Cesar Chavez of the ants, to notice the blue jay waiting to bring home her babies' next meal.

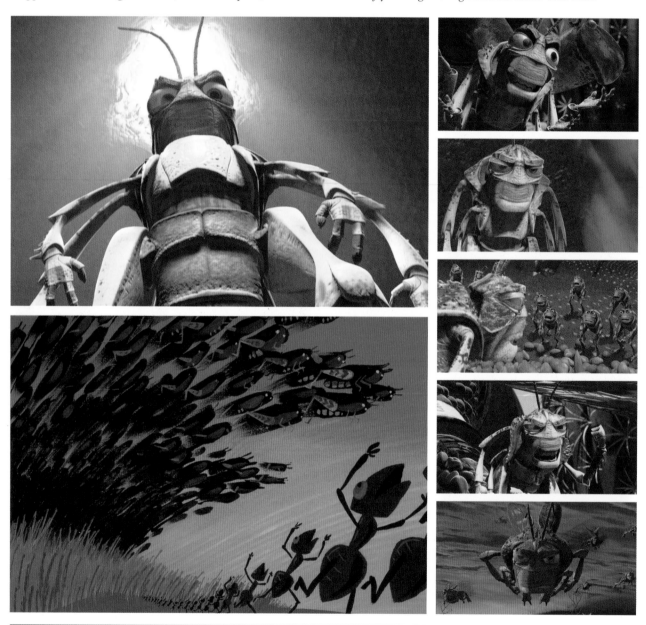

THIS PAGE: (TOP LEFT AND RIGHT COLUMN) Final frames of Hopper from *a bug's life*, 1998. (BOTTOM LEFT) Preliminary study of the grasshoppers attacking the ant colony. Artist: Geefwee Boedoe. Medium: acrylic.

# Rourke, Helga

*ATLANTIS: THE LOST EMPIRE*

**RELEASE DATE:** June 15, 2001

**DIRECTORS:** Gary Trousdale, Kirk Wise

**VOICE TALENT:** James Garner (Rourke), Claudia Christian (Helga)

**ANIMATORS:** Michael Surrey (Rourke), Yoshimichi Tamura (Helga)

Actor James Garner is no stranger to the action-adventure drama, starring in over thirty action or western movies prior to voicing the character of Rourke; it is why the Walt Disney Feature Animation team was so excited to cast Garner in the role of the ex-military commander who's returned to oversee the journey to Atlantis. He was a perfect fit for the hard-nosed commanding officer, who, unknown to Milo or the audience, has a secret agenda to find a hidden giant crystal. After accepting the role in *Atlantis*, Garner said in an interview with Bonnie Churchill from the Entertainment News Service that "It takes a minimum of work just supplying the voice for a character. Disney tells me it will take several years to complete the process of wedding the voices to the artwork. When I recorded the dialogue, they said they'd call me back in eighteen months to do some more. I said,

'Eighteen months? Can you speed things up? At my age, I don't even buy green bananas!'"

According to Don Hahn, and the two directors of the movie, Gary Trousdale and Kirk Wise, Helga's originally intended introduction was not at all what audiences saw in the theaters. In the film's planning stages, she was supposed to have come upon Milo—who's picking up his papers after they had fallen onto the street—while in a black car of the early 1900s. The audience catches a glimpse of fishnet stockings, and then out of a cloud of cigarette smoke, a blonde looking more like she belongs on the set of *Casablanca* appears. The only real similarity between this character (who was later scrapped) and the tough-as-nails lieutenant who is Commander Rourke's second-in-command and enforcer is the blonde hair.

THIS PAGE: (LEFT) Concept art of Rourke. Artist: Disney Studio Artist. Medium: marker and ink. (CENTER AND RIGHT) Concept art of Helga. Artist: Jean Gillmore. Medium: ink and marker.

# CHAPTER

# BASIC INSTINCTS

We are who we are . . . at least that is the motto for this group of villains. Sometimes it is just in one's nature to be a little bit naughty, and the horrible situations that arise cannot be helped. Whether acting out of the need for a meal—even if it happens to be one consisting of an innocent puppet and his family—or just looking to win the girl of their dreams, these "creatures" cannot be blamed for doing what just comes natural to them.

THIS PAGE: Concept art of Dr. Jumbaa Jookiba from *Lilo & Stitch*, 2002. Artist: Disney Studio Artist. Medium: graphite. OPPOSITE: Final frame of Monstro from *Pinocchio*, 1940.

# Giant

## *BRAVE LITTLE TAILOR*

**RELEASE DATE:** September 23, 1938

**DIRECTOR:** Bill Roberts

**VOICE TALENT:** Eddie Holden

**ANIMATOR:** Vladimir "Bill" Tytla

"I killed seven with one blow!" Be careful how you use your words, Mickey Mouse! Now the king believes he has a giant killer in his midst and assigns Mickey to sew up the problem and dispense with a giant terrorizing their land. (Of course, the fact that the hand of Princess Minnie is on the line also helps Mickey rally to become the "Brave Little Tailor.") The killer in question is actually a simple giant only looking for a place to sit and have a snack (and a smoke). The quick tailor thankfully assesses the situation accurately and then uses his tools to help him capture and tie up the giant, who's shown sleeping comfortably when the short comes to a close. While this was not the first Walt Disney Animation Studios giant to make it to the screen, in the opinion of animators Frank Thomas and Ollie Johnston, "This [giant] became the model for all other giants throughout the industry, from gags to personality, even though no one else could create ones that compared to Bill's animation."

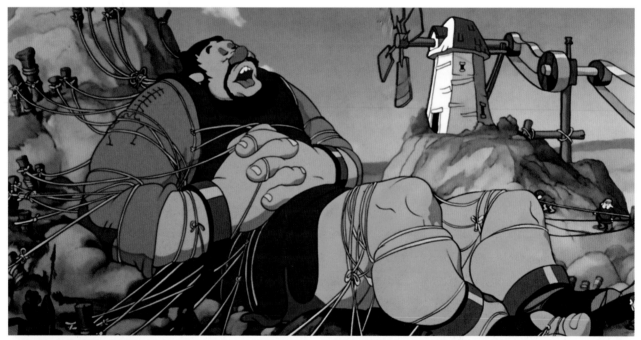

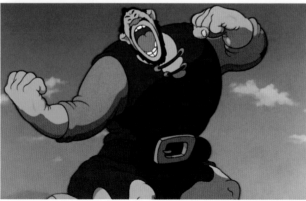

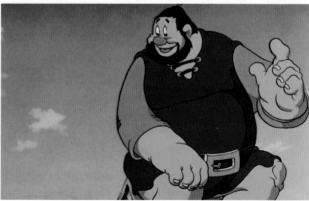

THIS PAGE: Final frames of the giant from *Brave Little Tailor*, 1938.

# Monstro

## *PINOCCHIO*

**RELEASE DATE:** February 23, 1940

**DIRECTORS:** Ben Sharpsteen, Hamilton Luske

**VOICE TALENT:** No voice

**ANIMATOR:** Vladimir "Bill" Tytla

What a big eye you have. . . . When a school of unsuspecting tuna swims up and Monstro's eye pops open, the audience is given a sense of scale and the heft of this giant sperm whale. Animators worked hard to add to the intensity of the Monstro character and Pinocchio's desperation to flee him by carefully creating a violent and threatening ocean under Walt Disney's instructions. "Pinocchio should use every ounce of force he has in his swimming to escape the whale," Walt once said. "This should build terrible suspense. It should be the equivalent of the storm and chase of the Queen [as the witch] in *Snow White [and the Seven Dwarfs]*."

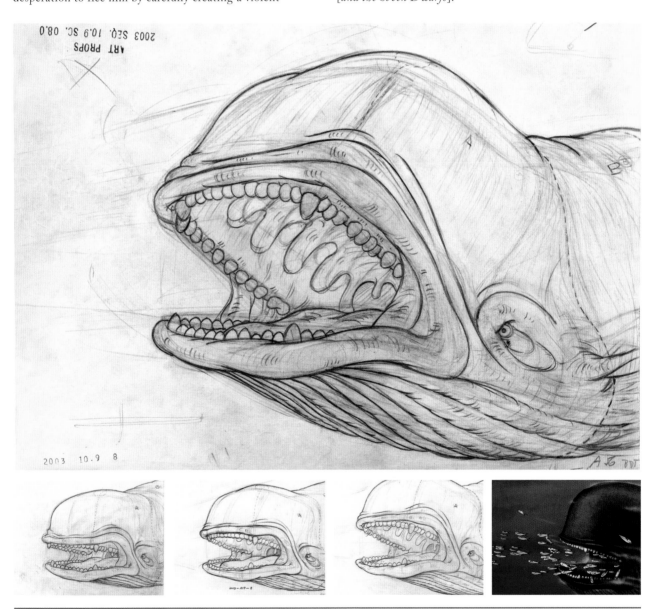

THIS PAGE: (TOP AND BOTTOM LEFT SEQUENCE) Cleanup animation drawings. Artist: Vladimir "Bill" Tytla. Medium: graphite, colored pencil. (BOTTOM RIGHT) Final frame of Monstro from *Pinocchio*, 1940.

# Man

*BAMBI*

**RELEASE DATE:** August 13, 1942

**DIRECTOR:** David Hand (supervising director)

**VOICE TALENT:** No voice

**ANIMATORS:** Ollie Johnston, Frank Thomas (supervising animators)

One of the most well-known and memorable deaths in film history is attributed to the villain from *Bambi* . . . Man. Unlike other villains, viewers never set eyes on this villain; they just hear the clear shots of his gun, the rush of the snow while Bambi and his mother try to flee to safety, and the crackling snap of the flames as the woodland creatures scurry from their homes. Man is not maliciously trying to harm the creatures of the forest and is unaware of the destruction and heartbreak he causes. Even though Man is the unintentional villain, he was still bad enough to make No. 20 on the American Film Institute's top-fifty villains list. There are only two other Disney villains on that list, which includes villain "heavies" like Dr. Hannibal Lecter (*The Silence of the Lambs*), Norman Bates (*Psycho*), and Darth Vader (Star Wars series): the Queen from *Snow White and the Seven Dwarfs* (at No. 10) and Cruella De Vil from *One Hundred and One Dalmatians* (at No. 39).

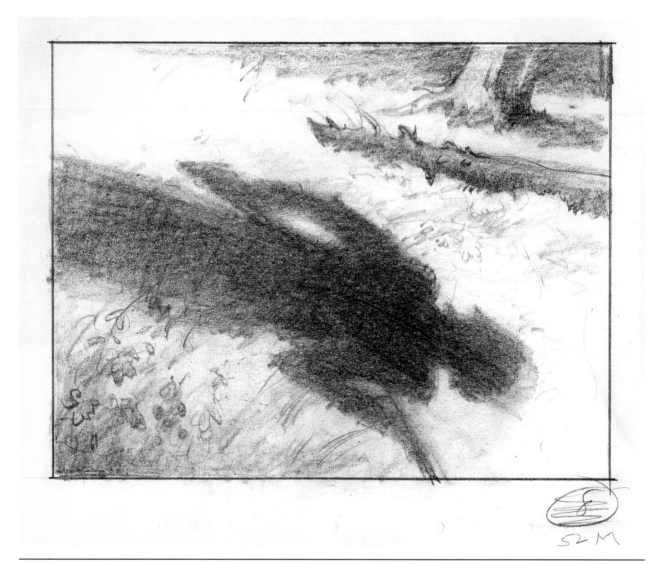

THIS PAGE: Concept art of Man from *Bambi*, 1942. Artist: Disney Studio Artist. Medium: graphite.

# The Wolf

**RELEASE DATE:** April 15, 1946

**DIRECTORS:** Jack Kinney, Clyde Geronimi, Hamilton Luske, Robert Cormack, Joshua Meador

**VOICE TALENT:** Sterling Price Holloway, Jr. (narrator)

**ANIMATORS:** John Lounsbery, Ollie Johnston

Oh Peter . . . you should have listened to your grandfather. There are wolves in the forest! Originally intended as a segment within a second *Fantasia* film, "Peter and the Wolf" features a wolf with razor-sharp claws, menacing yellow eyes, and salivating mouthful of teeth. Represented by dark bellowing French horns, this mean ol' creature is certainly not the wolf of Peter's heroic fantasies.

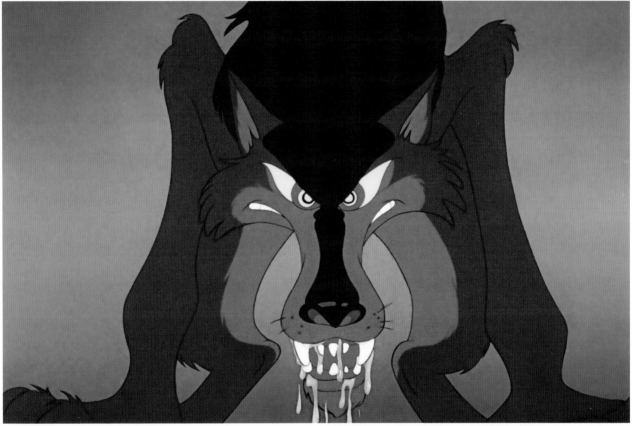

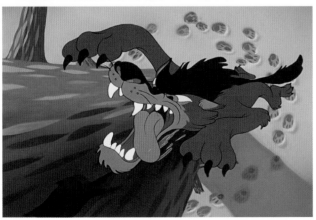

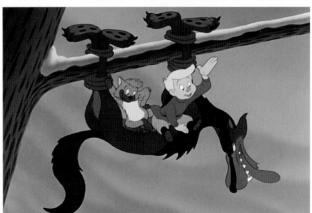

THIS PAGE: Final frames of the Wolf from *Make Mine Music,* "Peter and the Wolf," 1946.

# Brom Bones

## *THE ADVENTURES OF ICHABOD AND MR. TOAD*

**RELEASE DATE:** October 5, 1949

**DIRECTORS:** James Algar, Clyde Geronimi, Jack Kinney

**VOICE TALENT:** Bing Crosby

**ANIMATORS:** Ollie Johnston, Milt Kahl, Ward Kimball (directing animators)

Ichabod Crane and Brom Bones both wish to win the affections of the lovely "little coquette" Katrina van Tassel, and Brom will use everything he's got to best Ichabod. Brom takes full advantage of the young schoolmaster's propensity to be completely consumed by fear and superstition with the song, "The Headless Horseman," sung by beloved singer Bing Crosby. Crosby made the recording of the song a family affair, inviting his four sons (Gary, twins Phillip and Dennis, and Lindsay) to join him in the recording studio.

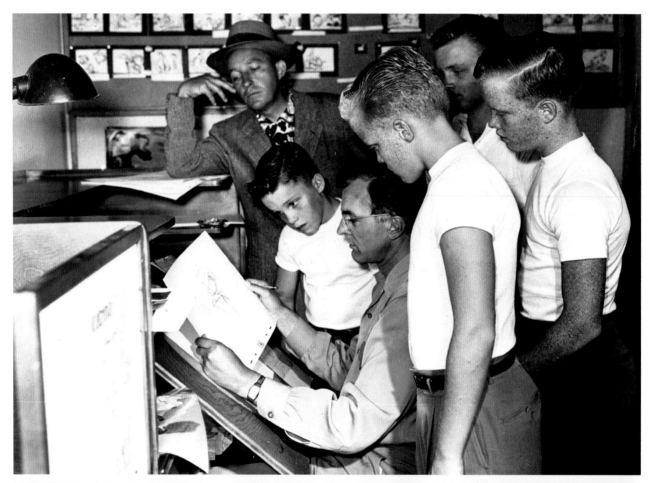

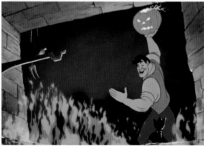 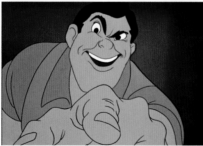 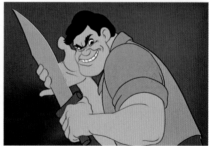

THIS PAGE: (TOP) Bing Crosby and his sons—Dennis, Phillip, Gary, and Lindsay—take a look at what Milt Kahl is working on at the drawing table. (BOTTOM ROW) Final frames of Brom Bones from *The Adventures of Ichabod and Mr. Toad*, 1949.

# Bear

*THE FOX AND THE HOUND*

**RELEASE DATE:** July 10, 1981

**DIRECTORS:** Art Stevens, Ted Berman, Richard Rich

**VOICE TALENT:** No voice

**ANIMATOR:** Glen Keane

The Bear is also a villain, of sorts, in *The Fox and the Hound*. Though unlike the other animal creatures in this movie, the Bear seems to be pure animal and acts on those instincts. Glen Keane was the animator who worked on the scenes with the Bear, creating an emotional and exciting climax to the movie. Like most animators, Keane used live-action footage and ball-and-socket models to capture motion; he also kept a scale model of the Bear's head on his easel as he worked on the fight scenes involving the animal.

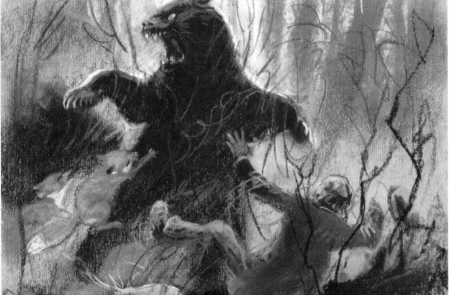

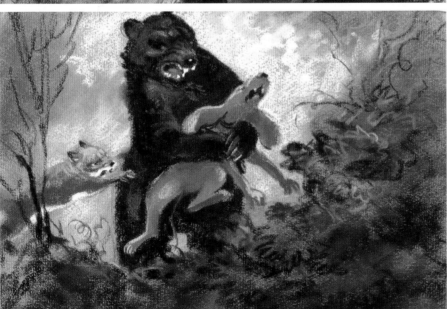

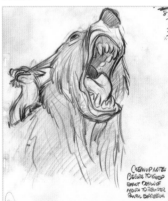

THIS PAGE: (LEFT COLUMN) Concept art of the Bear and Todd—with Vixie, Amos Slade, and Copper—from *The Fox and the Hound*, 1981. Artist: Mel Shaw. Medium: pastel. (RIGHT COLUMN) Rough animation of the Bear with Todd. Artist: Glen Keane. Medium: graphite and charcoal.

# Firebird

*FANTASIA/2000,* "FIREBIRD SUITE" (1919 VERSION)

**RELEASE DATE:** January 1, 2000

**DIRECTORS:** Gaëtan Brizzi, Paul Brizzi

**MUSICAL TALENT:** Igor Stravinsky

**ANIMATOR:** John Pomeroy (lead character animator)

They say, "Let sleeping dogs lie." That goes double . . . no, triple . . . for Firebirds. When a friendly sprite brings spring to the land, she unintentionally also wakes the Firebird in a black chrysalis state at the bottom of a volcano. Fiery lava, led by a set of glowing eyes, quickly engulfs the green lush surrounding area (and the sweet sprite) in a wave of bright, burning flames.

Loosely based on the eruption of Mount Saint Helens in 1980, this *Fantasia/2000* suite captures the destruction that can be caused by a disaster of that magnitude in a fanciful yet frightening way. *Fantasia/2000* was a sequel sixty years in the making and became the first Walt Disney Feature Animation animated movie of the millennium, opening on New Year's Day 2000.

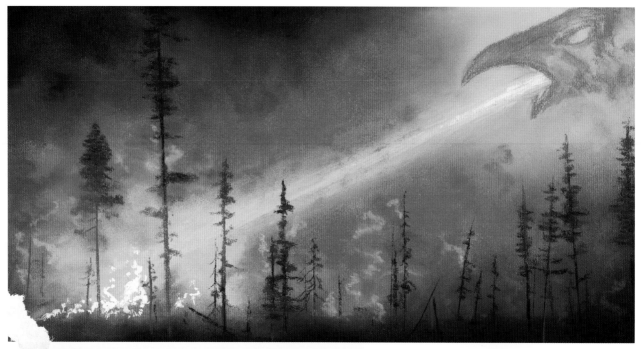

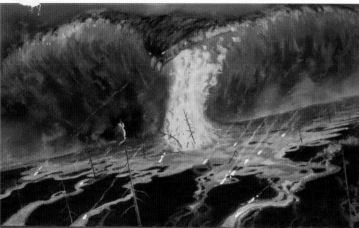

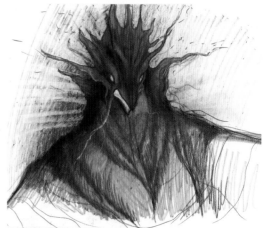

THIS PAGE: Concept art of the Firebird from *Fantasia/2000*, 2000. (TOP AND BOTTOM LEFT) Artist: Kelvin Yasuda. Medium: pastel. (BOTTOM RIGHT) Artists: Paul Brizzi and Gaëtan Brizzi. Medium: pastel.

# Carnotaurs (aka Carnotaurus)

*DINOSAUR*

**RELEASE DATE:** May 19, 2000

**DIRECTORS:** Eric Leighton, Ralph Zondag

**VOICE TALENT:** No voice

**ANIMATORS:** Atsushi Sato (supervising animator); Bobby Beck, Kent Burton, Don Weller, Stephen A. Buckley, Chris Hurtt, Paul Wood

Carnotaurus translates to "meat-eating bull," and the two Carnotaurs (aka Carnotaurus) seem to be hungrier than Hobbits and always on the hunt for their next meal. Crashing out of the trees, to the surprise of a young Parasaurolophus who is playfully chasing a flying lizard, a Carnotaur chases several dinosaurs before finding its first meal of the day in a Pachyrhinosaurus. Disney's artists took these ferocious, horned dinosaurs and made them appear to be as large as a Tyrannosaurus rex, but in reality, these dinosaurs were smaller than the T. rex, with teeth that were seven and a half times smaller and with even smaller and less useful arms. The pair of Carnotaurs was completely computer-generated, along with the rest of the less antagonistic cast, and set in real live-action environments from around the world with a digital effects specialist doing the work of turning day into night.

THIS PAGE: (TOP) Story sketch of the Carnotaur. Artist: Disney Studio Artist. Medium: graphite and conte crayon. (BOTTOM) Final frames of the Carnotaur from *Dinosaur*, 2000.

# Henry J. Waternoose

## *MONSTERS, INC.*

**RELEASE DATE:** November 2, 2001

**DIRECTORS:** Pete Docter; David Silverman, Lee Unkrich (co-directors)

**VOICE TALENT:** James Coburn

**ANIMATORS:** Scott Clark, Doug Sweetland (directing animators); Glenn McQueen, Rich Quade (supervising animators)

"I'll kidnap a thousand children before I let this company die, and I'll silence anyone who gets in my way!" shouts Henry J. Waternoose, the ultimate company man. Mr. Waternoose is just looking for a way to keep his company in the black as the human-world media desensitizes children and makes them harder to scare—which is not good for business. Mr. Waternoose is a large, five-eyed gray monster with six crablike legs, dressed for success in his bow tie, vest, and coat. He falls prey, like so many villains before and after him, to the desperation of his situation, which turns a completely rational and kind monster who is worried about his company and the creatures he supplies energy to into . . . well . . . a *monster*.

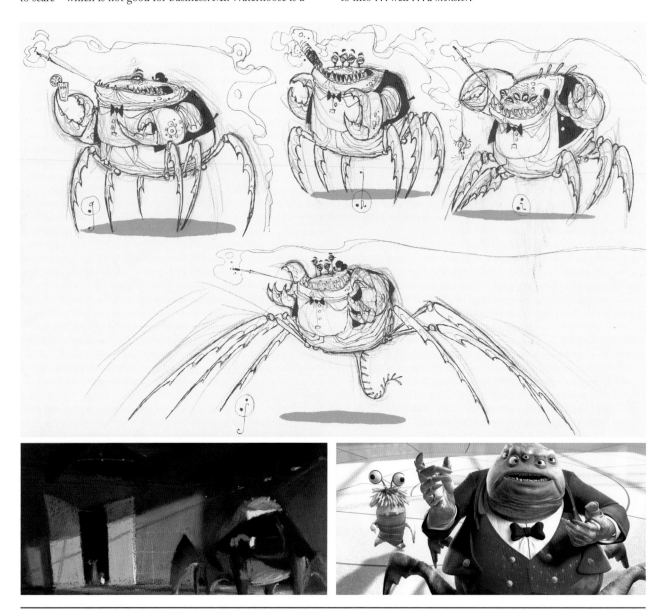

THIS PAGE: (TOP) Concept sketches of Henry J. Waternoose. Artist: Nicolas Marlet. Medium: colored pencil, ink. (BOTTOM LEFT) Concept of Waternoose's office. Artist: Dominique Louis. Medium: pastel. Layout by Harley Jessup. (BOTTOM RIGHT) Final frame of Waternoose from *Monsters, Inc.*, 2001.

# Dr. Jumba Jookiba

## *LILO & STITCH*

**RELEASE DATE:** June 21, 2002

**DIRECTORS:** Dean DeBlois, Chris Sanders

**VOICE TALENT:** David Ogden Stiers

**ANIMATOR:** Bolhem Bouchiba (supervising animator)

Dr. Jumba Jookiba is the evil scientific mind behind Experiment 626 (aka Stitch). Jumba has no scruples and a true passion for science—much like another famous evil scientist who gets lost in his creation (can you say Dr. Frankenstein?). He has been conducting illegal genetic experiments, landing him and his experiment in handcuffs. The only way to regain his freedom is to recapture Stitch, who has escaped to Hawaii. The animation style for the whole movie is based upon "rounded" character sketches. Chris Sanders (one of *Lilo & Stitch*'s creators,

directors, and the voice of Stitch himself) drew the sketches as part of a pitch presentation to studio head Thomas Schumacher. Ric Sluiter, *Lilo & Stitch*'s art director, said, "Everything has a roundness that is puffed up a little bit . . . almost like you could hug the movie without cutting yourself or getting poked by anything. There's a real comforting feel to this." This style is clear, especially the round, heavyset Dr. Jumba Jookiba with his four oval eyes and even, rounded teeth. That being said, who really wants to give this crazed scientist a hug?

 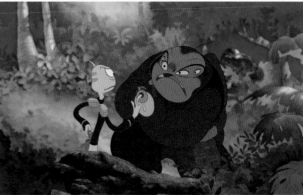

THIS PAGE: (TOP) Story sketch of Jumba. Artist: Disney Studio Artist. Medium: graphite. (BOTTOM ROW) Final frames of Dr. Jumba Jookiba from *Lilo & Stitch*, 2002.

# David Ogden Stiers

David Ogden Stiers is no stranger to voicing various characters for Walt Disney Animation Studios. He has voiced Cogsworth and the narrator from *Beauty and the Beast*, the Archdeacon from *The Hunchback of Notre Dame*, and Fenton Q. Harcourt from *Atlantis: The Lost Empire*, as well as some of our favorite villains: Governor Ratcliffe and Wiggins from *Pocohontas*, plus Dr. Jumba Jookiba from *Lilo & Stitch*. An actor best known for his role as Major Charles Emerson Winchester III in *M\*A\*S\*H*, a 1970s–mid-1980s sitcom about U.S. Army medics serving in the Korean War, Ogden Stiers is a seasoned veteran starring in more than a hundred movies and television shows over the span of his career. In the last forty years, Ogden Stiers has found another role that he seems to love: guest music conductor. He has conducted concerts all across the country. With no formal training, Ogden Stiers compares acting with conducting this way: "The pulse for an actor is kind of like the tempo for a musician. You change the tempo, and you alter the sense of pulse at the heart of the music." He brings all of his experience and talent into every animated role he voices. In the words of his *Lilo & Stitch* costar Kevin McDonald, David Ogden Stiers "is the master."

(TOP) David Ogden Stiers in the recording booth. (BOTTOM ROW) Final frames of Cogsworth from *Beauty and the Beast*, 1991.

# Darla

**RELEASE DATE:** May 30, 2003

**DIRECTORS:** Andrew Stanton; Lee Unkrich (co-director)

**VOICE TALENT:** LuLu Ebeling

**ANIMATORS:** Alan Barillaro, Mark Walsh (directing animators)

TAP . . . TAP . . . TAP: "Find a happy place . . . find a happy place!!!" Peach the starfish chants as Darla Sherman (niece of Nemo's original captor, dentist Dr. Sherman) taps on the glass of the fish tank in her uncle's office. Darla is definitely not a follower of the mantra, "Fish are friends." Or maybe it is just that she loves *too* hard. Unlike Sid Phillips, *Toy Story*'s child villain, Darla is not dark or evil per se; she is just a rambunctious child with no sense of the living things she is handling. Darla's main scene is set in the dentist's office where her uncle chases Nigel, Marlin, and Dory while Darla screams, equipment flies and crashes about, and the fish swim excitedly in the tank—a contrast to the serenity of the elevator music and the mother and son who are calmly waiting for their turn in an adjacent room. When director and cowriter Andrew Stanton and cowriter Bob Peterson would get stuck on working out the specifics of a scene, or another part of the story, they would drive from Pixar Animation Studios in Emeryville, California, to Los Angeles to meet with one of the upcoming movie's stars. During those six-hour drives, they would work out the kinks, or flesh out a great idea, without distraction. While it is unknown if the Darla scene was one of those scenes worked out in the car, it perfectly captures and plays up the fear that most people have of going to the dentist—and makes for one of the movie's most blatant laugh-out-loud moments.

THIS PAGE: (TOP LEFT) Final frame of Darla from *Finding Nemo*, 2003. (BOTTOM LEFT) Preliminary concept sketch of Darla. Artist: Andrew Stanton. Medium: pencil. (RIGHT) Concept of Darla for her photograph in the dentist's office.

# Cy-bugs

## *WRECK-IT RALPH*

**RELEASE DATE:** November 2, 2012

**DIRECTOR:** Rich Moore

**VOICE TALENT:** No voice

**ANIMATOR:** Renato dos Anjos (supervising animator for the *Hero's Duty* segment)

"Doomsday and Armageddon just had a baby, and it is *ugly!*" announces Sergeant Calhoun. These robotic insects blur the lines of what is real and what is just a game due to faulty programming. Attacking in swarms and multiplying faster than rabbits, they would kill everything and everyone in all of the games in the arcade, not just their game, *Hero's Duty*. They say you are what you eat, but that phrase becomes literal with the cy-bugs. With a chameleon-like ability to transform into anything they eat, they can become the weapon being used to fight them or the most frightening cupcake anyone has ever seen.

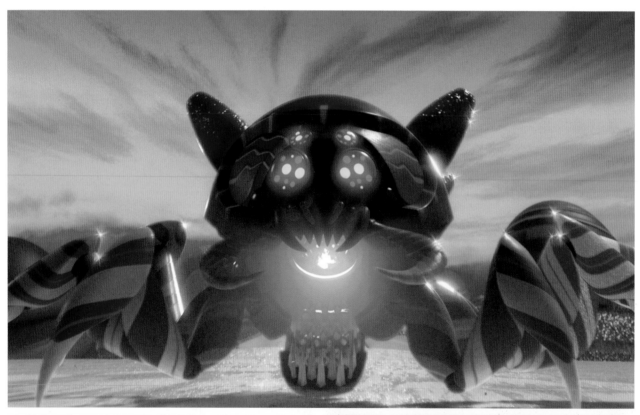

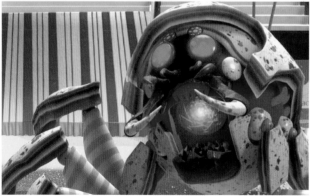

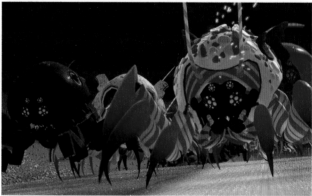

THIS PAGE: Final frames of the cy-bugs from *Wreck-It Ralph*, 2012.

# Raptors

*THE GOOD DINOSAUR*

**RELEASE DATE:** November 25, 2015

**DIRECTOR:** Peter Sohn

**VOICE TALENT:** Dave Boat (Bubbha), John Ratzenberger (Earl), Calum Mackenzie Grant (Pervis), Carrie Paff (Lurleane)

**ANIMATOR:** Matt Nolte (character art director)

This pack of four feathered raptors are determined to get their talons on the T. rexes' herd of longhorns. Comprised of leader Bubbha, who isn't exactly the sharpest pitchfork in the barn, Earl, a less-than-talkative tough guy, Pervis, who makes Bubbha look like the brains of the operation, and Lurleane, whose shenanigans often take center stage, the raptors are not the fiercest individually. But when they're together as a group, they can be quite threatening. Arlo and Spot had better watch out!

THIS PAGE: Velociraptor character studies. Artist: Matt Nolte. Medium: pencil, colored pencil.

## CHAPTER

# JUST PLAIN MEAN

No one likes a meanie, unless they are a moviegoer watching that meanie from the safety of their theater seat. There is no good reason for the following characters to be cruel. They may be working toward a goal, but it's not really a justification for their nasty personalities. Here are the spiteful, cranky characters that seem to have woken up on the wrong side of the bed . . . for their entire lives.

THIS PAGE: Cleanup animation of Madame Medusa from *The Rescuers*, 1977. Artist: Milt Kahl. Medium: graphite, colored pencil. OPPOSITE: Final frame of Percival McLeach from *The Rescuers Down Under*, 1990.

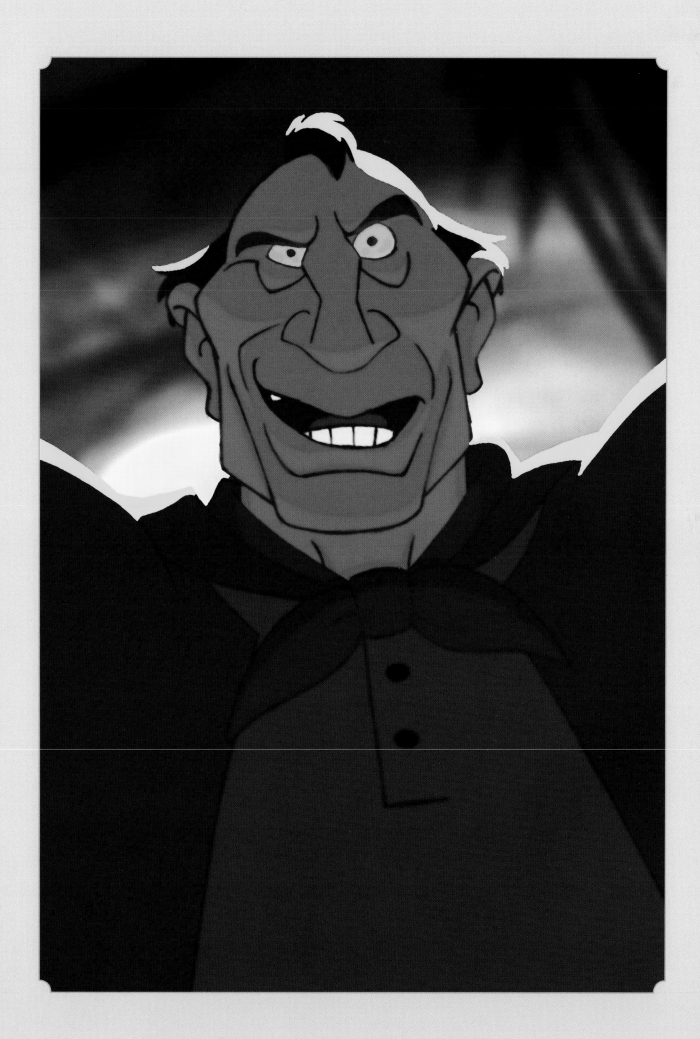

# Pete (aka Peg Leg Pete)

## ALICE COMEDIES SHORTS (1925–1927), OSWALD THE LUCKY RABBIT SHORTS (1927–1928), AND MICKEY MOUSE SHORTS (1928–2013)

**RELEASE DATE (FIRST APPEARANCE):** *Alice Solves the Puzzle*, 1925

**DIRECTORS:** Various

**VOICE TALENT MOST OFTEN USED:** Billy Bletcher, Jim Cummings

**ANIMATORS:** Various

Pete got his evil start in the Alice Comedies series in 1925 with the nickname "Bootleg Pete." He has gone through several incarnations and different victims, but he is a villain that is still included in current shorts with Mickey Mouse, most recently 2013's *Get a Horse!* short that was released with *Frozen*. Not always drawn with a peg leg, but sometimes with two legs or a peg leg on the left instead of the right, Pete is most commonly referred to as Peg Leg Pete. Often animated with a cigar hanging out of his mouth and wearing some sort of hat, he is one of the oldest Walt Disney Animation Studios characters, having appeared in more than thirty cartoons since *Steamboat Willie*. But his story is usually the same: he is a mean bully out to torment—whether it be Oswald the Lucky Rabbit or Donald Duck and Mickey Mouse—and he is always on the losing side of the classic struggle of good versus evil.

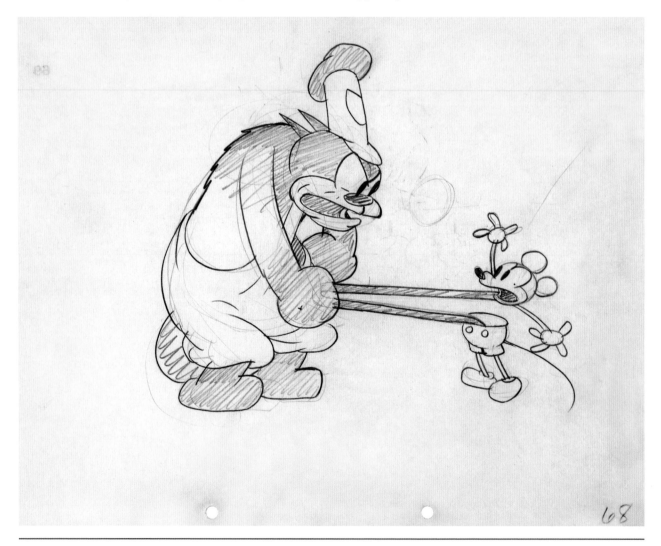

THIS PAGE: Cleanup animation of Pete and Mickey from *Steamboat Willie*, 1928. Artist: Ub Iwerks. Medium: graphite. OPPOSITE: (LEFT COLUMN) Cleanup animation of Pete from the Oswald the Lucky Rabbit short *Sagebrush Sadie*, 1928. Artist: Disney Studio Artist. Medium: graphite. (RIGHT COLUMN) Final frames of Pete and Alice from the Alice Comedy *Alice Solves the Puzzle*, 1925. (FUN FACT) Final frame of Pete from the 2013 short *Get a Horse!*

# FUN FACT

For the 2013 Mickey Mouse short *Get a Horse!* that theatrically debuted before *Frozen*, archival voice recordings were used so that Billy Bletcher, who passed away in 1979, is still the voice of Pete.

# Big Bad Wolf

*THREE LITTLE PIGS*

**RELEASE DATE:** May 27, 1933

**DIRECTOR:** Burton Gillett

**VOICE TALENT:** Billy Bletcher

**ANIMATOR:** Norm "Fergy" Ferguson

He'll huff, and he'll puff, but the Big Bad Wolf is never going to win against those three little pigs, no matter how much hot air he has to blow. The Big Bad Wolf is more than just a hungry wolf looking for his next meal; he is a thinking man's wolf trying to come up with clever ways of fooling those pigs into adding themselves to the menu. This makes him a more frightening kind of villain; he is a thinker and takes the time to really plot out his next move. Had any of his schemes come to fruition, he may have been the most frightening animated villain of the time. There would be three more shorts (*The Big Bad Wolf*, *Three Little Wolves*, and *The Practical Pig*) after this initial Silly Symphony cartoon for him to try out new plans, but we all know how the story ends.

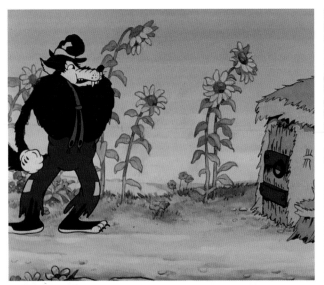
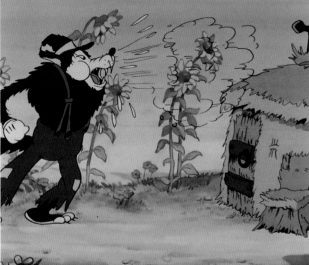
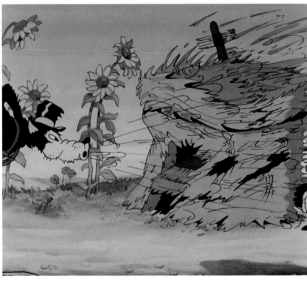
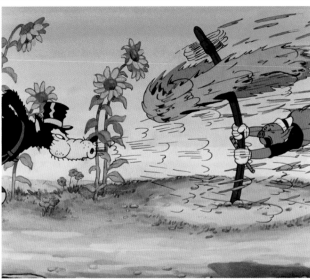

THIS PAGE: Final frames of the Big Bad Wolf from *Three Little Pigs*, 1933.

# Clowns and Other Elephants

*DUMBO*

**RELEASE DATE:** October 31, 1941

**DIRECTOR:** Ben Sharpsteen

**VOICE TALENT:** Noreen Gammill (Catty the Elephant), Dorothy Scott (Giddy the Elephant), Sarah Selby (Prissy the Elephant), Billy Bletcher (clown), Eddie Holden (clown), Billy Sheets (clown)

**ANIMATOR:** Art Babbitt (animation director)

"Everyone loves a clown!" Everyone but the poor, sweet elephant Dumbo. Just like the Ringmaster, the clowns are concerned only with their success and "hitting up the boss man for a raise." There is no regard to Dumbo's feelings or safety as they plot to make the show better by raising Dumbo's flaming platform "a hundred and eight feet . . . three hundred feet . . . a thousand!" They're certainly in for a show once Dumbo and his "magic feather" come to the big top!

"Look at those E-A-R-S," Catty the elephant cackles. From the moment the other lady elephants who share a train car with Dumbo and his mother see the young one's special ears, they turn from cooing women to cruel ladies with nothing nice to say. Things only go from bad to worse later on when Dumbo trips over his ears, causing the pyramid of pachyderms to come crashing down. They decide to shun little Dumbo, claiming, "He is no longer an elephant."

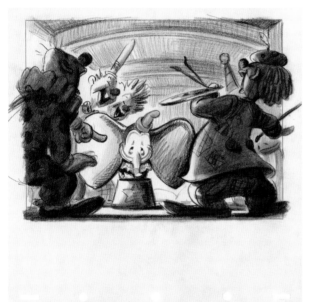

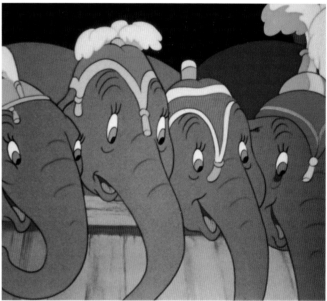

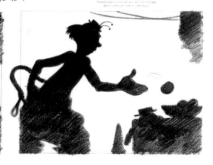

THIS PAGE: (TOP LEFT) Story sketch of Dumbo and the clowns. Artist: Disney Studio Artist. Medium: graphite, colored pencil, watercolor. (TOP RIGHT) Final frame of the mean elephants from *Dumbo*, 1941. (BOTTOM) Story sketches of clown shadows. Artist: Disney Studio Artist. Medium: black line.

# Teams of Mean

It takes a village, or in this case, a group of characters to really bring on the mean. These packs are only out to cause trouble and hurt for the hero and/or heroine of the film. Often tied to one villain or another, these groups are out to do their masters' bidding, or, even worse, are just self-motivated by personal meanness.

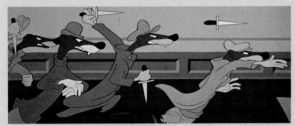

**Weasels**

*The Adventures of Ichabod and Mr. Toad*

**Flowers**

*Alice in Wonderland*

**Queen of Hearts' army of cards**

*Alice in Wonderland*

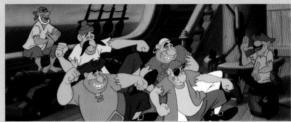

**Pirate crew of the *Jolly Roger***

*Peter Pan*

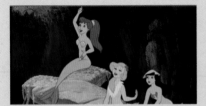

**Mermaids**

*Peter Pan*

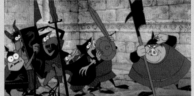

**Maleficent's goons**

*Sleeping Beauty*

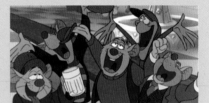

**Ratigan's thugs**

*The Great Mouse Detective*

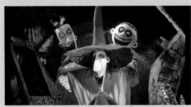

**Lock, Shock, and Barrel**

*Tim Burton's The Nightmare Before Christmas*

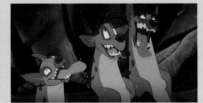

**Shenzi, Banzai, and Ed**

*The Lion King*

**Festival of Fools crowd**

*The Hunchback of Notre Dame*

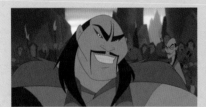

**Shan-Yu's Hun army**

*Mulan*

**Yzma's soldiers**

*The Emperor's New Groove*

**The Willie brothers**

*Home on the Range*

**Alpha, Beta, and Gamma**

*Up*

**Sunnyside Daycare gang**

*Toy Story 3*

**Sugar Rush racers**

*Wreck-It Ralph*

# Aconcagua (the mountain)

*SALUDOS AMIGOS, "PEDRO"*

**RELEASE DATE:** February 6, 1943 (U.S. premiere)

**DIRECTORS:** Bill Roberts, Jack Kinney, Hamilton Luske, Wilfred Jackson

**VOICE TALENT:** No voice

**ANIMATOR:** Frank Thomas (supervising animator)

"Neither snow nor rain nor heat nor gloom of night stays these couriers from the swift completion of their appointed rounds," states the United States Postal Service creed. But could one angry mountain keep Pedro the plane from delivering the mail for his sick father? Aconcagua, the personified mountain, sure isn't going to make it easy for this young plane's first solo trip.

THIS PAGE: Final frames of Aconcagua the mountain and Pedro the plane from the *Saludos Amigos* "Pedro" short, 1943.

# Come Fly with Me: Walt's Goodwill Trip to South America and the Pan Am Partnership

In August 1941, Walt Disney and a group of animators made a trip to Latin America as part of the Good Neighbor policy, funded by the United States government (the Office of the Coordinator of Inter-American Affairs, to be specific). The idea was that Walt Disney and his artists would travel to twelve different locations in Latin America and conduct research for new endeavors, all the while being "goodwill ambassadors" on behalf of the good ol' U.S.A.

The trip also involved a partnership with a major U.S. airline at the time, Pan American Airways. Roy O. Disney worked directly with George Strehlke, a sales manager for Pan Am, to make the travel arrangements for their trip; this partnership between the studio and the airline would prove to be invaluable for Walt Disney and his team as they prepared for the trip. As homage to the airline and a sign of the studio's gratitude for all of their help, a story about a brave plane named Petey, written earlier in 1941 by Joe Grant and Dick Huemer, was updated to fit in with the rest of the shorts that would come out of the Latin America Goodwill Tour. Petey, of course, became Pedro—flying against the backdrop of the Andes Mountains.

Travelers (left to right) Hazel and Bill Cottrell, Ted Sears, Lilly and Walt Disney, Norm Ferguson, and Frank Thomas arrive in Rio de Janeiro.

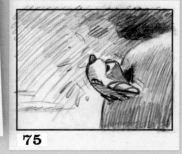

Animation drawing of Pedro. Artist: Fred Moore. Medium: graphite, colored pencil.

Story sketches of Pedro. Artist: Disney Studio Artist. Medium: graphite, colored pencil.

# Willie the Giant

*FUN AND FANCY FREE,* "MICKEY AND THE BEANSTALK" SEGMENT

**RELEASE DATE:** September 27, 1947

**DIRECTORS:** Jack Kinney, Hamilton Luske, Bill Roberts (animation directors)

**VOICE TALENT:** Billy Gilbert

**ANIMATORS:** Ward Kimball, Fred Moore, Wolfgang "Woolie" Reitherman (directing animators)

Ten years after his first Walt Disney animated film role as Sneezy in *Snow White and the Seven Dwarfs*, Billy Gilbert returned as Willie the Giant in the "Mickey and the Beanstalk" segment of *Fun and Fancy Free*. Audiences were first introduced to Willie's foreboding shadow and then heard him bellow out the famous phrase and the magic words, which in this case are "Fee, fi, fo, fum," only to realize a few seconds later that Willie is bouncing a ball like a happy child and singing a song. It is hard for Mickey and his pals to truly be afraid of this villain, especially after he transforms into a pink bunny.

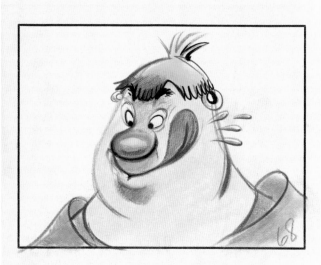

THIS PAGE: (LEFT) John Lounsbery illustrating Willie the Giant. (TOP RIGHT) Story sketch of Willie the Giant. Artist: Disney Studio Artist. Medium: pastel, ink. (BOTTOM RIGHT) Story sketch of Willie with his club. Artist: Disney Studio Artist. Medium: pastel, colored pencil, ink.

# Madame Medusa

**RELEASE DATE:** June 22, 1977

**DIRECTORS:** Wolfgang "Woolie" Reitherman, John Lounsbery, Art Stevens

**VOICE TALENT:** Geraldine Page

**ANIMATOR:** Milt Kahl

Diamonds are a girl's best friend; just ask Madame Medusa! She has her heavily mascara-covered eye on the prize, the Devil's Eye: "the world's largest diamond." Madame Medusa would be the legendary Milt Kahl's last villain prior to his retirement from the Walt Disney Animation Studios, and he was determined to make her one of the greatest animated villains in Disney history. Medusa has often been compared to Cruella De Vil by the critics, since she is another human woman without magical powers, and her obsession and determination to possess the Devil's Eye rivals Cruella's hysterical need "to get those puppies!" Animators had even considered using the Cruella De Vil character again for this movie, but they had not wanted to make *The Rescuers* into a sequel of *One Hundred and One Dalmatians*.

THIS PAGE: (TOP) Concept art of Madame Medusa with her pet alligators. Artist: Ken Anderson. Medium: marker, pen. (BOTTOM ROW) Cleanup animation drawings of Madame Medusa. Artist: Milt Kahl. Medium: graphite, colored pencil. OPPOSITE: (LEFT COLUMN) Story sketches of Madame Medusa. Artist: Vance Gerry. Medium: marker, pen. (RIGHT COLUMN) Cleanup animation drawings of Madame Medusa. Artist: Milt Kahl. Medium: graphite, colored pencil. (FUN FACT, LEFT) Final frame of Mr. Snoops from *The Rescuers*, 1977. (FUN FACT, RIGHT) Animation historian John Culhane.

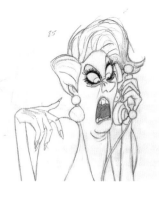

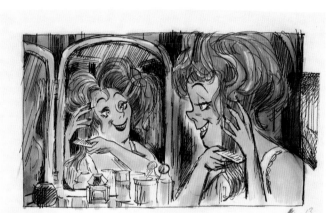

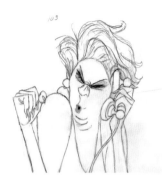

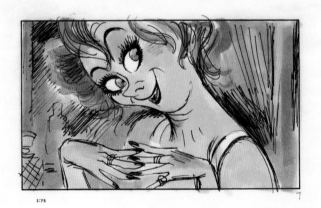

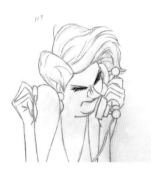

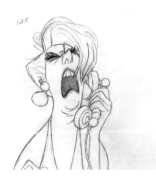

# FUN FACT

Animation historian John Culhane claims that after Milt Kahl showed director Wolfgang "Woolie" Reitherman a caricature that Milt had created of himself, Robin Hood, and Culhane as a ventriloquist's dummy, the director pointed at the caricature of Culhane and said, "There's our villain for *The Rescuers*, Medusa's sidekick—Mr. Snoops!" According to Culhane, "Becoming a Disney character was beyond my wildest dreams of glory."

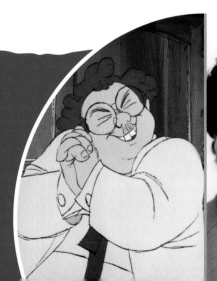

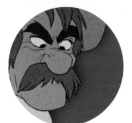

# Amos Slade

## THE FOX AND THE HOUND

**RELEASE DATE:** July 10, 1981

**DIRECTORS:** Art Stevens, Ted Berman, Richard Rich

**VOICE TALENT:** Jack Albertson

**ANIMATORS:** Randy Cartwright, Cliff Nordberg, Ron Clements, Ollie Johnston, Frank Thomas

*The Fox and the Hound* marked a changing of the guard. Frank Thomas and Ollie Johnston, two of the original "Nine Old Men," retired after this film, and a next generation of animators, including Glen Keane and John Musker, started to take over and really come into their own; even a freshly hired John Lasseter worked on animated scenes for this movie. Codirector Art Stevens, who's also the live-action model for Amos Slade, said that the cranky, hot-tempered old curmudgeon antagonist of the film was the most problematic character in a multitude of ways. Stevens recalled, "Basically [Slade] has a permanent scowl, and sometimes an animator would have him raise an eyebrow, and I'd say, 'No, get him back into character.'"

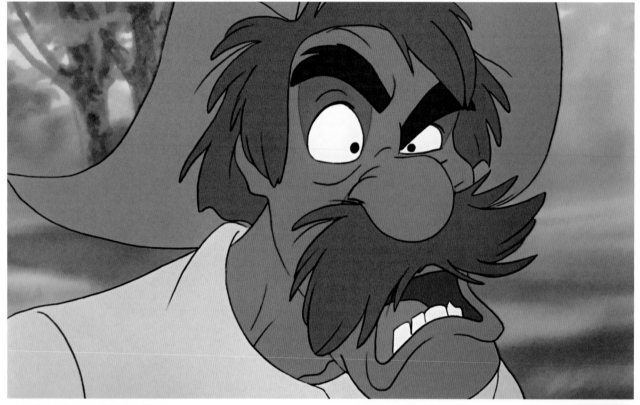

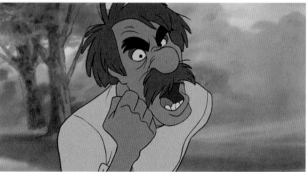

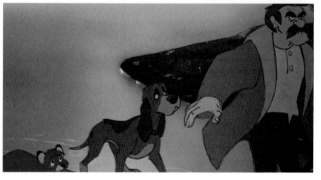

THIS PAGE: Final frames of Amos Slade from *The Fox and the Hound*, 1981.

# Percival McLeach

## THE RESCUERS DOWN UNDER

**RELEASE DATE:** November 16, 1990

**DIRECTORS:** Hendel Butoy, Mike Gabriel

**VOICE TALENT:** George C. Scott (voice), Frank Welker (singing)

**ANIMATOR:** Duncan Marjoribanks (lead animator)

*The Rescuers Down Under* was not only Walt Disney Feature Animation's first animated sequel, but also the first traditionally animated film to use CAPS (the Computer Animation Production System), which allows the artists' hand-drawn work to be scanned and then digitally colored on computer. The film also featured one of the most unlikable villains: Percival McLeach, a greedy poacher who seems to enjoy hunting and killing all animals, especially if their skins can turn him a profit. (Well, all animals except for his unlikely partner, most likely a victim of Stockholm syndrome: a goanna lizard named Joanna.) McLeach is voiced by *Patton* star George C. Scott, but McLeach's disturbing version of the classic song "Home on the Range" was actually sung by Frank Welker, the actor who voiced Joanna in the film, as well as Abu the monkey in *Aladdin*.

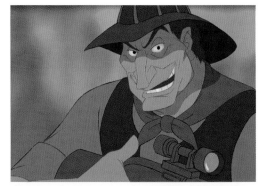

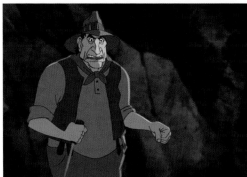

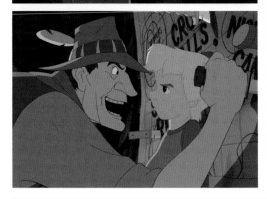

THIS PAGE: (LEFT COLUMN) Final frames of Percival McLeach from *The Rescuers Down Under*, 1990. (RIGHT) George C. Scott, the voice of McLeach, from his role as General Buck Turgidson from *Dr. Strangelove or: How I Learned to Stop Worrying and Love the Bomb*.

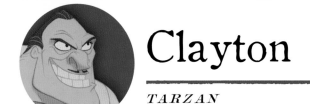

# Clayton

*TARZAN*

**RELEASE DATE:** June 18, 1999

**DIRECTORS:** Kevin Lima, Chris Buck

**VOICE TALENT:** Brian Blessed

**ANIMATOR:** Randy Haycock

Clayton appears to be a dependable gentleman and guides Jane and her father, Archimedes, through the dense jungle in search of gorillas to study. Little does the pair know: Clayton is not the refined protector they thought he was. Rather, he is a ruthless hunter looking for gorillas, too—not to study but to kill. Chris Buck, one of the film's codirectors, said in an interview with the *Chicago Tribune* of Brian Blessed, the voice of Clayton, "Everyone brings something to the character. In the case of Clayton,

actor Brian Blessed simply is that guy. We just drew Brian." But Blessed is not really a bad guy, nor does he only voice a villain in *Tarzan*. He is also the voice of Tarzan's famous yell as the title character stands atop the tree limb with Jane. Blessed said at the 2012 SFX Weekender convention in North Wales that his yodel is from when he was a boy and he and his friends would all mimic Johnny Weissmuller's Tarzan call in the wild after seeing the classic films.

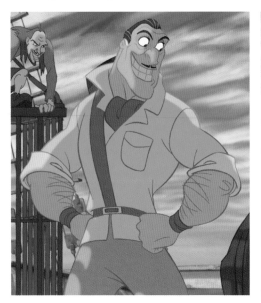

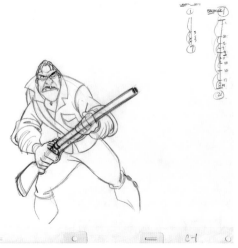

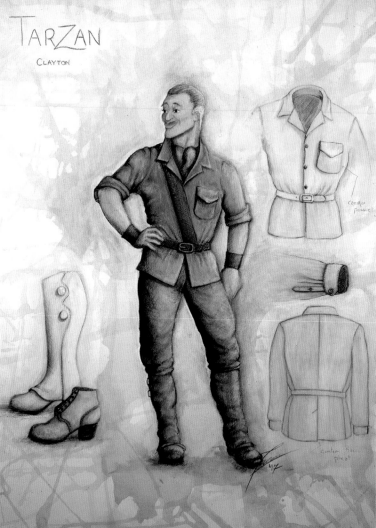

THIS PAGE: (TOP LEFT) Final frame of Clayton from *Tarzan*, 1998. (BOTTOM LEFT) Cleanup animation drawing of Clayton. Artist: Michael Stocker. Medium: graphite, colored pencil. (RIGHT) Concept art of Clayton and his outfit. Artist: Disney Studio Artist. Medium: graphite, colored pencil, paint.

# Alameda Slim

*HOME ON THE RANGE*

**RELEASE DATE:** April 2, 2004

**DIRECTORS:** Will Finn, John Sanford

**VOICE TALENT:** Randy Quaid

**ANIMATOR:** Dale Baer

"Yodeling IS AN ART!!!" declares wanted outlaw Alameda Slim, the pied piper of the Wild West. Instead of using a pipe to get the rats out of town, he uses his yodeling skills to hypnotize the cows to follow him away from their home and to wherever he wants them to go. Randy Quaid, the voice of Alameda Slim, said, "I would start the yodeling, and then they [the studio] had very gifted yodelers who would come in. And it is such a smooth transition from my voice to theirs." Unfortunately for Alameda Slim, the spell does not work on every cow, and Pearl's girls come out fighting with moves Bruce Lee would be jealous of.

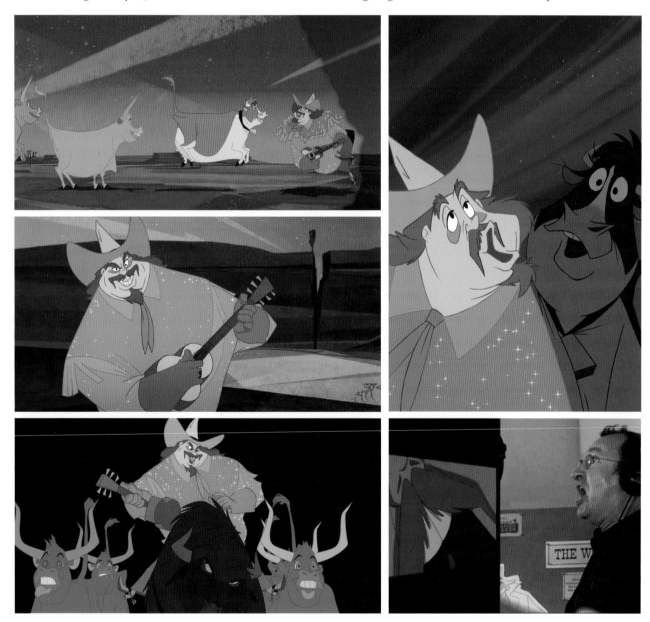

THIS PAGE: (LEFT COLUMN AND TOP RIGHT) Final frames of Alameda Slim from *Home on the Range*, 2004. (BOTTOM RIGHT) Randy Quaid recording his lines, including a few yodels.

# Foxy Loxy

*CHICKEN LITTLE*

**RELEASE DATE:** November 4, 2005

**DIRECTOR:** Mark Dindal

**VOICE TALENT:** Amy Sedaris

**ANIMATOR:** Mark Anthony Austin

From the trailers, one would think the sky might be the villain with the way Chicken Little is constantly panicking over it falling, but that is not the case. As with the 1943 Disney animated short *Chicken Little*, Foxy Loxy is the villain. Unlike the 1943 version, in which Foxy Loxy just wants to eat all of the birds on the farm and uses a psychology book to learn how, this Foxy Loxy is more concerned with her popularity by being good at everything and bullying Chicken Little and his friends. Luckily for everyone in town, while the sky isn't really falling, aliens are coming to town—and when they do, they accidentally give Foxy Loxy a personality makeover and make her the sweetest, nicest girl in town.

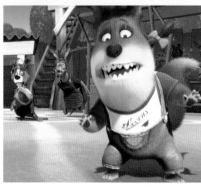

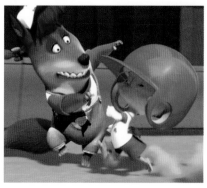

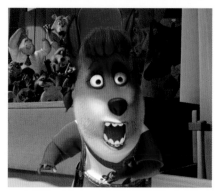

THIS PAGE: (TOP LEFT AND BOTTOM ROW) Final frames of Foxy Loxy from *Chicken Little*, 2005. (TOP RIGHT) Final frame of Foxy Loxy from the *Chicken Little* short, 1943.

# Professor Z

*CARS 2*

**RELEASE DATE:** June 24, 2011

**DIRECTORS:** John Lasseter, Brad Lewis

**VOICE TALENT:** Thomas Kretschmann

**ANIMATORS:** Shawn Krause, Dave Mullins (supervising animators); Michal Makarewicz (directing animator); Victor Navone (animation director)

Professor Z is one nasty microcar! Dave Mullins, one of the mean machine's supervising animators, said of Professor Z, "He's just a creep, so smarmy and full of himself." Professor Z's unpleasant disposition and his crazy monocle are not the only things that make this little car interesting; he is also the enforcer for a mystery puppet master who wants to see the end of Allinol fuel and the World Grand Prix. Professor Z calls for the death of Lightning McQueen, laying out his expectations in a thick German accent: "Allinol must be finished for good. McQueen cannot win the last race. Lightning McQueen must be killed!"

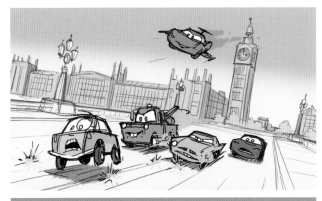

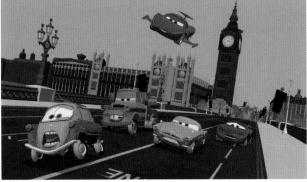

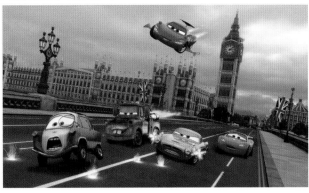

THIS PAGE: (LEFT COLUMN) Professor Z being chased by a flying Holley Shiftwell along with Mater, Finn McMissile, and Lightning McQueen, in storyboard through final frame from *Cars 2*, 2011. (TOP AND BOTTOM RIGHT) Preliminary studies of Professor Z. Artist: Grant Alexander. Mediums: pencil, marker and pencil, digital.

# CHAPTER

# SPOILER ALERT

*Wait, wait; don't tell me!* How many times have people said that to a friend, family member, or coworker when discussing a favorite television show, sporting event, or movie? Audiences love it when there is a surprise plot twist or a jaw-dropping ending that comes out of left field. Throughout the films of the Walt Disney Animation and Pixar Animation Studios, there are plenty of baddies that fall into the "I did not see that coming" category. So, we are giving you clear warning: *there be spoilers ahead!*

THIS PAGE: Concept art of King Candy from *Wreck-It Ralph,* 2012. Artist: Jin Kim. Medium: graphite. OPPOSITE: Final frame of Syndrome from *The Incredibles,* 2004.

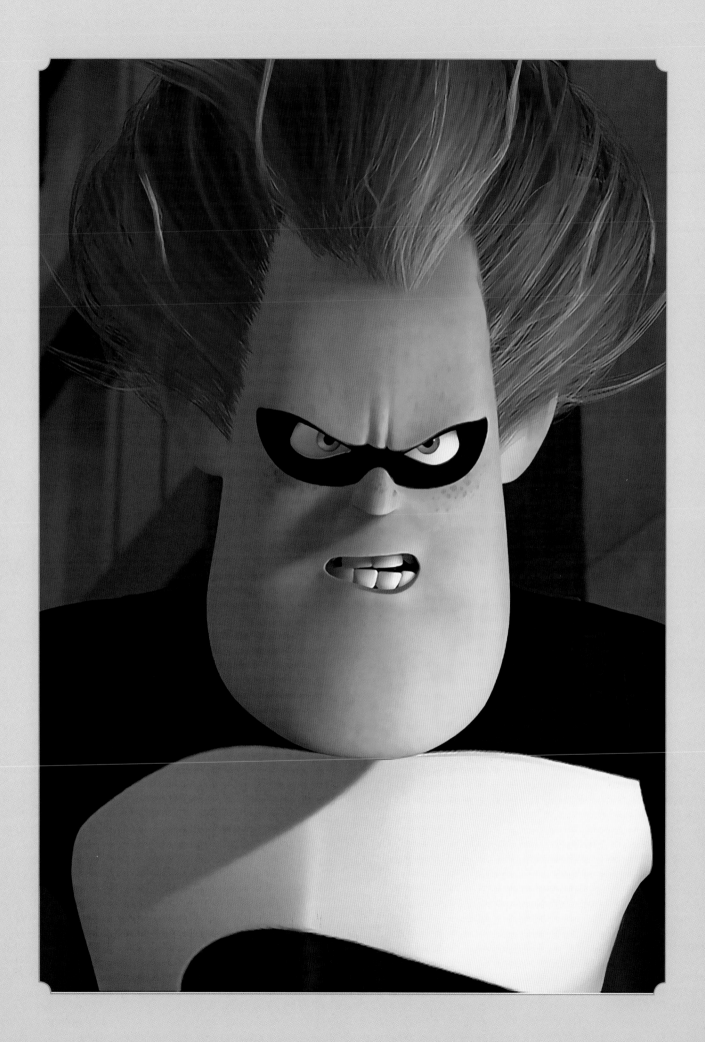

# Winkie

*THE ADVENTURES OF ICHABOD AND MR. TOAD*

**RELEASE DATE:** October 5, 1949

**DIRECTORS:** James Algar, Jack Kinney

**VOICE TALENT:** Alec Harford

**ANIMATORS:** Ollie Johnston, Milt Kahl (directing animators)

Fair trade? Not quite. The tavern keeper Winkie takes complete advantage of Mr. Toad's motor mania and gets him to trade Toad Hall for a motorcar, and then claims that Mr. Toad tried to sell him a stolen car. With his band of weasel henchmen, Winkie uses all of the weapons in his arsenal to keep Toad Hall for himself.

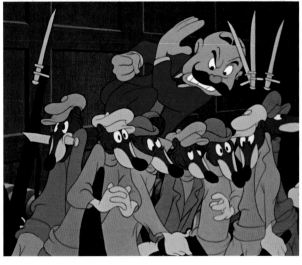

THIS PAGE: (TOP) Model line-up of the cast: Mr. Toad, Mole, Rat, Angus MacBadger, Winkie, and a weasel. Artist: Disney Studio Artist. Medium: black line. (BOTTOM LEFT) Model sheet of Winkie. Artist: Disney Studio Artist. Medium: black line. (BOTTOM RIGHT) Final frame of Winkie from *The Adventures of Ichabod and Mr. Toad,* 1949.

# Stinky Pete (the Prospector)

*TOY STORY 2*

**RELEASE DATE:** November 24, 1999

**DIRECTORS:** John Lasseter; Ash Brannon, Lee Unkrich (co-directors)

**VOICE TALENT:** Kelsey Grammer

**ANIMATORS:** Kyle Balda, Dylan Brown (directing animators); Glenn McQueen (supervising animator)

Stinky Pete the Prospector, despite his name, is supposed to be the jolly grandfather-like figure in the crew of *Woody's Roundup* toys. The problem is that he has never been loved by a child like his fellow cast mates. Stinky Pete has spent his whole life on the shelf, pristine in his box, and has become accustomed to being considered such a prize with all of his original accessories. In his mind, going to Japan together with all the others in their boxes where children can never damage them and where he can be appreciated instead of ignored and unwanted is what he truly deserves. And no "hand-me-down cowboy doll" is going to stop his plans to get there. Unfortunately for Stinky Pete, he ends up with a human girl named Amy after an altercation with Woody and Andy's other toys. Even worse for Stinky Pete, this little girl loves to give "makeovers"!

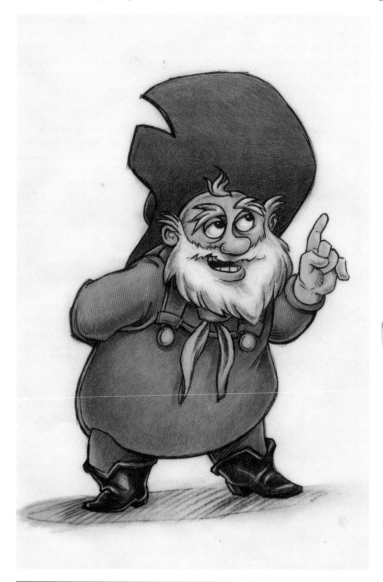

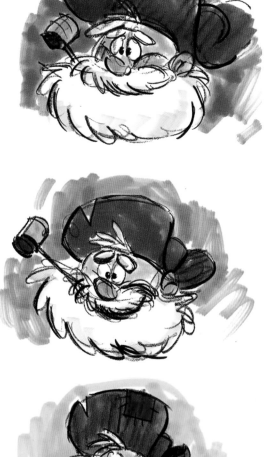

THIS PAGE: Preliminary studies of Stinky Pete's character development illustrate how the character can appear as a kind and trustworthy friend.

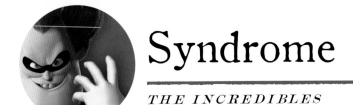

# Syndrome

## THE INCREDIBLES

**RELEASE DATE:** November 5, 2004

**DIRECTOR:** Brad Bird

**VOICE TALENT:** Jason Lee

**ANIMATORS:** Alan Barillaro, Tony Fucile, Steven Clay Hunter

Anyone familiar with comics is going to try to find correlations between the characters of *The Incredibles* and other comic book characters or story line moments. There are tons of theories and connections like this all over. But who is the inspiration for Syndrome? Well, it seems to be writer/director Brad Bird—at least as far as physical appearances go. Bird has even confirmed in interviews that everyone kept telling him that the similarities were there; when Bird finally saw it, they were already too far into production to change it, so

they just had to keep going. Syndrome, with his mass of flaming red hair and the intelligence and talent to create the amazing creative gadgets he uses to fight the Incredibles, is the ultimate fanboy gone horribly wrong. As the child Buddy Pine, he essentially worshipped Mr. Incredible and longed to be his sidekick, "Incrediboy." But when Mr. Incredible chastises him and tells him that he works alone, anger and resentment fester over several years—resulting in Syndrome, evil villain extraordinaire.

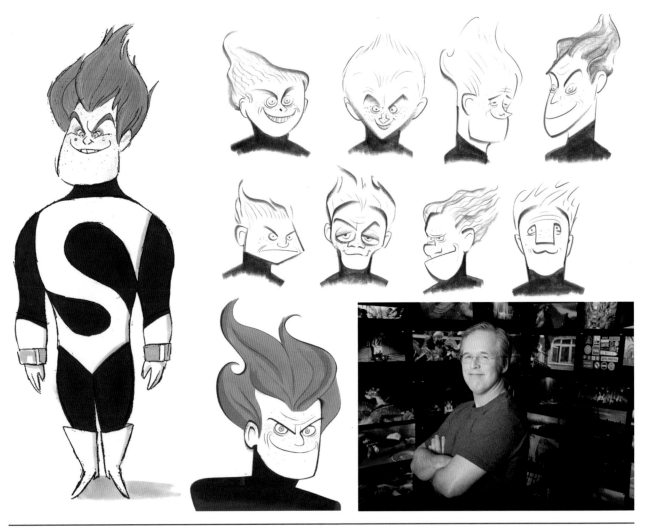

THIS PAGE: (LEFT) Preliminary study of Syndrome. Artists: Tony Fucile, Teddy Newton. Medium: pencil, marker. (TOP RIGHT AND BOTTOM CENTER) Character development of Syndrome. Artist: Teddy Newton. Mediums: pencil and pen, marker. (BOTTOM RIGHT) Brad Bird, shown working on *Ratatouille*.

# Bowler Hat Guy

*MEET THE ROBINSONS*

**RELEASE DATE:** March 30, 2007

**DIRECTOR:** Stephen Anderson

**VOICE TALENT:** Stephen John Anderson

**ANIMATOR:** Dick Zondag

Bowler Hat Guy, who is identified by that moniker for the majority of the movie, is playing the ultimate game of What If? We come to find out, however, that Bowler Hat is really Lewis's roommate from the orphanage, Michael Yagoobian, the young boy who loved baseball, yet fell asleep during the ninth inning of a game and missed an important play—all because he alleges Lewis's late-night experiments deprived him of rest. Bowler Hat Guy/Michael Yagoobian is convinced this is the pivotal moment when his world went off track and led him down the sad, dark path he has been on ever since. Stephen Anderson, the voice of Bowler Hat Guy, is also the director of *Meet the Robinsons*. In order to voice Bowler Hat Guy, along with Grandpa Bud and Tallulah, Anderson had to register a name with the Screen Actors Guild that had never been used before, so he was credited as Stephen John Anderson for all of his voice work, and Stephen Anderson for his directorial work.

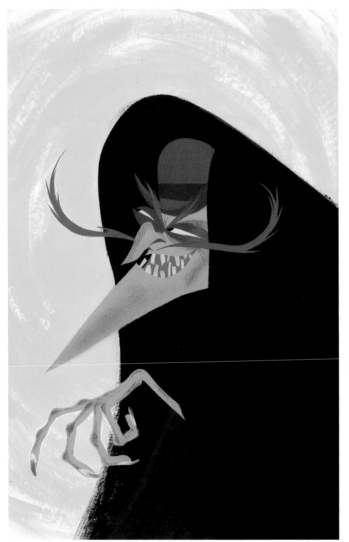

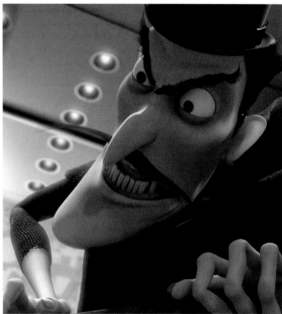

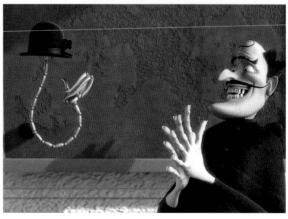

THIS PAGE: (LEFT) Concept art of Bowler Hat Guy. Artist: Joe Moshier. Medium: gouache. (RIGHT COLUMN) Final frames of Bowler Hat Guy from *Meet the Robinsons*, 2007.

# Charles F. Muntz

*UP*

RELEASE DATE: May 29, 2009

DIRECTORS: Pete Docter; Bob Peterson (co-director)

VOICE TALENT: Christopher Plummer

ANIMATORS: Shawn Krause, Dave Mullins, Michael Venturini (directing animators); Scott Clark (supervising animator)

Pixar character designer and character art director Albert Lozano said, "If you were to blend Errol Flynn, Clark Gable, Howard Hughes, and Walt Disney into one heroic 1930s man, that would be [Charles F.] Muntz." Now that doesn't sound bad and definitely not like any villain. Charles F. Muntz sounds more like a man to be admired, and Carl and his wife, Ellie, do. It's hard to believe Pixar Animation Studios artists who were working on *Up* were describing the villain of the film. Well,

at least the younger version of the villain. But seventy years later, when Carl and the audience finally get an opportunity to meet Charles F. Muntz, he's much different. Driven mad by his focus on finding a rare bird and the years of isolation with only his dogs to keep him company (until he loses even them as he obsessively tries to capture the rare bird), Muntz is a dark shadow of the man he once was. Guess that is why they say, "Never meet your heroes."

THIS PAGE: (LEFT AND TOP CENTER) Preliminary studies of a younger and older Muntz. Artist: Daniel López Muñoz. Medium: digital and pencil, digital. (TOP RIGHT) Clark Gable photograph. (RIGHT CENTER) Early concept drawing of Muntz resembling Gable. Artist: Teddy Newton. Medium: pencil. (BOTTOM RIGHT) Faux magazine cover featuring a younger Muntz. (BOTTOM CENTER) Final frame of Muntz from *Up*, 2009.

# Disney Villain Vehicles

Everybody needs a little help sometimes to get from Point A to Point B. In the worlds of Disney and Pixar animation, there are some fantastic ways to travel, ranging from Dr. Jumba Jookiba's spaceship in *Lilo & Stitch* to disappearing into a puff of purple smoke like Maleficent in *Sleeping Beauty*. But if you are a villain without magical powers or from the future or outer space, then you need something a little more everyday villainous. Here are some of the vehicles these scoundrels get around in.

Car
Cruella De Vil (*One Hundred and One Dalmatians*)

Motorcycle with sidecar
Edgar the butler (*The Aristocats*)

Car
Madame Medusa (*The Rescuers*)

Truck
Amos Slade (*The Fox and the Hound*)

Car
Sykes (*Oliver & Company*)

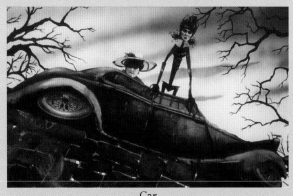

Car
Aunt Spiker and Aunt Sponge (*James and the Giant Peach*, dream sequence)

Zeppelin
Charles F. Muntz (*Up*)

Water buggy
Madame Medusa (*The Rescuers*)

# Lotso (aka Lots-o'-Huggin' Bear)

*TOY STORY 3*

**RELEASE DATE:** June 18, 2010

**DIRECTOR:** Lee Unkrich

**VOICE TALENT:** Ned Beatty

**ANIMATORS:** Bobby Podesta (supervising animator); Robert H. Russ, Michael Stocker (directing animators)

*Toy Story 3*'s villainy is all about Lots-o'-Huggin' Bear, a bright pink plush bear that anyone would want to hug—until he shows what kind of bear he really is. Veteran actor Ned Beatty, with his experience in comedic roles as well as his dramatic work, voiced Lotso in such a way that made audiences want to trust this rough-and-tumble old stuffed bear.

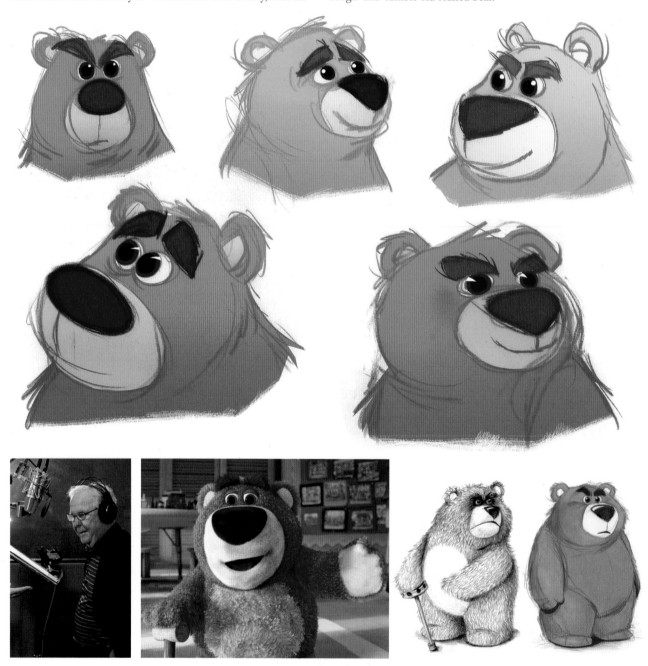

THIS PAGE: (TOP) Preliminary studies of Lotso. Artist: Daniel Arriaga. Medium: digital. (BOTTOM LEFT) Legendary actor Ned Beatty lending his voice to Lotso. (BOTTOM CENTER) Final frame of Lotso from *Toy Story 3*, 2010. (BOTTOM RIGHT) Preliminary studies of Lotso. Artist: Daniel Arriaga. Mediums: pencil and pencil, digital. OPPOSITE: (LEFT) Preliminary character study of Miles Axelrod. Artist: Jay Schuster. Medium: digital. (TOP RIGHT) Final frame of Axelrod from *Cars 2*, 2011. (BOTTOM RIGHT) Preliminary color study of Axelrod. Artists: Jay Schuster, Ellen Moon Lee. Medium: digital. (FUN FACT) Preliminary character study of Sid Phillips from *Toy Story 3*, 2010.

# Miles Axlerod

*CARS 2*

**RELEASE DATE:** June 24, 2011

**DIRECTORS:** John Lasseter, Brad Lewis

**VOICE TALENT:** Eddie Izzard

**ANIMATORS:** Shawn Krause, Dave Mullins (supervising animators); Michal Makarewicz (directing animator); Victor Navone (animation director)

"Alternative energy is the future," states Miles Axlerod, an oil billionaire utility vehicle who has converted from gasoline to electric and created a clean-burning fuel that is good for the environment. (Sounds more like an environmental hero so far.) Axlerod creates the World Grand Prix to showcase his new earth-friendly fuel, Allinol, inspired by this wacky backstory of Axlerod trying to go around the world without GPS and getting stuck in the jungle because he has run out of fuel. But this is just a veneer! Axlerod eventually shows himself as he really is—a greedy, gasoline-lovin' vehicle whose only interest in living "green" is making money hand over hubcap as he protects his monopoly on gasoline. The only thing Axlerod does not count on is Mater figuring out his plan and doing whatever it takes to stand by his friend, Lightning McQueen. No one puts it better than Miles Axlerod himself with his final words: "How did the tow truck figure it out?" That is like trying to figure out who built the pyramids, if the Loch Ness monster is real, or how to solve a problem like Maria. Not every mystery is meant to be solved.

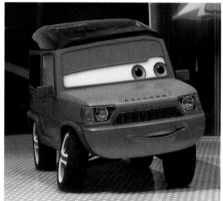

## FUN FACT

*Toy Story 3* was released fifteen years after the first *Toy Story* movie hit the theaters in 1995, but it still includes a quick appearance by the original *Toy Story* villain Sid Phillips, who shows up as a garbage man picking up trash from Andy's house.

# King Candy

*WRECK-IT RALPH*

**RELEASE DATE:** November 2, 2012

**DIRECTOR:** Rich Moore

**VOICE TALENT:** Alan Tudyk

**ANIMATOR:** Zach Parrish

Everyone should have known with a pass code like UP, UP, DOWN, DOWN, LEFT, RIGHT, LEFT, RIGHT, B, A, START that this sugary-sweet king was not on the up-and-up. Who in the gaming world doesn't know that cheat code?! King Candy is the ruler of *Sugar Rush*, a video game made of everything sweet to eat, or as a wise Wreck-It Ralph sees it, a "candy-coated heart of darkness." But *Sugar Rush* was not always such a dark place; it was once a happy kingdom where Princess Vanellope von Schweetz ruled until an evil racer from a game called *Turbo Time* messed with her code and took her game for his own. The biggest shock? King Candy and that villainous racer known as Turbo are one and the same. Alan Tudyk, the voice of King Candy, said he had imagined King Candy to be a much bigger character, size-wise, and found it really funny that he was actually such a small man.

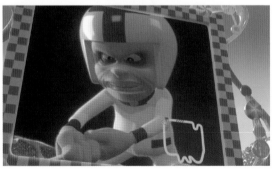

THIS PAGE: (LEFT) Portrait of King Candy. Artist: Clay Loftis. Medium: digital. (TOP RIGHT SEQUENCE) Final frames of King Candy/Turbo from *Wreck-It Ralph*, 2012. (BOTTOM RIGHT) Concept art of Turbo. Artist: Jin Kim. Medium: digital.

# Hans

*FROZEN*

**RELEASE DATE:** November 27, 2013

**DIRECTORS:** Chris Buck, Jennifer Lee

**VOICE TALENT:** Santino Fontana

**ANIMATORS:** Lino DiSalvo, Hyrum Osmond

Lucky number thirteen! The youngest of thirteen brothers, Hans is a prince from the Kingdom of the Southern Isles, and he knows the only way he will ever make it to a throne of his own is to marry into one. While he arrives in Arendelle with plans to woo soon-to-be-coronated Queen Elsa, he has a chance encounter with her younger sister, Anna, and sees her as an easy mark because she seems "so desperate for love" that she would marry him "just like that." Hans is smooth and seems to be very good in a crisis, stepping right into the role of the royal in charge of Arendelle when all snow breaks loose. Animator Lino DiSalvo describes Hans in *The Art of Frozen* as "a chameleon who adapts to any environment to make the other characters comfortable." When Hans's true, selfish motives come out in the end, he sees just how strong the bond of true love is—and a princess is when she punches you in the face and sends you overboard!

THIS PAGE: (LEFT) Concept art of Hans. Artist: Bill Schwab. Medium: digital. (RIGHT) Concept art of Hans dancing with Anna. Artist: Bill Schwab. Medium: digital.

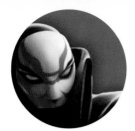

# Yokai (aka Professor Robert Callaghan)

*BIG HERO 6*

**RELEASE DATE:** November 7, 2014

**DIRECTORS:** Don Hall, Chris Williams

**VOICE TALENT:** James Cromwell

**ANIMATORS:** Zach Parrish (head of animation); Nathan Engelhardt, Jason Figliozzi, Michael Franceschi, Brent Homman (animation supervisors)

*Big Hero 6* shares certain similarities with the original Marvel comic by the same name: the story focuses on a young genius named Hiro Takachilo (renamed Hiro Hamada in the movie), who decides to fight for justice after a family tragedy, and a scientist named Honey Lemon, who battles alongside Hiro. What it does not share in common is the villain: Yokai. Yokai, a Kabuki-masked man in black (or as audiences later discover, Professor Robert Callaghan), is a villain whose path has also been driven by a family tragedy—the literal loss of his daughter. Instead of using his incredible scientific mind for good, Yokai decides to use Hiro's mind, and his microbots to take his revenge on those he believes wronged him. Using a fire as a distraction to steal Hiro's microbots, Yokai also inadvertently kills Hiro's older brother, Tadashi, leaving an already orphaned Hiro without his only sibling. Stealing from a kid, even one who's a genius, and killing his brother—villains don't get more evil than that.

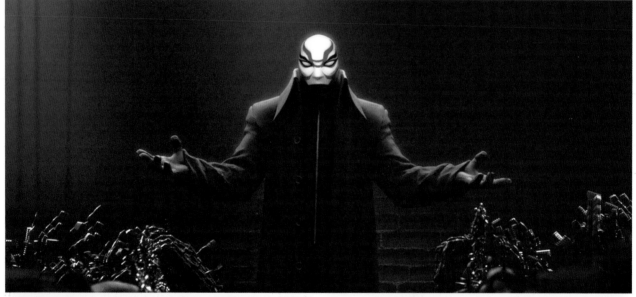

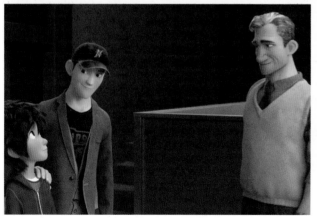

THIS PAGE: Final frames of Yokai (aka Professor Robert Callaghan) from *Big Hero 6*, 2014.

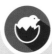

# Easter Eggs

Moviemakers love to include little inside jokes and messages, often called "Easter Eggs," in their films. Animators from Disney and Pixar are no exception. In addition to hiding "A113" in plain sight, animators have also hidden villains into the background for fans to find. *Big Hero 6* probably has the most, with at least three different villains and four different Easter Eggs. Check out some of our favorite background gems!

Ratigan, in a picture frame, from *The Great Mouse Detective* in *Oliver & Company*

Evil Witch from *Snow White and the Seven Dwarfs* attending a Halloweentown town meeting in *Tim Burton's The Nightmare Before Christmas*

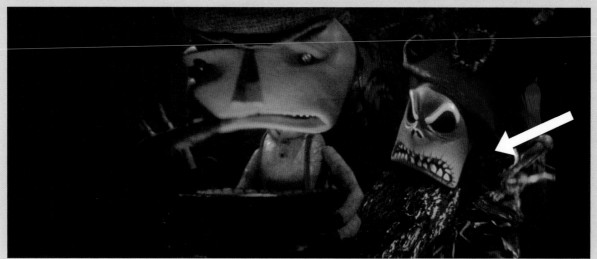

Jack Skellington from *Tim Burton's The Nightmare Before Christmas* in *James and the Giant Peach*

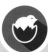

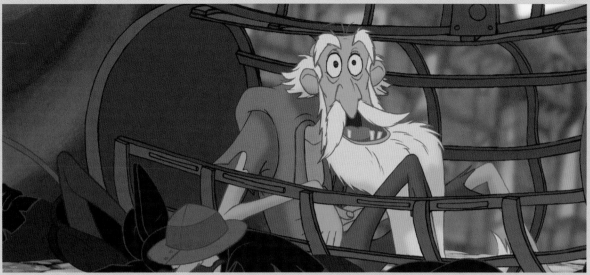

Jafar, in his old man disguise, from *Aladdin* as the old heretic in *The Hunchback of Notre Dame*

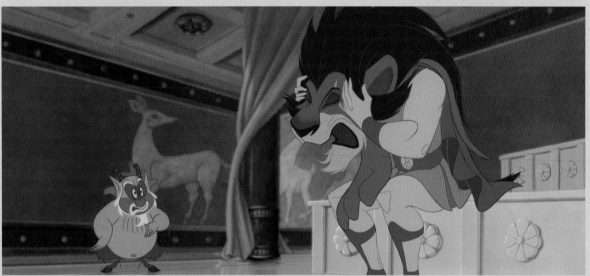

Scar from *The Lion King* as a throw rug in *Hercules*

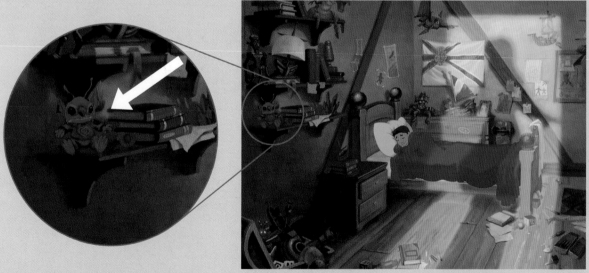

Stitch from *Lilo & Stitch*, as a doll in an astronaut's suit, in *Treasure Planet* when Jim's mother sits with Jim on his bed to read his book

Darla Sherman from *Finding Nemo* in Andy's little sister's magazine in *Toy Story 3*

Hans from *Frozen* as a statue in *Big Hero 6*. Hans is also on a wanted poster in the police station

Saitine, a villain from a game at Litwak's Arcade in *Wreck-It Ralph*, as a life-size statue in Fred's room in *Big Hero 6*

Hiro's cat, Mochi, dressed in a costume featuring Stitch from *Lilo & Stitch* in a stairway picture in *Big Hero 6*

# Pterodactyls

## *THE GOOD DINOSAUR*

**RELEASE DATE:** November 25, 2015

**DIRECTOR:** Peter Sohn

**VOICE TALENT:** Steve Zahn (Thunderclap), Mandy Freund (Downpour), Steven Clay Hunter (Coldfront), no voice (Frostbite and Windgust)

**ANIMATOR:** Matt Nolte (character art director)

It's raining men! Or at least these hungry pterodactyls wish it were. Thunderclap and his crew of winged scavengers, Downpour, Coldfront, Frostbite, and Windgust, may appear to be well-intentioned—in the manner of a dinosaur search-and-rescue team—but they chase storms for purely selfish reasons: any victims of the storm provide an easy meal. They may not have the massive jaws of a T. rex or the razor-sharp talons of a raptor, but the pterodactyls are definitely the most dangerous threat that Arlo and Spot come across.

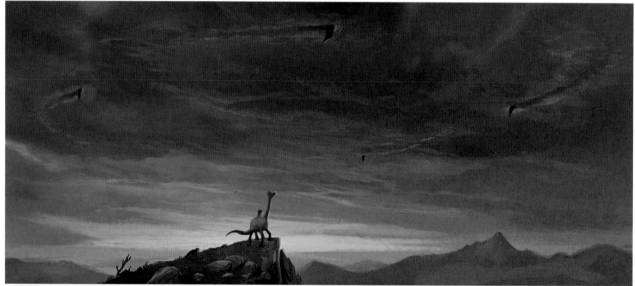

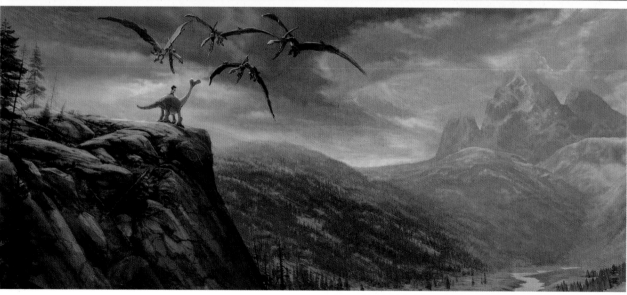

THIS PAGE: Arlo and Spot watching the pterodactyls soaring through the sky. (TOP) Concept art. Artist: Huy Nguyen. Layout by Rosana Sullivan and Edgar Karapetyan. (BOTTOM) Set design. Artist: Kristian Norelius. Layout by Matt Aspbury.

# Bellwether

*ZOOTOPIA*

**RELEASE DATE:** March 4, 2016

**DIRECTOR:** Byron Howard, Rich Moore, Jared Bush

**VOICE TALENT:** Jenny Slate

**ANIMATOR:** Jennifer Hager

To the citizens of Zootopia, Dawn Bellwether appears to be a meek and mild assistant mayor, always willing to help support the "little guys." But she isn't exactly happy at work. Mayor Lionheart treats her more like a personal assistant than a trusted colleague, and it's quite possible that her cramped "office" had a previous life as a broom closet. Despite her stereotypical appearance as a gentle sheep, Bellweather actually has a devious mission. With her ram henchmen working from a secret laboratory—a subway car in an abandoned subway station—Bellwether creates a special kind of serum made from behavior-altering flowers. She plans to target predators and turn them savage, upsetting the peaceful coexistence of the species by instilling fear in the population, and allowing traditional prey animals, who vastly outnumber predators, to gain control of the government.

THIS PAGE: Final character poses of Dawn Bellwether and Mayor Lionheart from *Zootopia*, 2016.

# I'M NOT BAD—I'M JUST DRAWN THAT WAY

Who doesn't love a story of redemption or a tale in which the bad guy is just misunderstood? Audiences often find themselves rooting for the dark horse in the race, hoping that he or she will find his or her way to being courageous at heart, noble, and good—or at least not as bad as initial appearances would have it seem. Some of our favorite heroes are the ones who make the transition from a selfish scoundrel or a mistaken monster to a somewhat rough-around-the-edges good guy or gal.

THIS PAGE: Cleanup animation drawing of Megara from *Hercules*, 1997. Artist: Ken Duncan. Medium: graphite, colored pencil. OPPOSITE: Final frame of Jack Skellington from *Tim Burton's The Nightmare Before Christmas*, 1993.

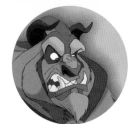

# Beast

*BEAUTY AND THE BEAST*

**RELEASE DATE:** November 22, 1991

**DIRECTORS:** Gary Trousdale, Kirk Wise

**VOICE TALENT:** Robby Benson

**ANIMATOR:** Glen Keane

*"Will you accept this rose?"* That spoiled, selfish Prince should have taken a page out of *The Bachelor* playbook and accepted that old woman's rose. Just like on the hit ABC television show, there can be consequences simply for playing. In *Beauty and the Beast*, the handsome prince was transformed into a hideous beast. Normally, it would be a no-brainer to identify a beast, magical or otherwise, as the villain of a movie, but it's not that straightforward in this film. The Beast is not a conventional villain; much like Gaston, the lines are blurred between hero and villain. He is an ugly monster on the outside, but in the end, he is the better person on the inside. Also like Gaston, the animator faced challenges with the dichotomy of the character. That animator, Glen Keane, said on animating the Beast, "He had incredible limitations. It's kind of like taking the villain and the hero and wrapping them up into one body."

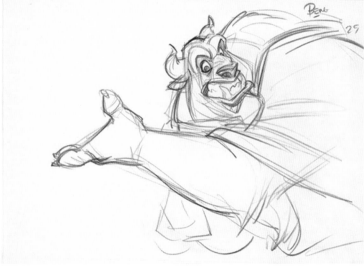

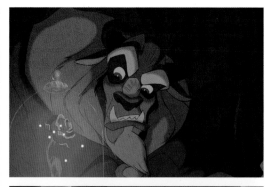

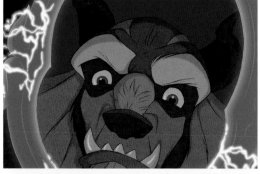

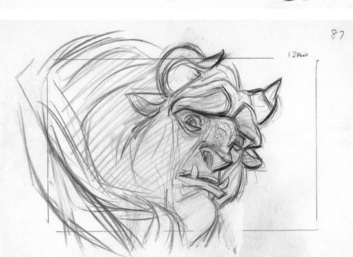

THIS PAGE: (LEFT COLUMN) Rough animation drawings of Beast. Artist: Glen Keane. Medium: graphite. (RIGHT COLUMN) Final frames of Beast from *Beauty and the Beast*, 1991.

# Making the Transition

Change is hard, and not everyone can make the transition from a spoiled prince to an angry, self-loathing beast and then back to a redeemed prince. Chernabog changed from a mountain into a demon in *Fantasia*, Mr. Whiskers into a vampire in *Frankenweenie*, and Madam Mim into a number of animals in *The Sword in the Stone*. Here are a few examples of miraculous transformations—though some may not have always been for the better.

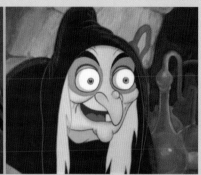

From the Queen to the Witch
*Snow White and the Seven Dwarfs*

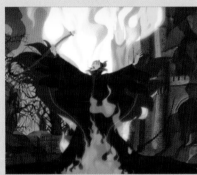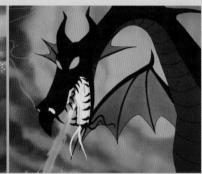

From Maleficent to a dragon
*Sleeping Beauty*

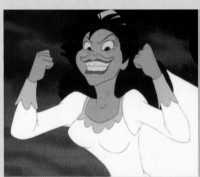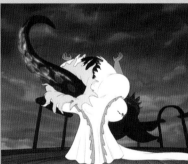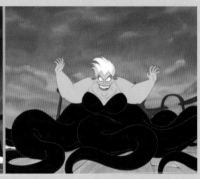

From Ursula to Vanessa and back to Ursula
*The Little Mermaid*

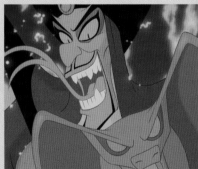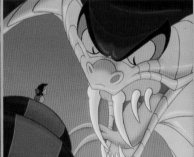

From Jafar to a snake and an evil genie
*Aladdin*

# Jack Skellington

## *TIM BURTON'S THE NIGHTMARE BEFORE CHRISTMAS*

**RELEASE DATE:** October 22, 1993

**DIRECTOR:** Henry Selick

**VOICE TALENT:** Chris Sarandon (voice), Danny Elfman (singing)

**ANIMATOR:** Eric Leighton (animation supervisor)

Jack Skellington doesn't mean to almost ruin Christmas; he is just bored with doing the same old thing. Who wouldn't want to wake up Christmas morning and find snakes and mice wrapped with spider legs and pretty bows under the tree? It would definitely be different. Unfortunately, like many great minds with creative spirits, Jack gets lost in the journey and does not really think about what the finished product could mean for the holiday, or the children waking up to find the holiday darkly altered . . . though it can't be any darker than Chris Sarandon, the speaking voice of Jack Skellington, who was seen taking a box of Jack Skellington heads home with him after a session of voice acting.

THIS PAGE: Twenty-five models of Jack Skellington interchangeable stop-motion puppet heads. OPPOSITE: (TOP LEFT) Sketch of Jack in his Santa outfit. Artist: Disney Studio Artist. Medium: ink. (CENTER LEFT) Creator Tim Burton with director Henry Selick on set. (BOTTOM LEFT) Selick in front of the iconic spiral hill. (RIGHT COLUMN) Final frames of Jack Skellington from *Tim Burton's The Nightmare Before Christmas*, 1993.

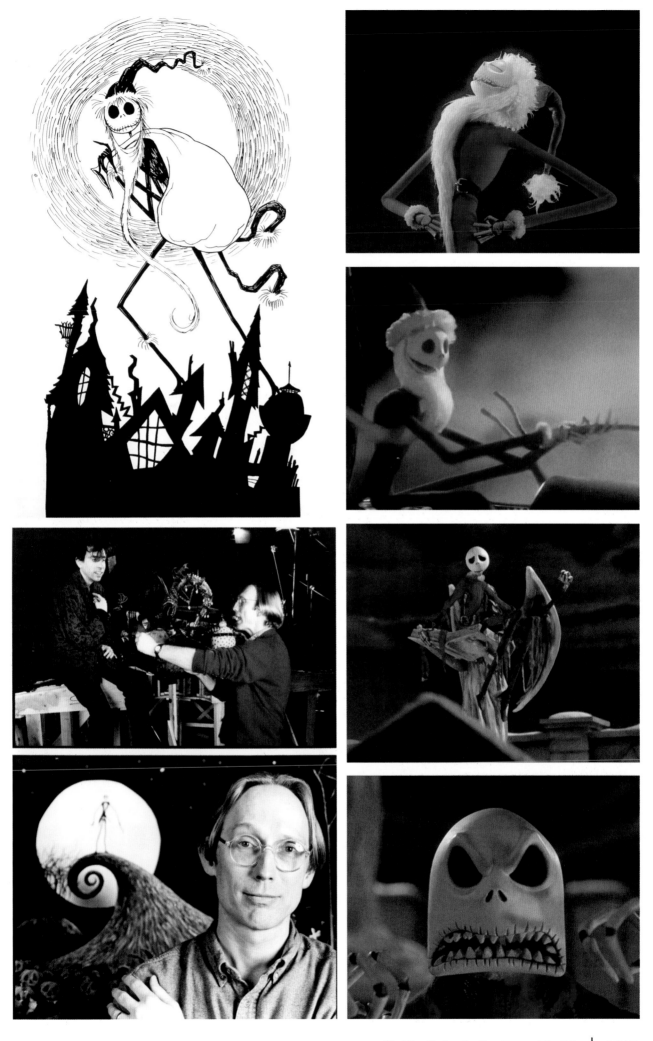

# Quasimodo

## THE HUNCHBACK OF NOTRE DAME

**RELEASE DATE:** June 21, 1996

**DIRECTORS:** Gary Trousdale, Kirk Wise

**VOICE TALENT:** Tom Hulce

**ANIMATOR:** James Baxter

It's what's on the inside that counts, especially in the case of Quasimodo in Walt Disney's animated movie, which is based on Victor Hugo's novel *Notre-Dame de Paris*, published in 1831. The hunchback has been a popular evil henchman in the horror genre for centuries. Igor, from the gross misreading of the literary classic *Frankenstein*, is probably the most well known of these characters. According to Gary Trousdale, one of the film's directors, "Every character in the [Victor Hugo] book hinges on the idea of duality. The most ugly creature has the most beautiful spirit, and the most pious man has the ugliest soul." Walt Disney Feature Animation captured the essence of that original novel: Quasimodo as a gentle and kind soul, despite being born deformed and hidden away from the world by his "master," a loathsome man responsible for the death of Quasimodo's mother.

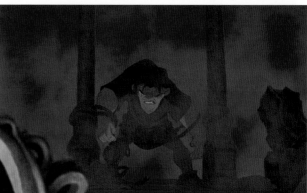

THIS PAGE: Final frames of Quasimodo from *The Hunchback of Notre Dame*, 1996.

# Megara (aka Meg)

*HERCULES*

**RELEASE DATE:** June 27, 1997

**DIRECTORS:** Ron Clements, John Musker

**VOICE TALENT:** Susan Egan

**ANIMATOR:** Ken Duncan

A tale as old as time: Megara is the victim of that oh-so-common story of boy meets girl, boy falls in love with girl, girl betrays boy because girl's soul belongs to the God of the Underworld. Ken Duncan, the supervising animator for Megara, created sketch after sketch of the character, trying to capture just the right look. Early sketches show her "looking too realistic" for the cartoon movie, but Duncan reported the right look came eventually by incorporating "Greek forms for the design of her body. The torso is similar to an 'iconic order.' Her hips, chest, head were basic vase shapes." The most unique sketch, though, came after the voice talent for Megara, Susan Egan, broke her toe. Duncan presented Egan with a sketch of Megara with her toe wrapped in bandages and a thought bubble reading, "That's the last time I let Herc rub my feet!!"

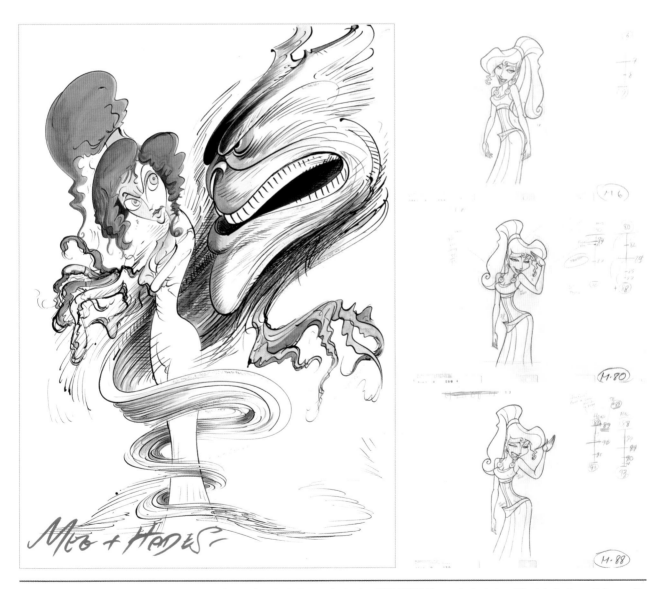

THIS PAGE: (LEFT) Concept art of Meg and Hades from *Hercules*, 1997. Artist: Gerald Scarfe. Medium: ink and marker. (RIGHT COLUMN) Cleanup animation drawings of Meg. Artist: Ken Duncan. Medium: graphite, colored pencil.

# Stitch (aka Experiment 626)

*LILO & STITCH*

**RELEASE DATE:** June 21, 2002

**DIRECTORS:** Dean DeBlois, Chris Sanders

**VOICE TALENT:** Chris Sanders

**ANIMATOR:** Alex Kupershmidt (supervising animator)

A genetic experiment gone completely wrong, or completely right—however you want to look at it—Experiment 626 (aka Stitch) finds, or most likely creates, trouble everywhere he goes. Stitch transforms himself from an alien with six legs and antennae into "the ugliest dog" in order to escape his creator, Dr. Jumba Jookiba, after their prison transport crashes. As Lilo and her sister, Nani, soon find out, Stitch is no ordinary dog. Before *Lilo & Stitch* was released, Walt Disney Feature Animation created several short trailers with scenes from some of their earlier popular movies, like *Beauty and the Beast* or *The Lion King*, and added Stitch into the mix. Suddenly, sweet scenes of Belle learning to love a Beast were marred with Stitch crashing chandeliers or Rafiki presenting Stitch rather than Simba as the new prince. The studio wanted everyone to know that Stitch was going to be the new bad boy of Disney, leaving destruction everywhere he went on his path to fame.

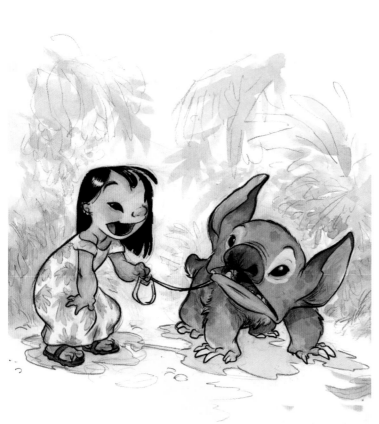

THIS PAGE: (LEFT) Concept art of Lilo with Stitch as a "dog." Artist: Chris Sanders. Medium: ink, marker, watercolor. (RIGHT) Final frames of Stitch (aka Experiment 626) from *Lilo & Stitch*, 2002.

# Dr. Calico

*BOLT*

**RELEASE DATE:** November 21, 2008

**DIRECTORS:** Byron Howard, Chris Williams

**VOICE TALENT:** Malcolm McDowell

**ANIMATORS:** Mark Anthony Austin, Doug Bennett, Lino DiSalvo, Renato dos Anjos, Mark Mitchell, Wayne Unten (supervising animators)

"I'm not a villain, but I play one on TV." Dr. Calico is not really an evil man; he is just an actor in a role on the television show *Bolt*. Dr. Calico, as his name suggests, is a cat lover and has cats to help with his evil bidding. He also has one green eye that looks very catlike. All of the cat connections make Dr. Calico the perfect villain for a hero canine like Bolt to face week after week on the show. While Dr. Calico is not actually present in person, except at the beginning and end of the movie, his character is referenced throughout the film, and he motivates Bolt to continue on his journey to find Penny and do what he does best: save her.

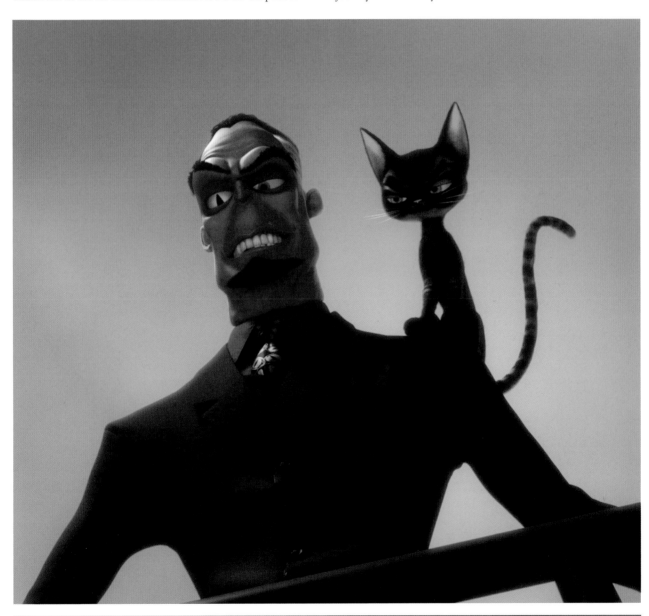

THIS PAGE: Final frame of Dr. Calico from *Bolt*, 2008.

# Wreck-It Ralph

## *WRECK-IT RALPH*

**RELEASE DATE:** November 2, 2012

**DIRECTOR:** Rich Moore

**VOICE TALENT:** John C. Reilly

**ANIMATOR:** Nik Ranieri

Wreck-It Ralph is a "bad guy" who has been forced to spend every day for the last thirty years trying to destroy the apartment building that took his home away and to thwart Fix-It Felix from fixing everything Ralph wrecks. After "wrecking" the thirtieth anniversary celebration of his game, Ralph decides to go on a quest to earn a medal and prove to everyone, including himself, that he can be a good guy and do good things. In an interview with the *Los Angeles Times*, director Rich Moore said

that the idea for *Wreck-It Ralph* came when he was asked by Walt Disney Animation Studios to revamp an idea they had been working on for a while: a movie that takes place in a video game. "Video game characters do the same job every day," said Moore. "I don't know how you could tell a story about that, and then it kind of hits me. . . . What if the main character did not like his job? If you had a character who is actually wondering: Is this all there is to life?"

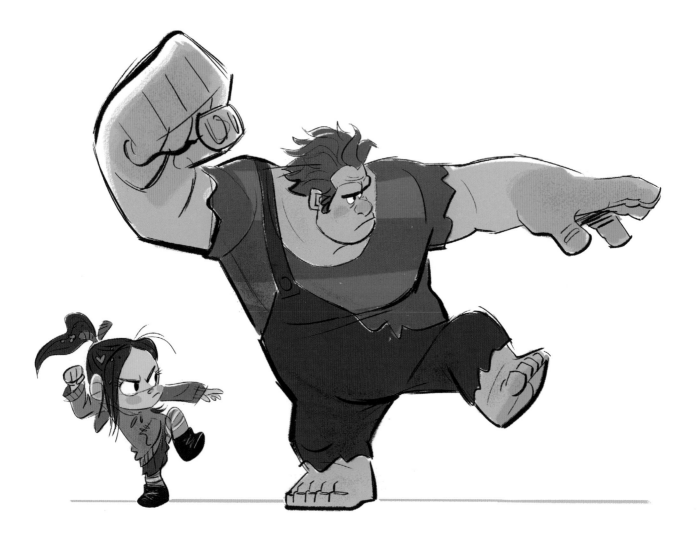

THIS PAGE: Concept art of Vanellope and Ralph. Artist: Bill Schwab. Medium: digital. OPPOSITE: (LEFT COLUMN) Story sketches of Ralph. Artist: Jim Kim. Medium: graphite. (TOP RIGHT): Final character pose of Ralph. (SIDEBAR) Final frame of Ralph with the Bad-Anon support group from *Wreck-It Ralph*, 2012.

# Bad-Anon—One Game at a Time

**"I'm bad, and that's good. I will never be good, and that's not bad. There's no one I'd rather be than me."**
—The Bad Guy Affirmation

Everyone needs a little help from their friends, even if their friends are a group of "bad guys." Bad-Anon is a place where the who's who of gaming bad guys can meet and talk about their feelings and what it is like to always be the one everyone loves to beat. Here are some of the familiar faces from the video games of the 1980s and 1990s.

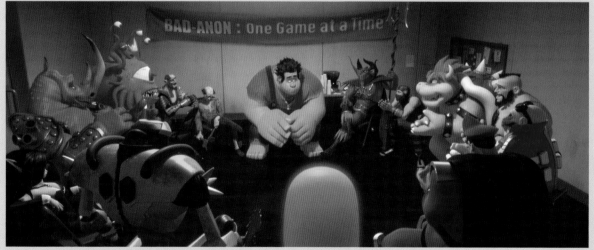

Bowser—King Koopa from *Super Mario Bros.*
Clyde—Ghost from *Pac-Man*
Dr. Robotnik—as himself from *Sonic the Hedgehog*
Kano—as himself from *Mortal Kombat*
M. Bison—as himself from *Street Fighter*
Neff—as himself from *Altered Beast*
Zangief—Red Cyclone from the Street Fighter series

# Sources

## Print and Internet Sources

"AFI's 100 Years . . . 100 Heroes & Villains." *AFI.com*. 2003. Web.

All Music. *Allmusic.com*. Web.

"Carnotaurus." *BBC Earth*. Web.

"Disney Legends: Marc Davis." *D23.com*. Web.

"Disney Shutters Florida Studio." *CNN/Money*. 12 Jan. 2004. Web.

"Future is at hand for Danny Devito's Sci-Fi Project." *The Orlando Sentinel*. 19 Jan. 1996. Web.

"'Hades' Inspiration came from Buddies." *Spartanburg Herald Journal* via *Google Newspapers*. 1 Jul. 1997. Web.

"Monsters, Inc.: Production Notes." *Cinema.com*. Web.

"The Cars of Pixar's Cars 2." *Car and Driver*. Apr. 2011. Web.

"The Story Behind Postal Service's Unofficial Motto." *Postal Employee Network: Postal News*. Web.

"This Day In Disney: Walt Disney Founds WED Enterprises." *D23.com*. Web.

"Toy Story 2—Production Notes." *Pixar Talk*. Web.

"Virginia Records Timeline 1553–1743." *The Thomas Jefferson Papers: The Library of Congress*. Web.

"We ranked every song in The Little Mermaid." *Entertainment Weekly*. 18 Jan. 2015. Web.

Belcher, David. "Tallulah's Back in Town, Still Famous for Her Infamy." *The New York Times*. 15 Feb. 2010. Web.

Boyar, Jay. "Vincent Price's Villainy Has Logical Secret." *The Orlando Sentinel*. 7 Aug. 1986. Web.

Burch, Rob. "Disney 53: The Rescuers Down Under." *The Hollywood News*, 30 Jul. 2013. Web.

Churchill, Bonnie (Entertainment News Service). "Garner Truly Thanks God for His Latest Starring Role." *The Chicago Tribune*. 25 Feb. 2000. Web.

Culhane, Shamus. *Talking Animals and Other People: The Autobiography of One of Animation's Legendary Figures*. New York: St. Martin's Press, 1986. Page 196.

Deja, Andreas. "Deja View—Scar Pencil Tests." *Deja View*. 18 Sep. 2011. Web.

Dodge, Brent. *From Screen to Theme: A Guide to Disney Animated Film Reference Found Throughout the Walt Disney World Resort*. Indianapolis: Dog Ear Publishing, 2010.

Dutlka, Elaine. "'Planet' treasured for new techniques." *The Los Angeles Times*. 06 Dec. 2002. Web.

Gilchrist, Todd. "The Incredibles: An Interview with Brad Bird." *blackfilm.com*, Nov 2004. Web.

Gilland, Joseph. "Avalanche Special Effects from Disney's Mulan." *Elemental Magic*. May 2008. Web.

Grant, Joe. *Encyclopedia of Walt Disney Animated Characters*. New York: Hyperion, 1998.

Hischak, Thomas S. *Disney Voice Actors: A Biographical Dictionary*. Jefferson: McFarland, 2011.

Hauser, Tim. *The Art of UP*. San Francisco: Chronicle Books, 2009.

Internet Broadway Database. *ibdb.com*. Web.

Internet Movie Database. *imdb.com*. Web.

Irving, Washington. *Rip Van Winkle and The Legend of Sleepy Hollow*. The Harvard Classic Shelf of Fiction. 1917. Web.

Johnston, Ollie, and Frank Thomas. *The Disney Villain*. New York: Hyperion, 1993.

Johnston, Ollie, and Frank Thomas. *The Illusion of Life: Disney Animation*. New York: Hyperion, 1981.

Kaufman, J. B. *South of the Border with Disney: Walt Disney and the Good Neighbor Program, 1941–1948*. New York: The Walt Disney Family Foundation Press, 2009.

Keegan, Rebecca, and Ben Fritz. "'Wreck-it Ralph': Disney animators zip around in video game realities." *Hero Complex: Pop Culture Unmasked – The Los Angeles Times*. 27 Oct. 2012. Web.

King, Susan. "Lovable orphan meets oddball clan." *The Los Angeles Times*, 26 Mar. 2007. Web.

Lammers, Tim (DirectConversations.com). "Oogie Boogie actor loves celebrating 'Nightmare Before Christmas' every Halloween." *WCVB 5*. 31 Oct. 2014. Web.

Lammers, Tim (StrictlyCinema.com). "Sarandon remains proud of 'Nightmare Before Christmas' as film classic turns 20." *NBC Montana*. 24 Dec. 2013. Web.

Lawson, Terry. "Tarzan Yell." *The Chicago Tribune*. 16 Jun. 1999. Web.

Maltin, Leonard. *The Disney Films Encyclopedia*, fourth edition. New York: Disney Editions, 2000.

Moore, Roger. "A Voice for all Seasons, Characters." *The Los Angeles Times*. 24 Jun. 2002. Web.

Nagy, Péter. "Hercules (1997)—Model Drawings & Sheet Production Drawings." *Living Lines Library: Collection of Animated Lines*. Web.

New York Theatre Guide. *newyorktheatreguide.com*. Web.

Ponitillas, Bobby. "Tappers Caricatures." *The Animation Art of Bobby Pontillas*. 23 Nov. 2012. Web.

Schedeen, Jesse. "The Familiar Faces of Wreck-It Ralph." *IGN*. 8 Jun. 2012. Web.

Smith, Dave. *Disney A to Z: The Updated Official Encyclopedia*, second edition. New York: Hyperion, 1998.

Smith, Dave. *Disney A to Z: The Official Encyclopedia*, fourth edition. Los Angeles: Disney Editions, 2015.

Smith, Linell. "Why, that's Charles up there taking on the role of music conductor." *The Baltimore Sun*. 9 Apr. 1992. Web.

Snekiter, Marc. "'Aladdin': The original Jafar talks musicals, hanging with Ursula, and the 'brutal' scene you didn't see." *Entertainment Weekly*. 18 Jan. 2015. Web.

Solomon, Charles. *The Art of Disney's Frozen*. San Francisco: Chronicle Books, 2013.

Switek, Brian. "Why did Carnotaurus have such wimpy arms?" *Smithsonian.com*. 22 Sep. 2011. Web.

Zeraphyne. "Big Hero 6." *Marvel Universe Wiki*. Web.

## Video Sources

7UpDoll. "Disney's The Emperor's New Groove Behind The Voices" Online video clip. *YouTube*. YouTube, 9 Oct. 2011. Web.

Apartededisney. "Alan Tudyk— 'King Candy' Wreck It Ralph." Online video clip. *YouTube*. YouTube, 30 Oct. 2012. Web.

ArtisanNewsService. "Keaton and the Cable Guy in Cars." Online video clip. *YouTube*. YouTube, 3 May 2007. Web.

ClassicHarlequin. "Original Helga introduction." Online video clip. *YouTube*. YouTube, 1 Aug. 2010. Web.

DisneyFrozenHD. "Disney Frozen—Deleted Scene 'Evil Elsa' Online video clip. *YouTube*. YouTube, 25 Feb. 2014. Web.

"Home on the Range: Recording Studio Behind-the-Scenes." Online video clip. *YouTube*. YouTube. Web.

Hernandez, Melissa. "Monsters University, Nathan Fillion is the voice of the 'Smarmy' Johnny Worthington." Online video clip. *YouTube*. YouTube, 18 Jun. 2013. Web.

MOVIECLIPS Extras. "Frankenweenie Behind the Scenes—helping Puppets Act (2012)—Tim Burton Movie HD." Online video clip. *YouTube*. YouTube, 26 Feb. 2013. Web.

POPSUGAR Entertainment. "Monsters University Star Nathan Fillion Says 'Playing Smarmy is Pretty Satisfying.'" Online video clip. *YouTube*. YouTube, 14 Jun. 2013. Web.

Rachelcakes1985. "Ratatouille—Character Profiles—Target Bonus Disc." Online video clip. *YouTube*. YouTube, 27 Jan. 2008. Web.

Ramezani, Arezou. "The Making of Lilo & Stitch." Online video clip. *YouTube*. YouTube, 10 Jul. 2008. Web.

Redmorgankidd. "The Making of The Hunchback of Notre Dame (2 of 2)." Online video clip. *YouTube*. YouTube, 15 Jun. 2013. Web.

Sims, Steph. "Brian Tarzan story." Online video clip. *YouTube*. YouTube, 11 Feb. 2012. Web.

Snouty Pig. "Disney Pixar Brave An Inside Look and Clips." Online video clip. *YouTube*. YouTube, 7 Nov. 2012. Web.

Spacek, Patrick. "Making of Finding Nemo (English)." Online video clip. *YouTube*. YouTube, 30 Jun. 2014. Web.

TheCoolBrotherhood. "The Making of Toy Story 3." Online video clip. *YouTube*. YouTube, 6 Jan. 2012. Web.

Verity Taylor. "All Frozen Deleted Scenes + Life's Too Short Outtake." Online video clip. *YouTube*. YouTube, 6 May. 2014. Web.

Walt Disney Studios. Sverige "The Princess and the Frog—Featurette 2—Conjuring The Villain featurette." Online video clip. *YouTube*. YouTube, 28 Aug. 2009. Web.

# Image Credits

Bert Lahr photograph on page 70 © Superstock.

Clark Gable photograph on page 162 © Album / Superstock.

Colin O'Donoghue photograph on page 17 © ABC Studios / Bob D'Amico / Getty Images.

Cyril Richard photograph on page 15 © Everett Collection.

Design icons and elements used throughout: © Kapreski/ Shutterstock; © gbreezy/ Shutterstock; © Ratana21/ Shutterstock; © grmarc/ Shutterstock; © PinkPueblo/ Shutterstock; © lana rinck/ Shutterstock; © VoodooDot/ Shutterstock; © Paper Street Design/ Shutterstock; © Paul Crash/ Shutterstock; © Visual Idiot/ Shutterstock; © Vector pro/ Shutterstock; © Alexander Ryabintsev/ Shutterstock; © okili77/ Shutterstock; © eladora/ Shutterstock; © Bloomua/ Shutterstock; © T-Kot/ Shutterstock; © rungrote/ Shutterstock; © yyang/ Shutterstock; © Alvaro Cabrera Jimenez/ Shutterstock; © browndogstudios/ Shutterstock; © Scott Dunlap/ Shutterstock; © iHonn/ Shutterstock.

Disney Parks images on the following pages courtesy Resource Café: 65 (Haunted Mansion photograph produced by Jeff Clausen and Mark Stockbridge), 81 (Buzz Lightyear's Space Ranger Spin photographed by Kent Phillips, produced by Jeff Clausen and J. William Washington), 82 (Fantasmic! Queen/the Witch and Maleficent photographed by Andrea Barnett; Fantasmic! Jafar photographed by David Roark; Festival of the Lion King photographed by Matt Stroshane; and Finding Nemo Submarine Voyage photographed by Piotr Redlinski), 83 (It's Tough to Be a Bug! photograph produced by Jeff Clausen and Mark Stockbridge and The Little Mermaid~Ariel's Undersea Adventure), 84 (Peter Pan's Flight photograph produced by Jeff Clausen and Mark Stockbridge), and 85 (Snow White's Scary Adventure; Splash Mountain and Stitch's Great Escape! photograph produced by Jeff Clausen and Mark Stockbridge; and Storybook Land Canal Boats photographed by Bob Desmond).

Disney Parks images on the following pages courtesy Walt Disney Imagineering Art Collection: 81 (Alice in Wonderland Maze) and 85 (Sorcerers of the Magic Kingdom art by Kyle Price).

Disney Parks images on the following pages courtesy Walt Disney Imagineering Photograph Collection: 81 (Alice in Wonderland photographed by Don Saban; Cinderella Castle Mystery Tour), 83 (The Many Adventures of Winnie the Pooh; Mr. Toad's Wild Ride; Monsters, Inc. Mike & Sulley to the Rescue! model photographed by Jess Allen), and 84 (Pinocchio's Daring Journey; Ratatouille L'Aventure Totalement; Sleeping Beauty Castle Walkthrough photographed by Jess Allen).

Disney•Pixar final frames, photographs, and visual development art on the following pages courtesy Pixar Animation Studios: 7, 24, 25, 26, 27, 28, 29, 31, 42, 43, 54, 59, 68, 71, 75, 76, 78, 79, 88,89, 91, 107, 111, 117, 120, 128, 132, 135, 137, 144, 155, 157, 159, 160, 162, 163, 164, 165, 171, and 172.

Dustin Hoffman photograph on page 16 © Superstock.

George C. Scott photograph on page 151 © Superstock.

George Sanders photograph on page 187 courtesy the Watt Disney Archives.

Haunted Mansion Holiday on page 82 photographed by and courtesy Jennifer Eastwood.

Jack Skellington illustration on page 179 courtesy the Walt Disney Archives Photo Library.

Jason Isaacs photograph on page 17 © Universal Studios / Boland, Jasin / Album / Superstock.

Keith David photograph on page 109 © Jaquar PS / Shutterstock.

Linda Blair photograph on page 70 © Warner Brothers / Album / Superstock.

Music sheet cover images on page 21 courtesy the Walt Disney Archives Photo Library.

Photographs on the following pages courtesy the Walt Disney Archives Photo Library: 13, 14, 15 (Peter Pan and Captain Hook), 16 (Disneyland), 21, 33, 37, 40, 41, 49, 61, 63, 65 (Eleanor Audley), 80, 97, 99, 103, 105, 106, 117, 128, 134, 146, 147, 149, 150, 151, 153, 154, 158, 178, and 179.

Photographs on the following pages courtesy Walt Disney Theatrical Productions: 17 (*Peter and the Starcatcher*) and 52.

*Pirates 'n' Pixie Dust* image on page 17 courtesy Disney on Ice.

Tallulah Bankhead photograph on page 18 © Album / Superstock.

Walt Disney Pictures and Touchstone Pictures final frames on the following pages courtesy Walt Disney Animation Studios Classic Projects: 11, 12, 13, 15, 16, 19, 20, 21, 23, 32, 33, 36, 37, 39, 40, 41, 44, 45, 47, 48, 50, 51, 53, 54, 55, 67, 68, 69, 70, 72, 73, 74, 76, 77, 84, 86, 87, 90, 93, 94, 95, 96, 97, 99, 100, 102, 104, 105, 106, 107, 108, 109, 113, 114, 116, 117. 118, 119, 123, 124, 125, 127, 131, 133, 134, 136, 139, 141, 142, 143, 144, 145, 149, 152, 161, 163, 166, 168, 169, 170, 171, 175, 176, 177, 179, 180, 182, 183, and 185.

Walt Disney Pictures final character poses on the following pages courtesy Walt Disney Animation Studios: 173 and 185.

Walt Disney Pictures live-action final frames on page 64 courtesy Walt Disney Pictures.

Walt Disney Pictures visual development art on the following pages courtesy the Walt Disney Animation Research Library: 1, 3, 5, 8–9, 10,15, 18, 20, 21, 22, 23, 30, 34, 35, 38, 39, 46, 48, 51, 56, 57, 58, 60, 61, 62, 63, 66, 67, 72, 73, 74, 80, 90, 92, 94, 95, 96, 97, 98, 99, 100, 101, 102, 103, 106, 108, 110, 112, 114, 115, 121, 122, 125, 126, 129, 130, 131, 133, 138, 140, 141, 143, 146, 147, 148, 149, 152, 153, 156, 158, 161, 166, 167, 174, 176, 181, 182, 184, 185, and 192.

Washington Irving illustration on page 113 © Everett Historical.

THIS PAGE: George Sanders with his animated counterpoint, Shere Khan, in a publicity image included in the original press kit for *The Jungle Book*, 1967.

Image Credits | 187

# Index by Featured Characters' Names

*List indicates the characters' first on-screen appearance.*

# Index by Featured Characters' Film Release Dates

*List indicates the characters' first on-screen appearance.*

PAGE 192: Cleanup animation drawing of Ursula from *The Little Mermaid*, 1989. Artist: Ruben Aquino. Medium: graphite. Courtesy Animation Research Library.

"You pitiful, insignificant fools!"

—Ursula, *The Little Mermaid*